DAVID

BY THE HAND OF MICHELANGELO

The Original Model Discovered

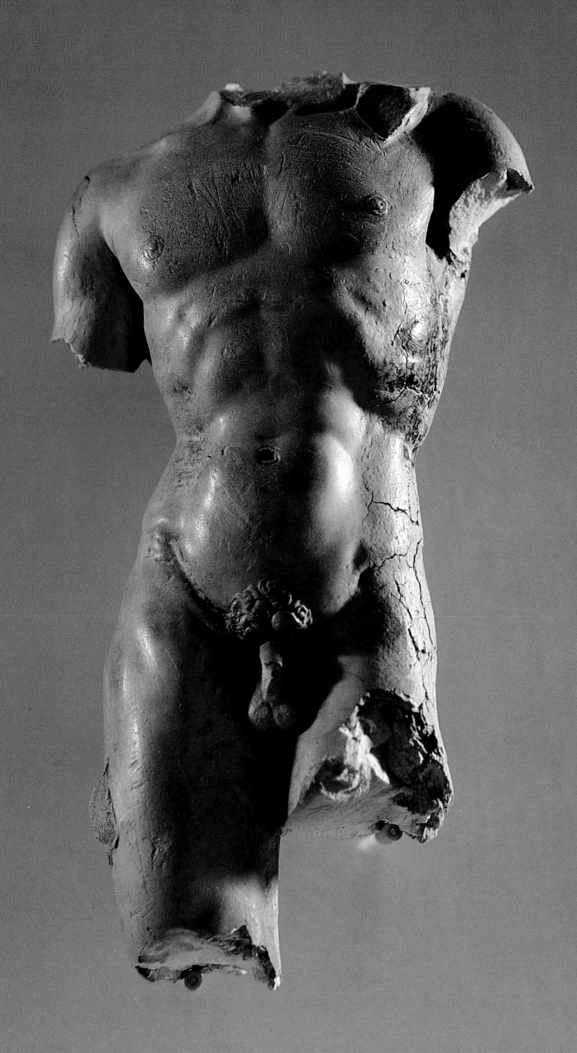

DAVID

BY THE HAND OF MICHELANGELO

The Original Model Discovered

BY FREDERICK HARTT

Sculpture Photography by David Finn

ABBEVILLE PRESS, *Publishers*

NEW YORK

JACKET AND FRONTISPIECE

Michelangelo, model for the *David*, 1501, gesso.
Honegger Foundation.

Editors: Regina Kahney, with Emily Pearl

Designer: Philip Grushkin

Production manager: Dana Cole

FIRST EDITION

Library of Congress Cataloging-in-Publication Data
Hartt, Frederick.
 David—by the hand of Michelangelo.
 Bibliography: p.
 1. Michelangelo, Buonarroti, 1475–1564. David.
2. Marble sculpture, Italian. 3. Marble sculpture, Renaissance—
Italy. 4. Artists' preparatory studies—Italy. 5. Models
(Clay, plaster, etc.). 6. David, King of Israel—Art. I. Title.
NB623.B9A64 1987 730'.92'4 87-1072
ISBN 0-89659-761-X

To the memory of
Charles Seymour, Jr.

Les oeuvres d'art sont objets de métamorphose—comme les dieux.

ANDRÉ MALRAUX

CONTENTS

PREFACE

THERE IS NO FORMULA for writing such a book as this. It is hard even to find a precedent. This is not the customary artist-monograph, which classically commences with a survey of critical opinion, continues with a biography, a stylistic assessment, and chapters treating in roughly chronological order the successive periods in the artist's creative life, including analytical, iconographic, and historical studies of his major works, all supported by massive footnotes, and concludes with a section on documents and an exhaustive bibliography. Nor is it the kind of exhaustive analysis of a single work of art in every conceivable aspect to which we have also become familiar in recent decades through such brilliant monographs as that on the subject of Michelangelo's *David* by the late Charles Seymour, Jr., to whom this book is appropriately dedicated.

Rather it is a presentation of a single work of art of first importance, hitherto absolutely unknown, which I am the first scholar to evaluate and attribute. Any such attempt is inevitably beset by many pitfalls. The most perilous of these is argumentation in the manner of a defense attorney, which can only arouse suspicion in the mind of the reader. No scholar can do this without endangering the objectivity which ought to be (and alas, not always is) the prime goal of scholarship. One cannot and must not present arguments in an emotional light, to convince the reader that the newly discovered work of art really *is* by such and such a great master. Winning a case is not the point. We are, after all, concerned with fact and with fact alone. Did the artist really do the work of art in question or did he not? It has seemed to me that the only possible way to lay the foundation for judgment was to spread the evidence—stylistic, documentary, historical—before the reader as completely as possible, and allow this evidence to speak for itself. In doing so, if I cannot conform to the precedent either of the artist-monograph or of the study of a single work, I am nonetheless obligated to follow their method as closely as is compatible with the special requirements of this unusual instance.

Of necessity the order of the chapters is special. I have played by ear, as the table of contents will disclose, beginning with the informal narrative of my own connection with the newly discovered model. I might add that my own lifelong devotion to Michelangelo began when at fourteen I drew from full-scale plaster casts of some of his statues, including the head of the *David,* in the Metropolitan Museum of Art

in New York. My master's thesis in 1937 dealt with Michelangelo's sources, and since then I have published four books and a number of articles and reviews on Michelangelo. Several more are projected, including the text for the official publication in four volumes of his frescoes in the Sistine Chapel as revealed by the current restoration.

Until now my most intense experience of the great artist's work was the unforgettable moment in 1944 when, in the dark basement of a villa outside Florence used as a storehouse for major works of Florentine sculpture evacuated from the city in fear of bombardments, I climbed on a huge crate and saw inside its bars a ray of sunlight strike the agonized face of Michelangelo's *Dawn* from the Medici Chapel. Now the experience of seeing and studying the model for the *David*, unseen by any scholar's eyes save mine, has transcended even that moment.

My first and warmest thanks go to the representative of the Swiss foundation who acquired the model and recognized in it the hand of Michelangelo, for calling on me to study and publish it. Then I must express my deep gratitude to David Finn, not only for his wonderful photographs, but for his willingness to go to any lengths to take them according to my desires and hopes, to add fresh artistic insights of his own, and to get them done on time. At innumerable points in the making of this book I have relied on his critical judgment and his sound good sense.

Professor Max Schvoerer, who directs the laboratory of Physics applied to Archaeology at the University of Bordeaux, together with his staff conducted an exhaustive scientific study of the model by the process thermoluminescence, and their entire study is incorporated in this volume, along with the gratitude of the author.

At my request Carol Bradley searched through all the many volumes of inventories of the ducal collections in the State Archives of Florence that could possibly contain references to the model, an immense undertaking. Dr. Bradley then carefully transcribed every reference she found and checked the text as given here in Appendix C.6.

Important comments were offered by the five scholars who saw the photographs and listened to my account of the circumstances and documentation at the New York Academy of Sciences on March 5, 1987: Andrée Hayum, Douglas Lewis, Anita Moskowitz, John T. Paoletti, and Leo Steinberg. I am especially grateful to the academy for having made its facilities available for that meeting and for the press conference on the following day, which was Michelangelo's five hundred and twelfth birthday.

At my request James Elkins, who is producing an extensive scientific study of Michelangelo's anatomy, has studied the photographs and made valuable suggestions, in preparation for his forthcoming detailed article on the anatomy of the model. Dr. Raymond F. Morgan, of the Plastic Surgery Department at the University of Virginia Hospital, has kindly corroborated my hypothesis regarding the original pose of the model.

The staff of the Casa Buonarroti in Florence, especially its director, Dottoressa

Pina Ragionieri, gave David Finn and me every assistance in permitting us to study and photograph the Michelangelo *bozzetti* (sketches) in its care under ideal circumstances.

Robert Abrams and Mark Magowan have contributed all that publishers could possibly be expected to and more, in the way of support, advice, and encouragement. Regina Kahney edited the manuscript, tempering thoroughness with sensitivity and patience. The beautiful design of the final volume is due to Philip Grushkin. The bibliography was compiled by Alice W. Campbell.

Gene Markowski shared all the excitement of the discovery, listened to my ideas, and gave me both criticism and understanding when I most needed them during the months when the book was in preparation.

To all, my heartfelt thanks!

Frederick Hartt
Charlottesville, Virginia

DAVID

BY THE HAND OF MICHELANGELO

The Original Model Discovered

M·D·Iiij

Adi 3 di Nouembre

·V̊ᵃ figuretta a Cauallo di stucco in su basa di legname
·V̊ Modello di stucco del Gigante di mano di michelagio

A NOTE ABOUT THE CAPTIONS

After figure 1, the name of Michelangelo will be omitted from all works by him, and the model for the *David* will be listed as "the model." After figure 3, the *David* will be listed as "the statue."

ONE

A SUMMONS TO GENEVA

AT NINE O'CLOCK in the morning of May 22, 1986, my seventy-second birthday, I had just finished breakfast when my telephone rang. I answered, and heard a pleasant voice with a French accent.

"Professor Hartt?"

"Yes."

"This is M—— from Paris, France. I am calling from New York. First I want to wish you Happy Birthday."

Amazement.

"Thank you very much."

"I am calling on the part of a foundation which has a document of Michelangelo, and the representative would like me to come to see you in Charlottesville to show you this document."

Profound skepticism. This sort of thing happens far too often to people like me. Strangers write or call up about Giulio Romanos (naturally, after my book nearly thirty years ago), but also about Botticellis, Raphaels, Titians, and on and on. They even turn up in my driveway with the work of art itself. Nine times out of ten I have to disappoint them. Michelangelo was an especially risky prospect, after some dismal drawings, not to mention a marble statue a dozen years back, for which a huge commission was brandished if I would only "authenticate" it (dreadful word: the only person who can authenticate a work of art is the artist who made it).

I outlined to M—— the policy I have had to establish out of self-protection, to reward me for my time and effort, and to discourage frivolous questions. No problem.

"*C'est normal.*"

Next day, the most beautiful day of the entire year, in perfect light, with every

mountain and every tree looking its best, M—— and his wife arrived on my front porch. What would the "document" be—an unpublished letter or poem? A quick sketch for a work of architecture? I had forgotten that in French a *document* can mean a work of art. A portfolio was opened and an excellent group of large, clear photographs in color and in black and white were drawn forth. The relative dimness of my library, in contrast to the blue and gold outside the windows, was defeating, so we moved into the living room, normally flooded with soft light. Even then I felt compelled to bring the photographs to a window.

Frontis. I was utterly unprepared for what the light revealed. At first, partly due to the astounding quality of the work, partly because it had been reduced to hardly more than a torso, I thought I was looking at photographs of a noble, lifesize Greek fragment from the fifth century B.C. (One gets much the same impression for a moment when looking at photographs of the full-scale model for one of the River *Fig. 1* Gods for the Medici Chapel, and thinks of the reclining male figures from the Parthenon pediments.) The subject was a bony, rangy young man, tense and proud. *Fig. 2* My mind was simply not working. Then a photograph of the *David* was brought out. It was immediately clear that the statue and the fragment were closely related. In methodical, art historical fashion, I began to compare.

"How big is it?"

"The size you see in the photographs."

At last my mind began to tick. Different . . . physically another type . . . not the smooth, idealized beauty of the statue . . . anatomical features observed from life, without reference to the statue . . . pose slightly different . . . slingshot strap in not quite the same place . . . therefore not a copy but an original study from a living model. . . .

I even knew a drawing Michelangelo had made of the same young man, perhaps a marble cutter at Carrara. The bony structure, the vibrant muscles, the wonderful, ungainly grace—like a basketball player's—all were the same. The material, which looked like marble, was stucco, and exquisitely finished down to the wrinkles under the arms, the circles around the nipples, and the meticulously patterned locks of the pubic hair. In a flash my defenses crumbled. This was the only true, small-scale, finished model by Michelangelo in existence as distinguished from the six or seven authentic, fairly rough *bozzetti* (sketches in clay or wax). And it was the actual model he had used for the creation of the most beloved of all his statues, the marble *David* in the Accademia in Florence!

The whole procedure, which looks so lengthy on paper, might have taken sixty seconds. Then I was aware that for the first time in my long, professional life I had encountered an unknown masterpiece by one of the world's greatest artists. I began literally to shake.

We called Geneva from my study.

My visitor's voice in the quiet room: "*Allo, c'est moi. . . . Je suis chez le professeur Hartt.* . . . Yes, he saw them. He is overwhelmed."

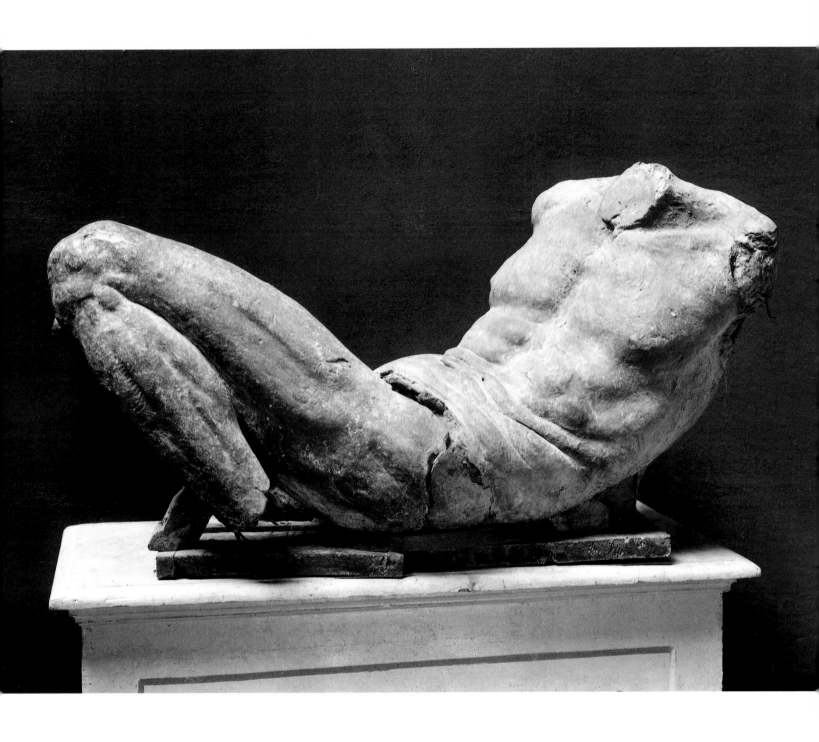

FIGURE I

Full-scale model for a River God, 1520–21, mixed media.
Casa Buonarroti, Florence.

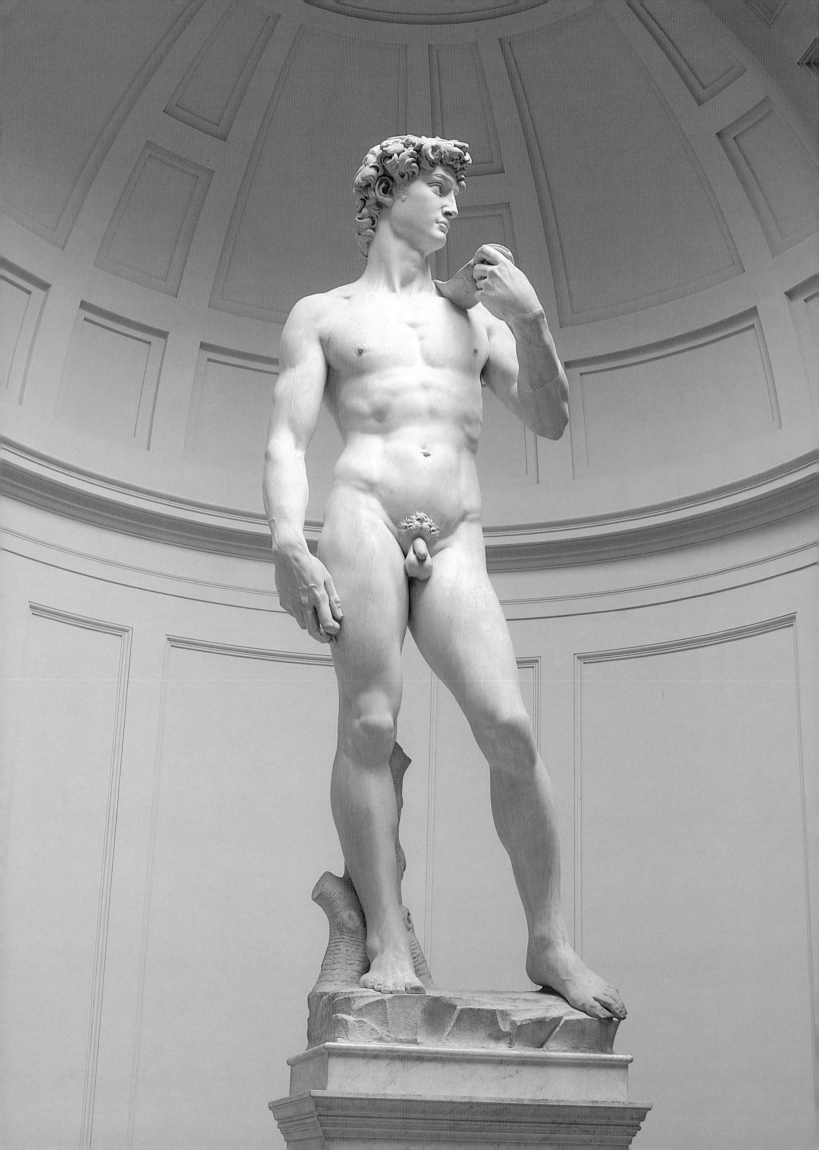

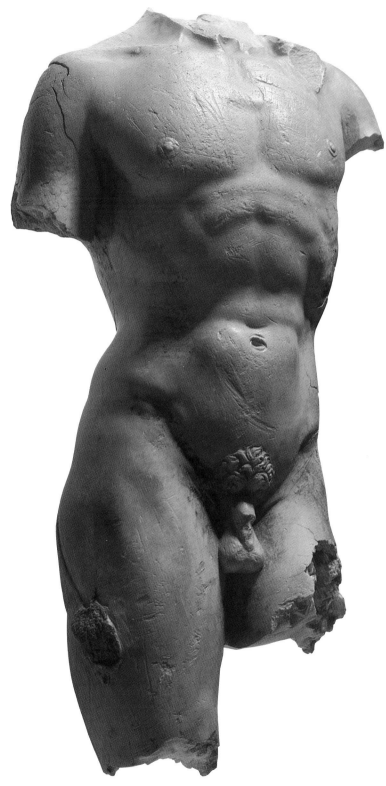

FIGURE 2 *(opposite)*

Statue of *David*, 1501–04,
marble, 79½ in.
Accademia, Florence.

FIGURE 3 *(above)*

The model, one-quarter right.

That was an understatement. It was my turn to talk to the representative of the foundation, and discoverer of the model. I'm not at my best on the telephone in any language, and my French, fluent enough in the 1930s, was rusty from disuse. My voice trembling from the excitement over what I had seen, I faltered and fumbled. Nonetheless, I must have been able to communicate some of my enthusiasm, for I was promptly invited to come to Geneva and see the original. My arthritis makes travel problematic. Moreover, I was in a jam with the third edition of my *History of Italian Renaissance Art*. On both counts I begged off. The response was instantaneous: *"Je viens."* We continued talking about the model, and then came a remark I will never forget: "Sleep on it, if you *can* sleep."

After the phone call I began to have visions of a gentleman arriving from Switzerland at the Charlottesville–Albemarle Municipal Airport carrying a work of sculpture by Michelangelo, and the more I thought of the prospect the less agreeable it seemed. Entrust a work of art of that quality to a commercial airline . . . I know it is done all the time, and so far no disasters, but my wartime training as a monuments and fine-arts officer in Italy got the upper hand. Better that I should go, however inconvenient. We called Geneva again and chose a tentative date for my trip. After the ritual visits to Monticello and the University of Virginia, my visitors were driven to their plane for New York, leaving the photographs with me.

I spread them all out on a table in my study, under slabs of glass, and for hours I could not take my eyes off them. The discoverer was prophetic; I slept very little that night. I was assailed by doubts. Couldn't it be a copy? Wasn't I just deceiving myself? Hadn't I succumbed at this late moment in my career to the wishful thinking that every conscientious art historian tries to fight off? I thought of all those certificates bearing the signatures of eminent "experts," shown me by dealers trying to interest me in impossible pictures in those far-off days when I directed the Smith College Art Museum. Was I at last going to join *that* line-up? Then I remembered a remark by the eminent and delightful art historian Walter Friedlaender to a dealer who was showing him a superb oil sketch by Van Dyck: "What do you want a certificate for? The picture is genuine." If the model was authentic, surely it would certify itself.

Next morning I hurried to my study in dressing gown and slippers. In the early light the photographs were overwhelming. There could be no doubt. Nonetheless, after breakfast I continued to study them, applying every comparison I could think of, from the photographs of the marble *David* in the great work on Michelangelo by Charles de Tolnay and in my own book to those of related figures in Michelangelo's drawings and paintings. The model (its apparent scale was so grand that I could hardly believe it was really small) passed every test. The forms were Michelangelo's, the anatomy showed his knowledge, the power was his alone. I compared the model with the smooth copies of bits and pieces of Michelangelo sculptures that have never won professional acceptance, and it showed them up for what they were. Above all, it was a study for, not a copy after. If not Michelangelo, then was

there some other sculptor around just as good? Then I recalled my pet story about the little boy who wrote on his test paper that the Pentateuch was not set down by Moses but by another man with the same name.

As a final clincher, there were the discoverer's notes on the entry in Ugo Procacci's meticulous catalog of the Casa Buonarroti in Florence (see bibliography), where a weak and unconvincing wax *bozzetto,* supposedly for the *David,* is exhibited. The original model—in stucco, not wax, Procacci underlined—was recorded in an inventory of the ducal collections in the Palazzo Vecchio in 1553.

Fig. 4

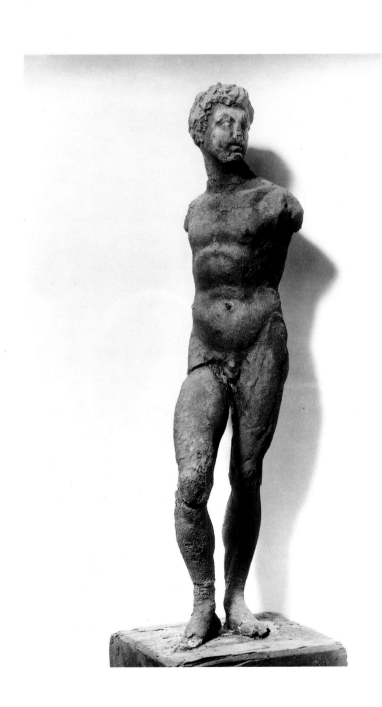

FIGURE 4

Anonymous, standing male figure, early sixteenth century, wax. Casa Buonarroti, Florence.

During the next two weeks I collected still more information, all of it tending to strengthen my conviction that this was the original model for the *David*. There were many telephone conversations with Geneva. I was overjoyed to be asked to write a book, but daunted by the obvious necessity for a degree of secrecy, to which my nature does not incline me. One person close to me was the only one permitted to know as I made arrangements for the trip. On Sunday, June 9, I arrived in Geneva, just two weeks short of the fiftieth anniversary of my first trip to Europe in 1936. I was met by my original visitor and driven to a hotel, where the dramatic meeting with the discoverer took place. I was permitted to sleep off the jet lag in an elegant suite filled with books, flowers, and a color photograph of the model in a magnificent sixteenth-century carved wood frame. That evening came my first visit to M——'s apartment. The model was promptly set before me, in the soft gray light coming from tall windows.

Figs. 5–11

There it was at last! I could hold it in my hands, move it about to obtain a variety of lights and shadows, turn it over, look at it from every conceivable point of view, enjoy the soft, inner glow of the stucco, apparently a gesso made of alabaster, and mourn the damage by fire and fracture. The model was even greater than I had thought. My procedure disclosed beauties of form, subtleties of drawing, and delicacies of detail unsuspected from the photographs. Within its tiny compass I could feel in germ not only the marble *David* but the whole race of heroic beings with whom Michelangelo populated his famous, classic compositions. My wartime job had meant that I sometimes found myself carrying paintings by Duccio or Masaccio on my lap or between my knees in a pitching jeep, or on one occasion pulling out a sculptured relief by Benedetto da Maiano with my own fingers from the ruins of a church bombed the night before. Like all students of manuscript illumination I have turned page after page of scores of the most beautiful of all illuminated manuscripts preserved in European and American libraries. And my long experience in all the principal drawing cabinets meant, as it does for all students of drawings, that I have held thousands of drawings by great masters in my hands. I may even be the only person living who has handled all of Michelangelo's drawings three times. Museum people handle great works of art every day of the week. Yet whenever I have to undertake such responsibility I always feel a sense of awe, and never more so than in the case of this unknown masterpiece.

For safety's sake, white gloves were essential, and a handsome pair of butler's gloves was provided. I spent the next three days studying the model from every

FIGURE 5

The model from below, one-quarter left.

22

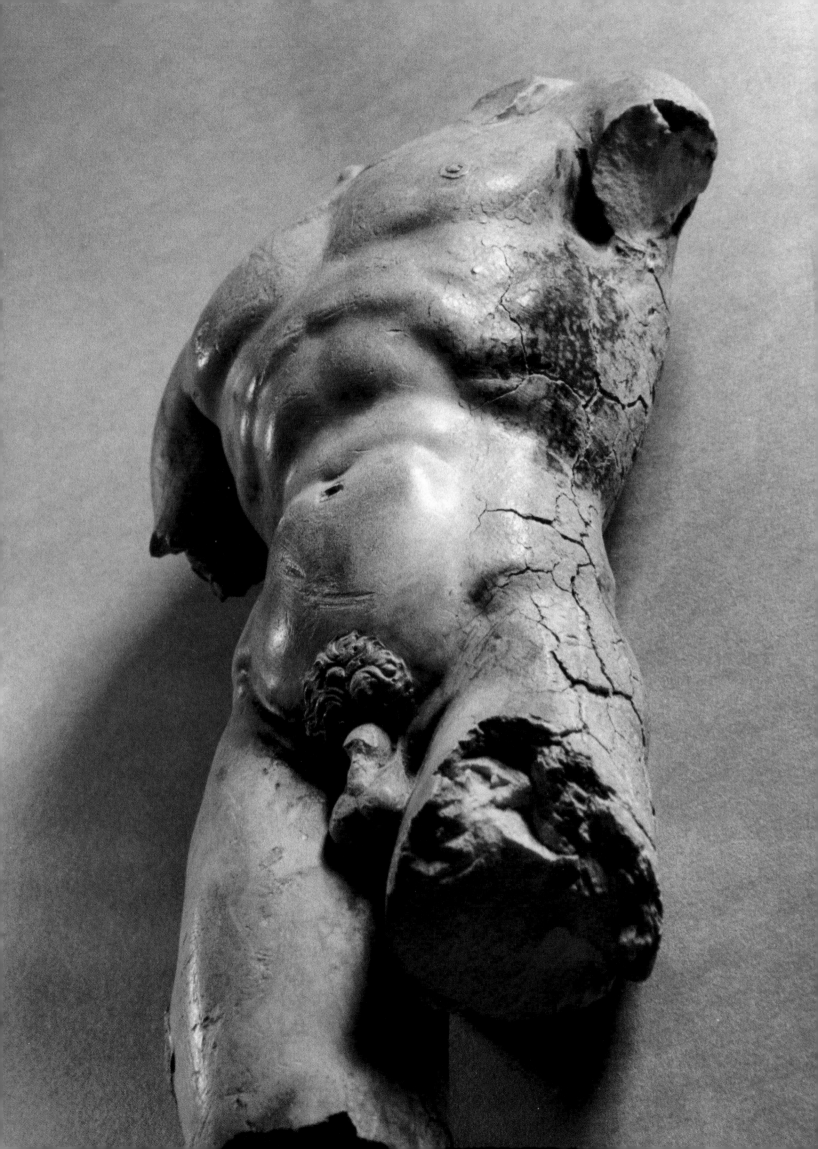

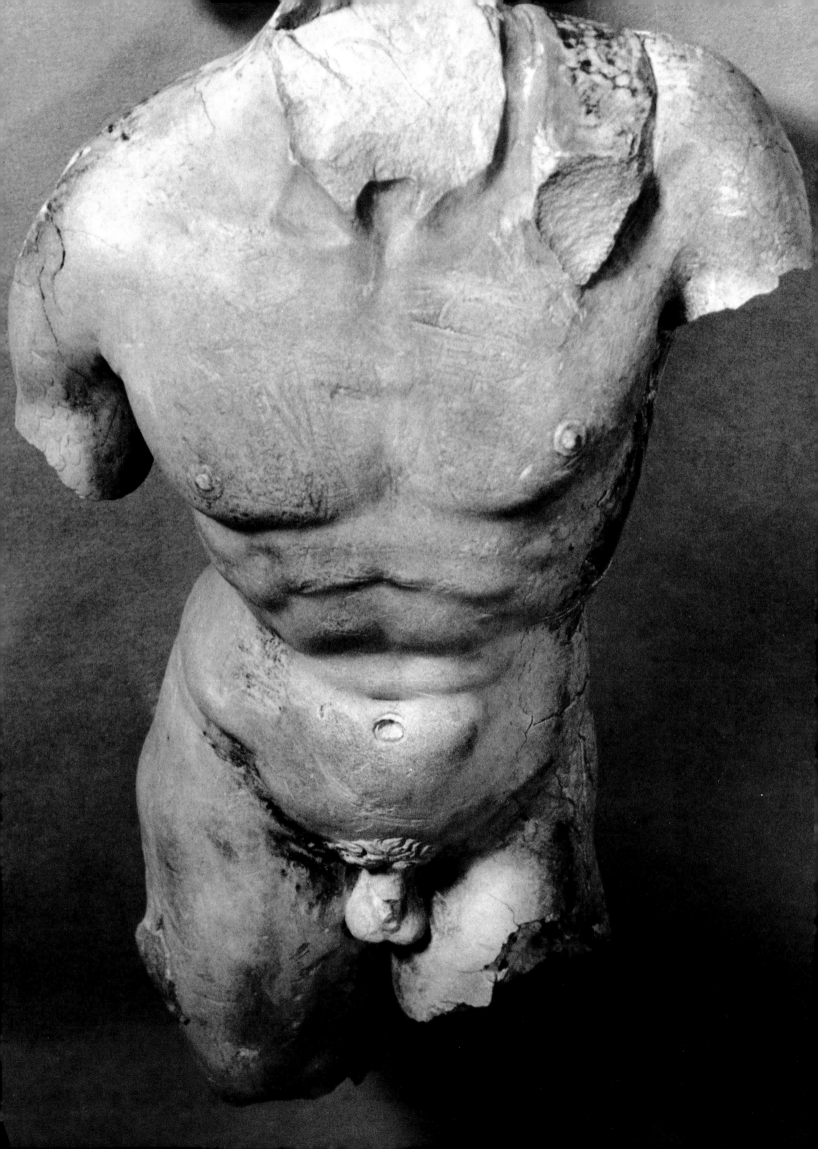

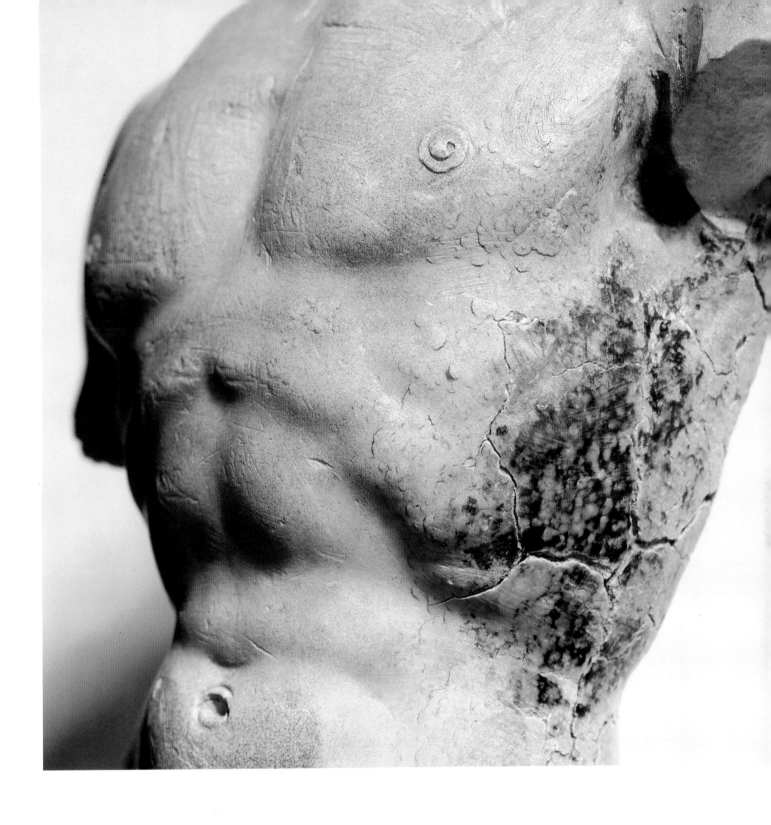

FIGURE 6 *(opposite)*
The model from above, front, showing original pose of neck.

FIGURE 7 *(above)*
The model, one-quarter left, detail, upper torso.

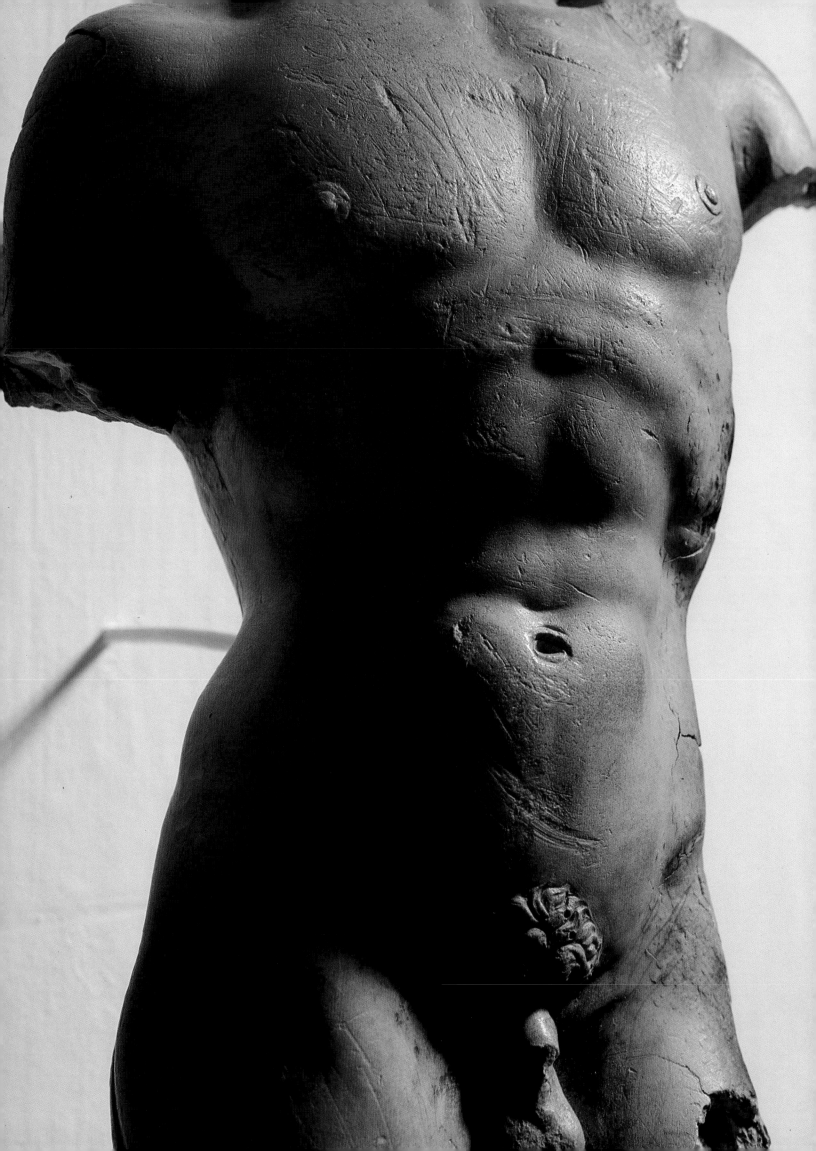

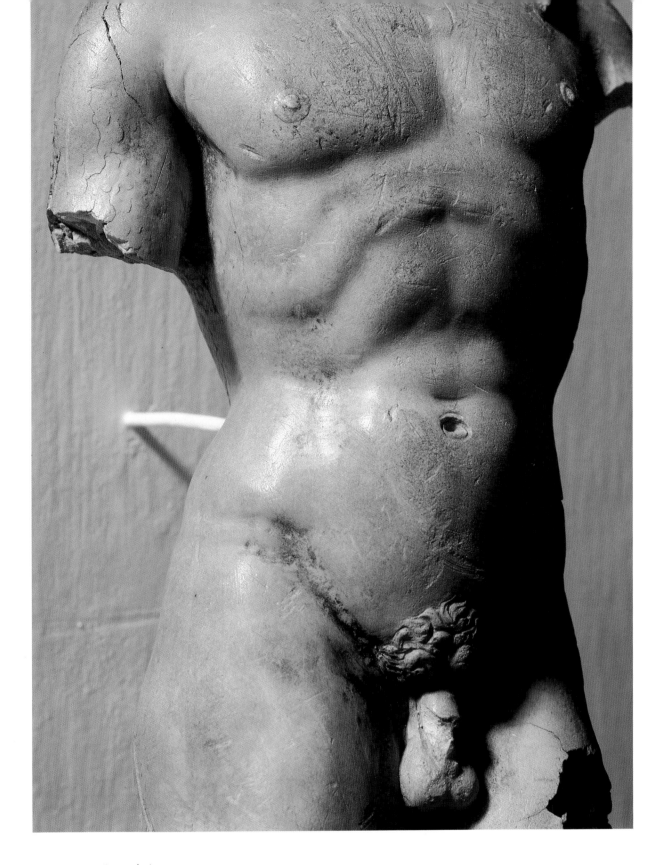

FIGURE 8 *(opposite)*
The model, one-quarter right, detail, torso.

FIGURE 9 *(above)*
The model, one-quarter right, detail, torso.

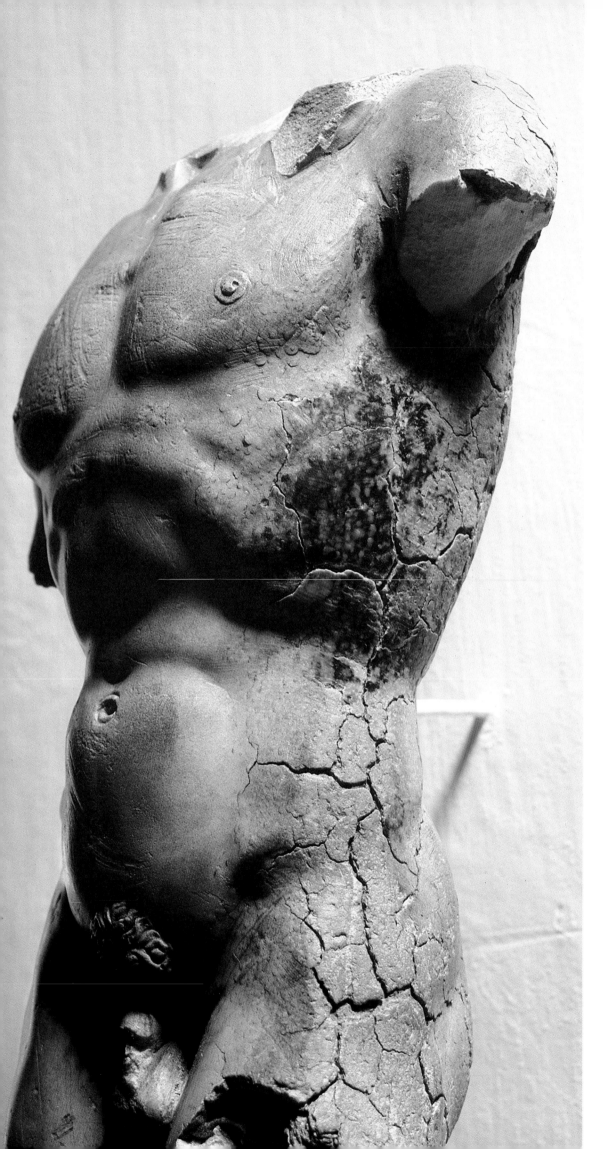

FIGURE 10 *(left)*

The model from below, one-quarter left, detail, torso.

FIGURE 11 *(opposite)*

The model, one-quarter left, detail, torso.

conceivable point of view and in every possible light. I took copious notes on style, material, technique, and condition, the results of which are embodied in the appropriate chapters of this book. Every now and then a break was essential, and these breaks were enlivened by conversations with M—— and the delighted inspection of his other treasures.

Departure from the discovery was difficult indeed, but I had my appointments in New York lined up, first with David Finn, an old friend from previous collaborations, and then with Abbeville Press. In each case my routine was the same. "The contents of this envelope have changed my life, and I think they will change yours." This book is ample evidence that they did, in both cases. I hope the book will do the same for the reader.

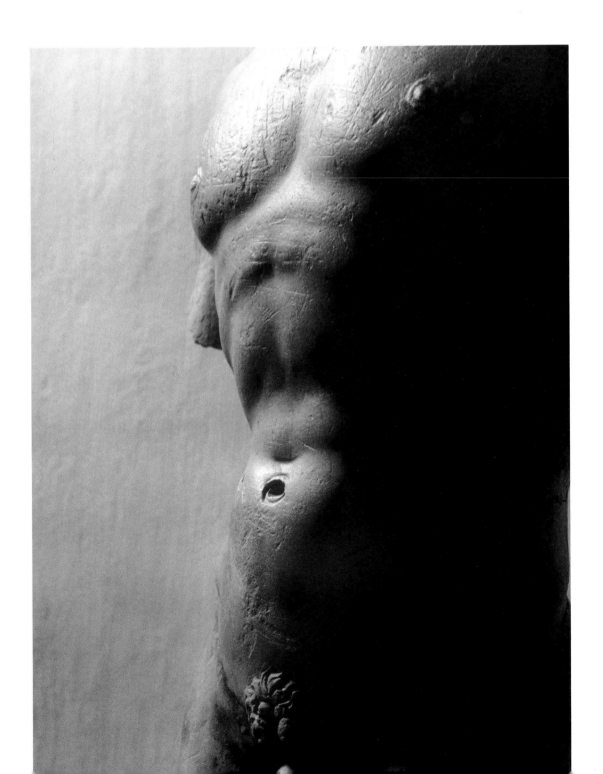

T W O

AUTHENTICITY

How can one tell a sketch, a drawing, a model for a work of art, from a copy or a study after the work? That is an old and painful question, and it has too often been answered wrongly. Countless copies *after* have masqueraded as studies *for*. That is to be expected, considering the eternal resiliency of hope in the breast of a collector, a museum director, a dealer, or a scholar. Paradoxically, in the case of Michelangelo scores of drawings *for* have been resolutely rejected as studies *after*. Both he and Raphael were subjected to real mass attacks in the iconoclastic years immediately before and after World War II, and much of the activity of specialists ever since has been devoted to careful reconstruction of their graphic work. This was much more difficult in the study of Raphael, because he had many gifted assistants who worked with him and helped him with preparatory studies for major works of art.

With Michelangelo it is another story. He seldom used assistants save in individual, limited jobs, and only because he was overwhelmed by pressure. Until the last decades of his long life he distrusted assistants, treated them roughly, and in consequence few stayed around. Generally their productions can be told from his at a glance. Only in purely mechanical work, the kind involved in some kinds of architectural drawings, painted architectural enframements for frescoes (the Sistine Ceiling, for instance), and mechanically repeated architectural ornament copied from his models, is there any serious question of large-scale participation by assistants. So in almost every instance a sketch, a life study, a composition drawing, a drawing intended for presentation to a friend, a *bozzetto* (of which more will be said in chapter 3), or a working model is either entirely by Michelangelo or it is a copy or an imitation. Quality ought to be the most reliable criterion of authenticity. But quality can be deceptive. Some copies of important Michelangelo drawings are extremely attractive, simply because the copyist did his level best to reproduce what he saw. Seldom is it possible to set the original drawing and the copy side by side, yet in the long run there is little difference of opinion among scholars as to which

is which. Despite their superficial charm, the copies are of necessity a bit slow and halting, because the copyist cannot proceed with the same dash as the original artist. He must look and draw, look and draw, and in this laborious process the freshness and the energy of the original are lost. The original artist often makes *pentimenti,* or corrections, of a line or shape that did not satisfy him. When the copyist tries to imitate these *pentimenti* he is doomed. The labored uncertainty of strokes is usually enough to convict a copy even when the original is lost.

A case in point is the now universally accepted drawing in the British Museum for the recumbent Adam in the *Creation of Adam* on the Sistine Ceiling. Four scholars formerly published it as a copy, and even Bernard Berenson sighed, "This *Fig. 12*

FIGURE 12

Life study for Adam, in the *Creation of Adam* on the
Sistine Ceiling, 1511, red chalk. British Museum, London.

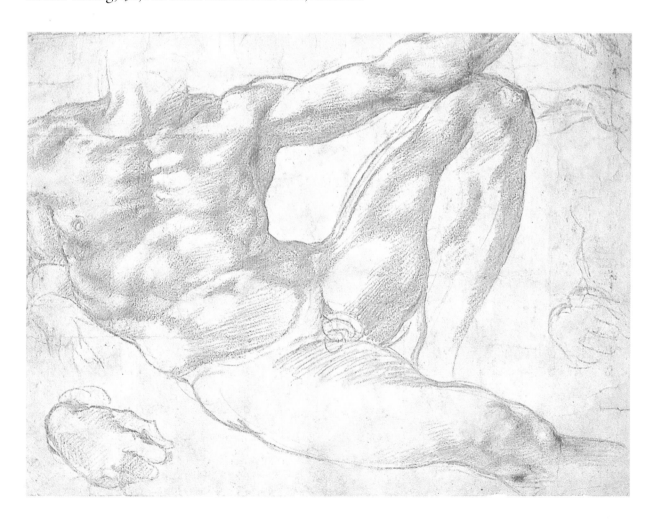

is the kind of drawing about which I find it impossible to make up my mind." Luitpold Dussler, the author of the last catalog of Michelangelo's drawings before mine in 1959, found that the British Museum drawing lacked Michelangelo's characteristic spontaneity and "diverged noticeably" from the style of the great study in the Metropolitan Museum for the Libyan Sibyl. Setting the two side by side, the innocent bystander can only wonder. Both the carefully finished passages and the rapidly sketched marginal studies of bits and pieces of anatomy are identical in contours, hatching, and polishing, with the sole exception that portions of the Metropolitan drawing are carried to a slightly higher pitch of smoothness. The telltale *pentimenti* show all the rapidity and authority of the original draftsman, working at top speed.

But doubts can breed doubts, and preconceptions can blind any eye to fact. The Metropolitan drawing itself, a touchstone of authenticity to Dussler, seemed to Robert Oertel only ten years earlier an obvious copy. And why? Because it was incontestably by the same hand as the group of nude studies for the *Battle of Cascina* and the Sistine Ceiling in the Teylersmuseum in Haarlem. And in 1922 Erwin Panofsky, then thirty years of age, had rejected the Haarlem drawings. Guilt by association. At that juncture it might have occurred to Oertel that maybe Panofsky was mistaken and the Haarlem drawings were authentic. This is just what I have demonstrated, without great difficulty, and as far as I know without contradiction.

What even the greatest scholars seem to have done is to establish a set of criteria of authenticity based on a group of originals which for various reasons seem impregnable, forgetting two cardinal points. First, if a group of preparatory studies as extensive as those in Haarlem is clearly consistent (all by the same hand, according to any test, of the highest quality, and vibrant with the spontaneity of the master), then they are most likely by him, whether or not there are documented analogs. Otherwise one would have to produce a master as great as Michelangelo, and that might take quite a search.

Second, what seems to have been lost in the discussion about criteria of attribution is that no artist's style can be homogeneous throughout his career. Breezy sketches for known works, particularly if they bear Michelangelo's own handwriting, were traditionally accepted as authentic, especially because they fitted so well with the legend of the tempestuous genius invented during the Romantic period

Fig. 13

Fig. 14

Fig. 15

FIGURE 13

Life studies for the Libyan Sibyl, 1511, red chalk. Metropolitan Museum of Art, New York; Purchase, 1924, Joseph Pulitzer Bequest (24,197.2)

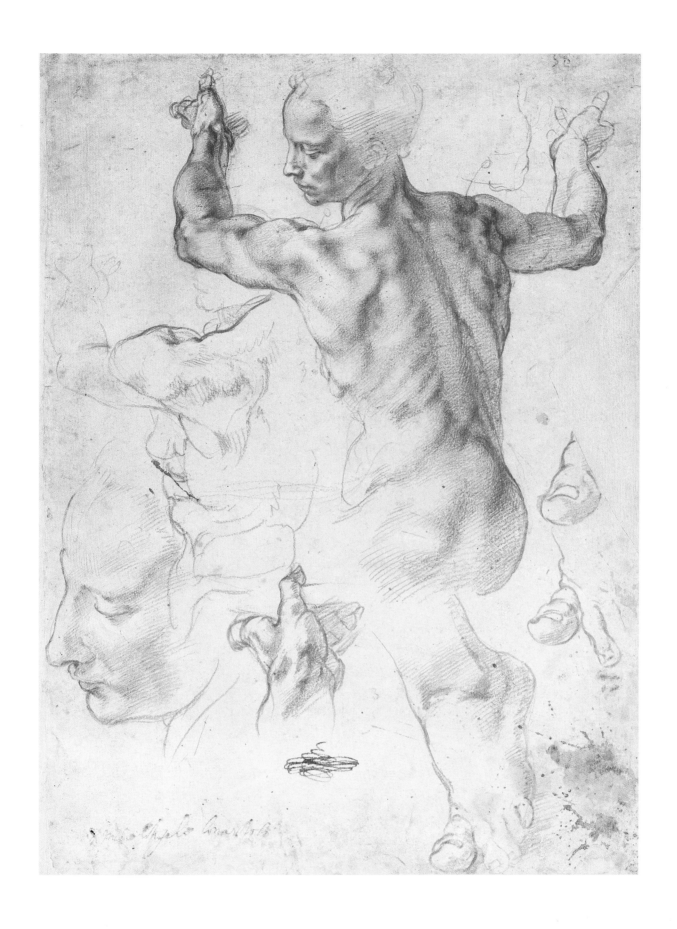

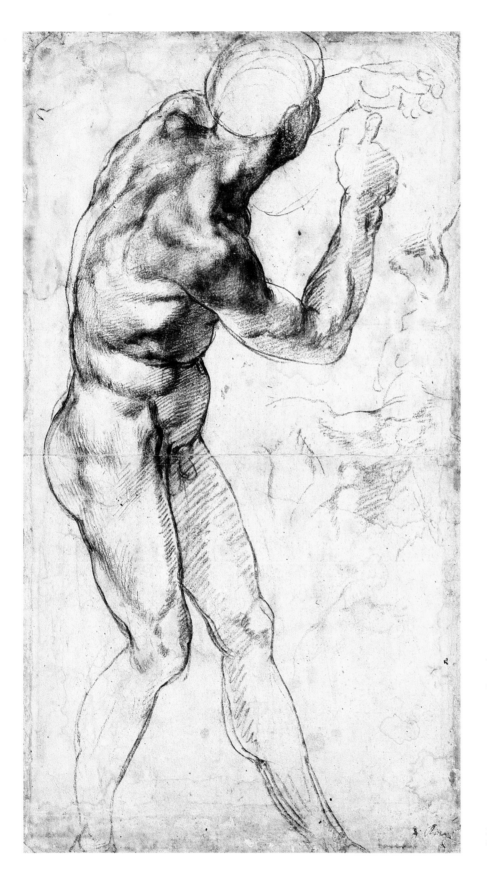

FIGURE 14 *(left)*

Life study for the
Battle of Cascina, 1504,
black chalk.
Teylersmuseum, Haarlem.

FIGURE 15 *(opposite)*

Life studies for Haman,
in the *Punishment of Haman*
on the Sistine Ceiling,
1511, red chalk.
Teylersmuseum, Haarlem.

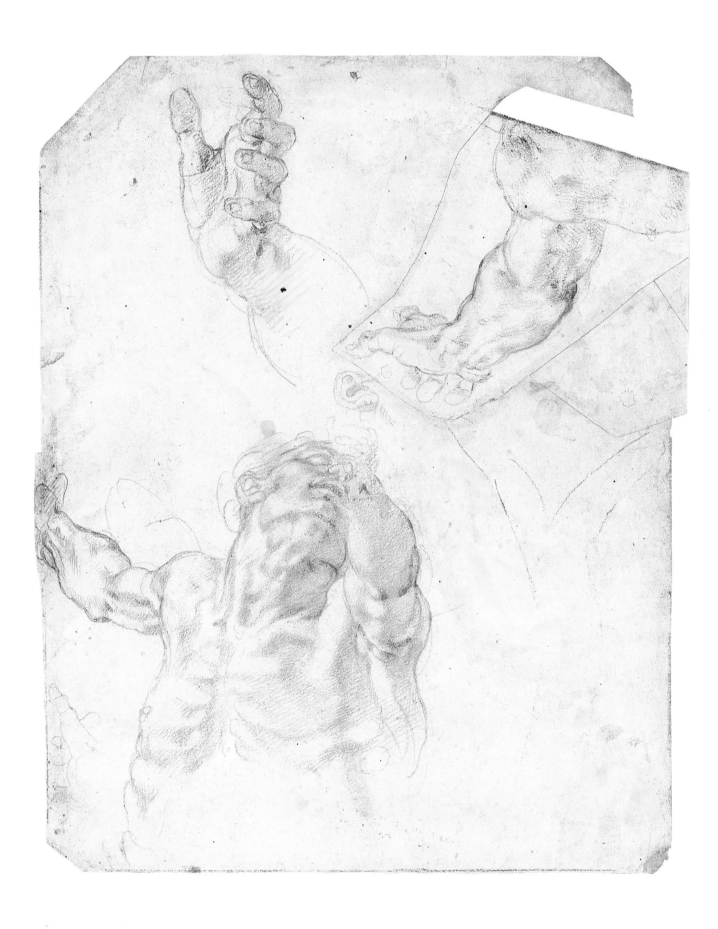

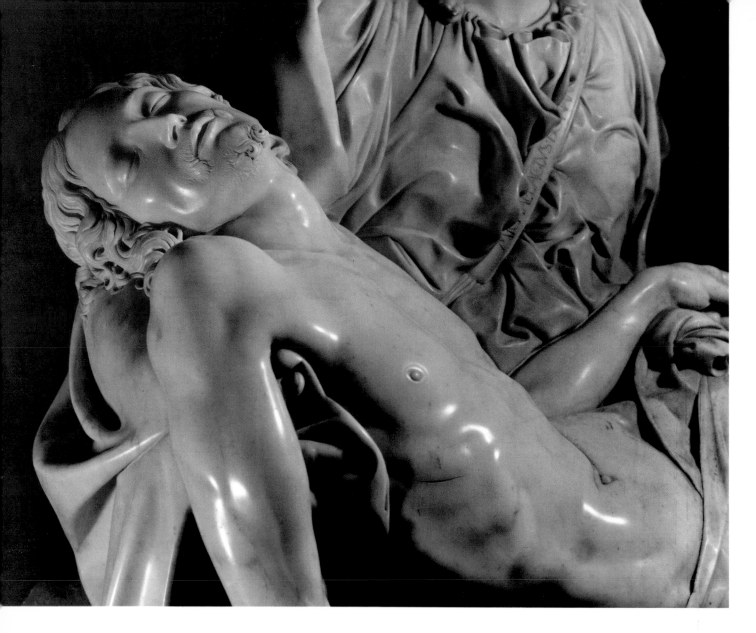

and devoured ever since. But the meticulous, carefully polished drawings, some-times of miniaturist delicacy, did not, and have all been doubted. There was little reason for this, as the rough, unfinished statues are no more authentic than such *Fig. 16* minutely graven and smoothly polished works as the *Pietà* in St. Peter's or the *Figs. 17, 18* *Bruges Madonna*. Even the legs of the *Rondanini Pietà* show the perfect finish to which the entire group had doubtless been brought before Michelangelo's attempt to destroy and recreate it during the last days of his life.

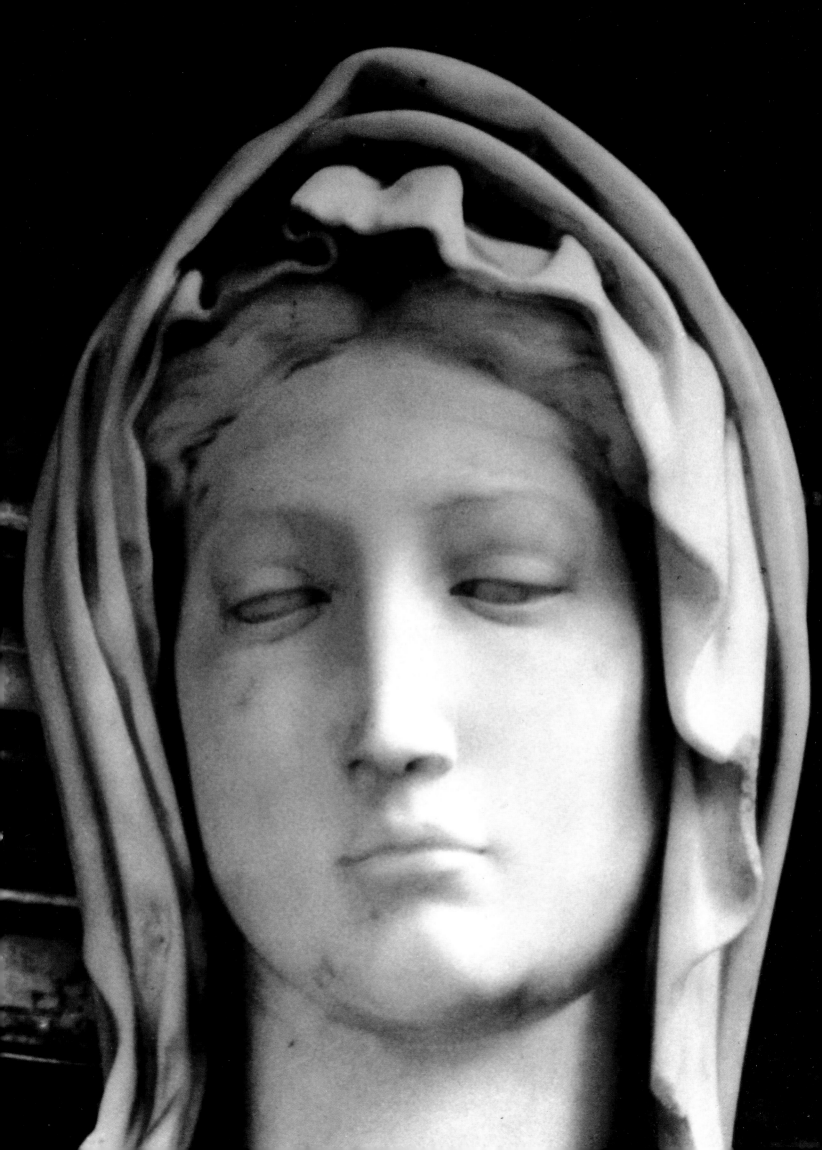

FIGURE 18 *(left)*
Legs of Christ, detail
of the *Rondanini Pietà,*
about 1560, marble.
Civico Museo d'Arte Antica,
Castello Sforzesco, Milan.

FIGURE 19 *(opposite)*
Crucified Christ, 1538–40?,
black chalk.
British Museum, London.

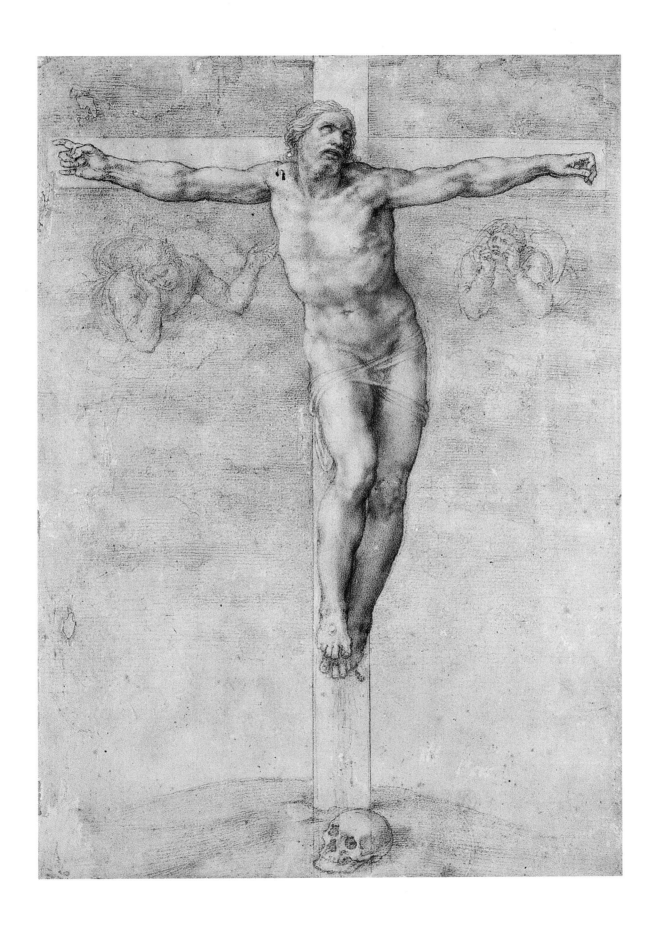

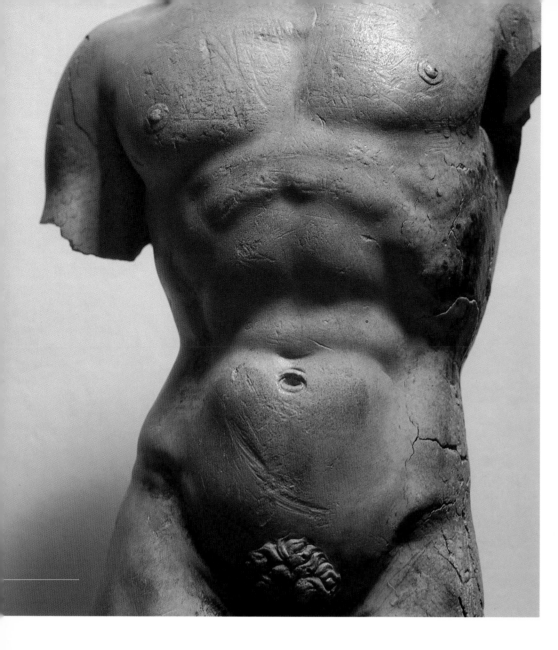

Fig. 19

Fig. 20

Fig. 21

FIGURE 20 *(left)*
The model from the front, detail, torso.

FIGURE 21 *(opposite)*
The model, one-eighth left, detail, torso, showing original position of right hand.

When Michelangelo's friend and patron Vittoria Colonna had studied with care the drawing of the *Crucifixion* Michelangelo gave her, she wrote to him: "One can see no better made, more living, or more finished image, and certainly I could never express how subtly and admirably it is done. . . . I have looked at it well in the light, both with a glass and with a mirror, and I never saw a more finished thing." The finish visible in the undamaged portions of the model for the *David,* down to nipples, wrinkles, and locks of pubic hair, is so exact that David Finn's photographs—the equivalent of Vittoria Colonna's glass—give the impression of a lifesize figure. Such precision, as we shall see in chapters 3 and 4, is essential to its purpose as a working, small-scale model for the execution of the colossal statue in marble. This kind of precision in the work of the young Michelangelo begins with the amazing delicacy and exactitude of the *Pietà* in St. Peter's. Interestingly enough, the three marble statuettes he carved for the Tomb of St. Dominic in San Francesco in Bologna, despite the fact that they are half again larger than our model, show that in 1494–95 he had not yet acquired comparable skill. The proud and angry *Saint Pro-*

Fig. 22

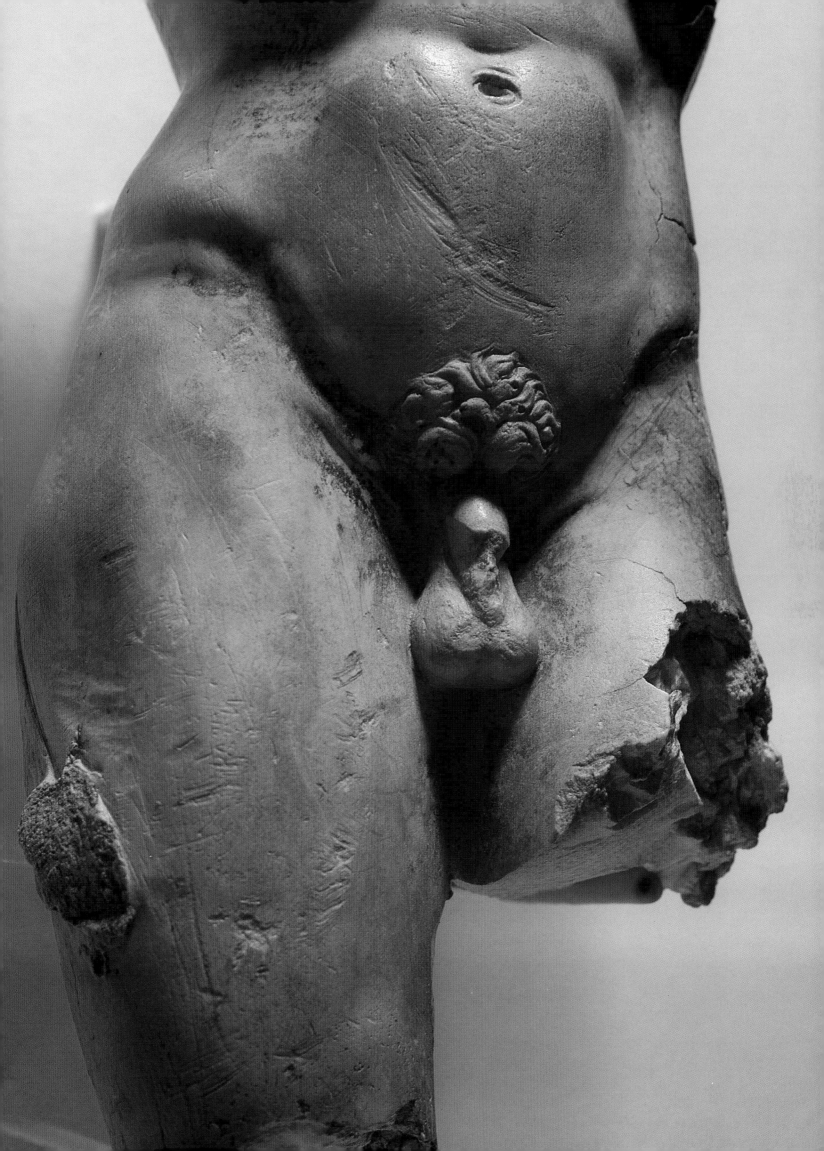

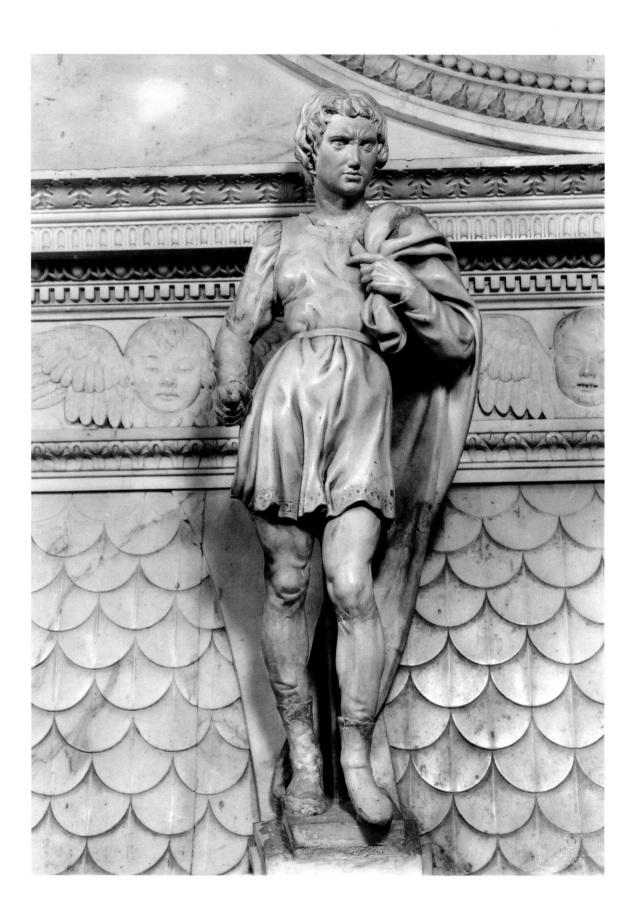

culus, in fact, often cited as a kind of spiritual ancestor of the *David,* is notably summary in detail and even a bit coarse in execution as compared to our model. (The resemblance to the *David* would be less apparent if the young warrior were still carrying the hatchet he originally held in his right hand.) Precision in the model, however, does not necessarily mean that the artist—any artist, let alone Michelangelo, who changed his mind countless times, even during the course of execution—considered himself bound to carry out every detail just as he had planned it. There are sure to be many and sometimes significant differences, which will be treated in chapter 5.

In my study of Michelangelo's drawings I found myself rehabilitating literally scores of drawings rejected by older scholars, with the single exception of Johannes Wilde, whose keen eye and mind persuaded him that we must all take what he called "a fresh look." Inevitably my attributions differed sharply from those of Charles de Tolnay, embodied in his fundamental five-volume *Michelangelo.* Although I have not yet made an exact check, my impression is that in his splendidly illustrated *Corpus dei Disegni di Michelangelo,* published after my catalog, Tolnay eventually adopted all or nearly all of my attributions, reversing his own. No one is infallible, and there are a few cases that still cause me anxiety, but the general problem of authenticity in Michelangelo's drawings is far closer to solution than with those of Raphael.

I began this chapter with drawings because the Italians themselves, including Michelangelo, were convinced that drawing was the foundation of all the other arts. They contended that, although painting and sculpture have their own individual problems, their procedures derive from those of drawing as, let us say, those of Impressionism do not. Models and drawings are intimately interconnected as preparations for the finished work of art. And especially with Michelangelo, pen and chalk on the one hand and chisel on the other seem at times interchangeable.

Yet there are glaring instances in which the tangible criterion of chisel marks has been ignored. In spite of universal rejection by scholars, based on the lack of any connection between its technique and the known methods of Michelangelo, not to speak of the total absence of relative documents, the large and ugly *Pietà* from Palestrina until very recently bore a Michelangelo label in the Accademia in Florence. All the perceptive visitor needs to do to convince himself that this work is by another hand is to compare it carefully with the unfinished *Slaves* and *St. Matthew* exhibited with it, in a long gallery which culminates with the glorious *David.* An

Fig. 24

FIGURE 22

Saint Proculus, from the Tomb of St. Dominic, 1494–95, marble. San Domenico, Bologna.

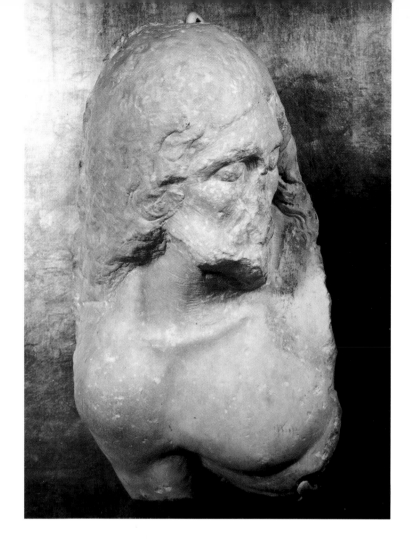

FIGURE 23

Modern imitator of Michelangelo, head of Christ, purporting to come from the *Rondanini Pietà,* 1970s (?), marble. Palazzo Vecchio, Florence.

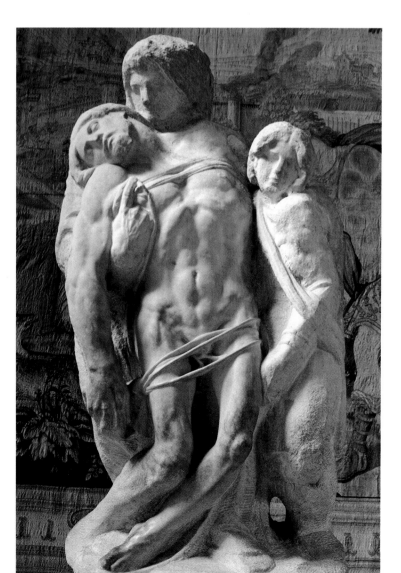

FIGURE 24

Imitator of Michelangelo, *Pietà,* about 1590–1610, marble, Accademia, Florence.

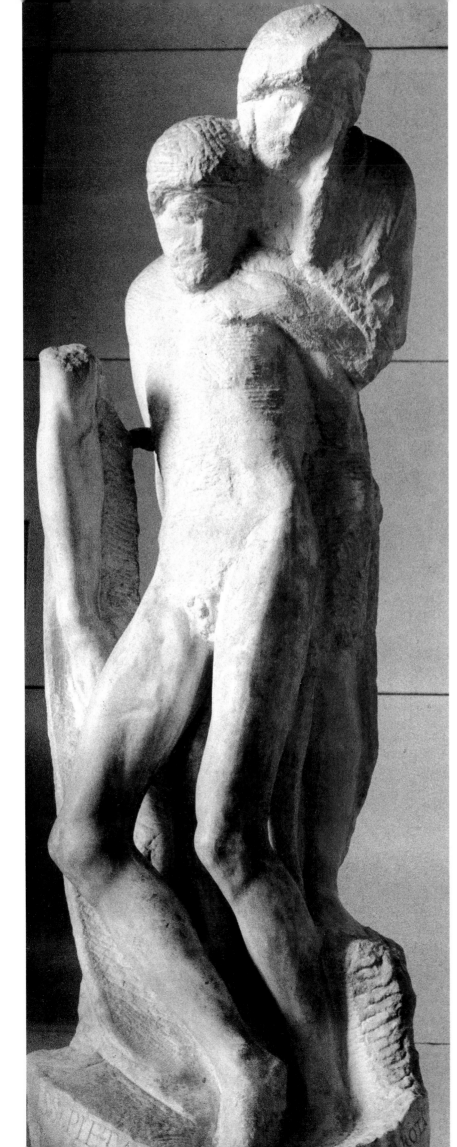

FIGURE 25

Rondanini Pietà,
Castello Sforzesco, Milan.

FIGURE 26 *(below)*

Anonymous, copy after *Night*, sixteenth century, terracotta. Alejandro Pietri Collection, Caracas.

FIGURE 27 *(opposite)*

Hercules and Cacus or *Samson and a Philistine*, 1528?, clay. Casa Buonarroti, Florence.

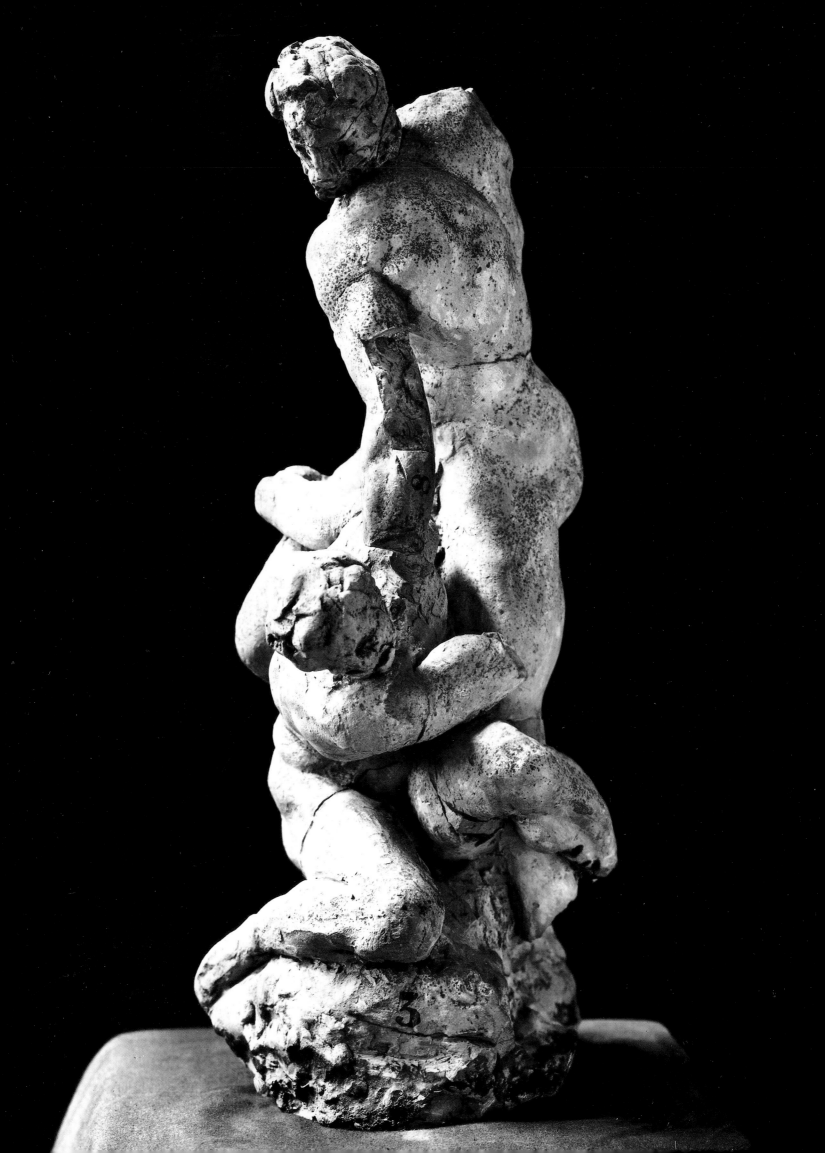

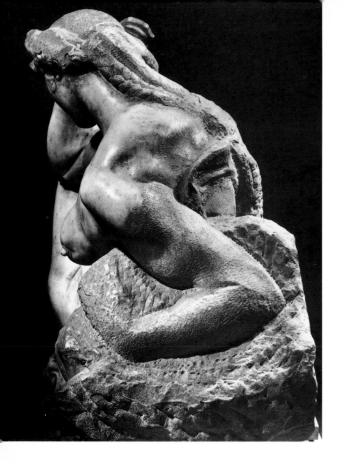 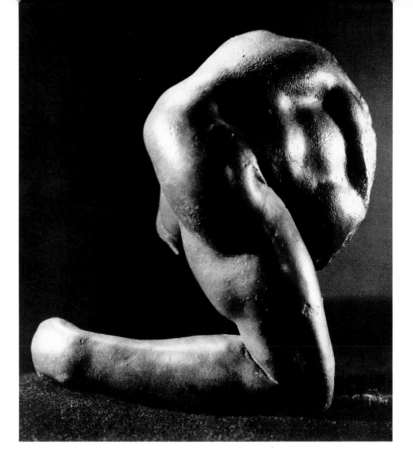

Fig. 23

Fig. 25

Fig. 26

Fig. 27

Fig. 28

Fig. 30

Fig. 29

even more striking instance is the modern forgery, devoid of any traces of Michelangelo's known style but carefully contrived to fit the breaks accessible through casts, and exhibited in the Palazzo Vecchio as the lost original head of the *Rondanini Pietà* in Milan. The claim is ludicrous, in that the head of a dead man in the arms of a woman would not be lifting itself up to look at the spectator. The technique with the chisel, moreover, bears no relation to that of Michelangelo. And then there are the small-scale "models" in various public and private collections. A case in point is the small terracotta *bozzetto* in a private collection in Caracas, supposedly for the *Night* in the Medici Chapel. First, the volutelike element on which Michelangelo's marble figure rests appears in the terracotta. This is a dead giveaway. The sculptor invariably restricted his life studies to the individual figure or, in a single instance, a group of figures. Surrounding elements, to be carved from separate blocks, appear only in preliminary sketches for an entire composition, and were then studied separately in working drawings given to assistants for execution. Worse yet, the hanging left arm which Michelangelo cut away *after* completion of the figure, carving a new and still unfinished arm twisted behind the back and replacing it with a menacing mask, appears cut off and replaced already in the supposed preliminary model! To cap the climax another "model" has turned up, claiming to be for this very left arm, although bearing only the most generic relation to it. After all, bent, muscular left arms have a tendency to look remarkably alike. The terracotta arm, like all the works in the series, shows little direct knowledge of anatomy. Bones, tendons, muscles, are uncertainly placed, standardized in shape, and devoid of any of Michelangelo's tension or vibrancy.

FIGURE 28 *(far left)*

Detail of *Night,* showing unfinished replacement of the left arm,
1526–27?, Medici Chapel, San Lorenzo, Florence.

FIGURE 29 *(near left)*

Anonymous, study of a bent left arm, after Michelangelo, late sixteenth century,
terracotta. LeBrooy Collection, Vancouver.

FIGURE 30 *(below)*

Detail of *Night,* 1526–27?, Medici Chapel, San Lorenzo.

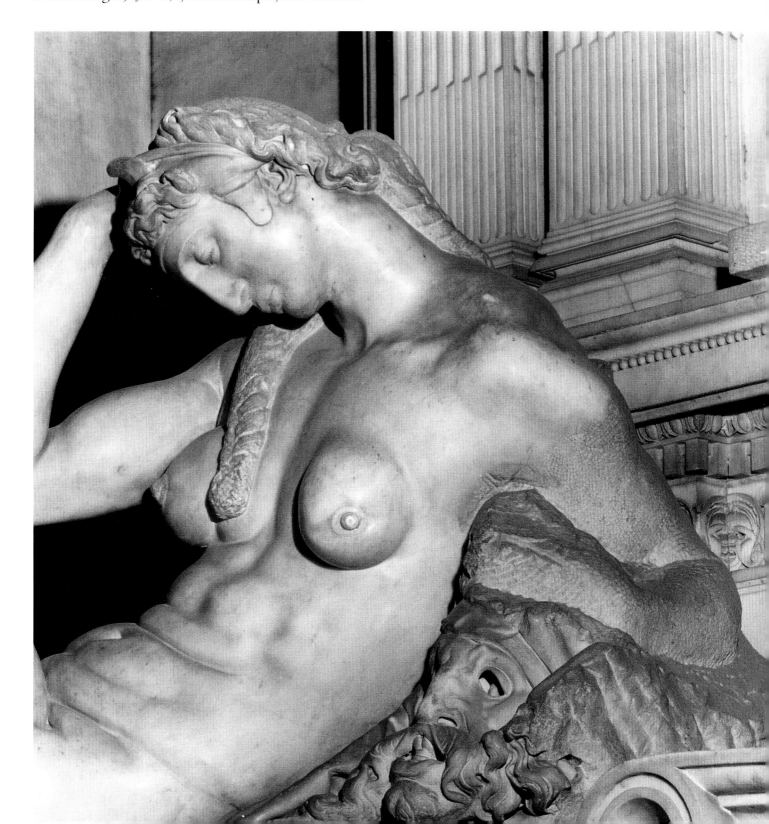

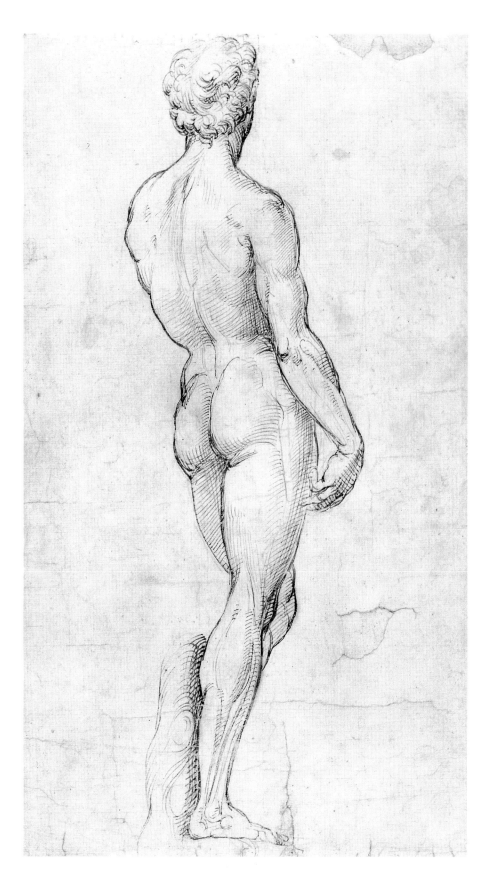

FIGURE 31 *(left)*

Raphael, study after
the statue, 1504,
pen and brown ink
over traces of black chalk.
British Museum, London.

FIGURE 32 *(opposite)*

Raphael, study after
the model, from right,
slightly forward
(torso and arms) and
one-eighth back (legs),
1504, pen and brown ink.
British Museum, London.

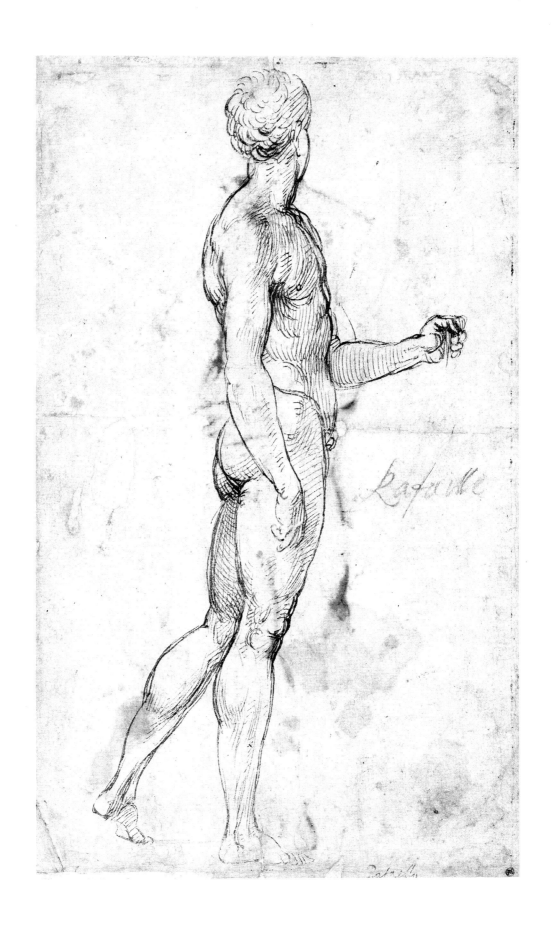

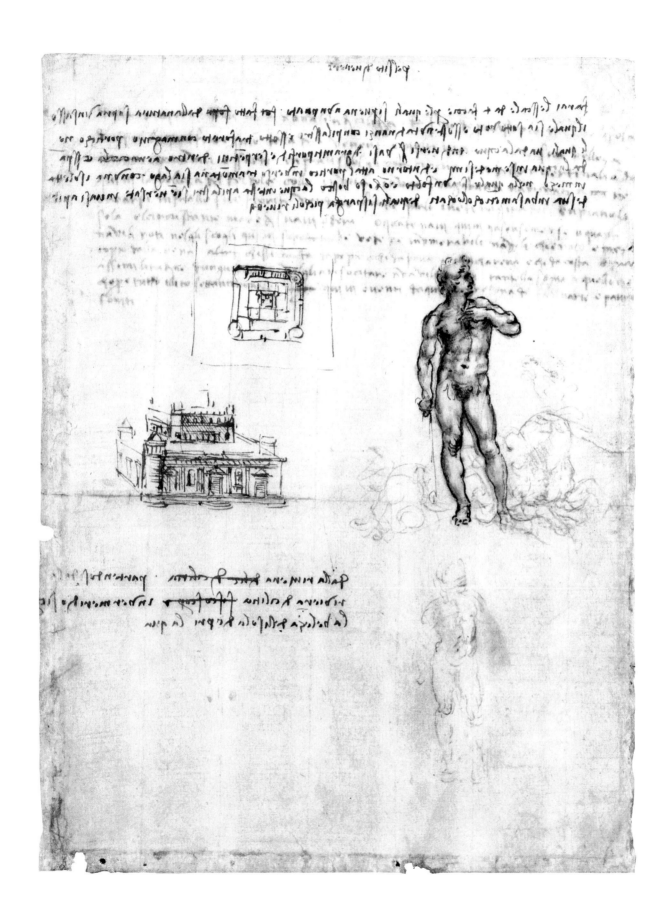

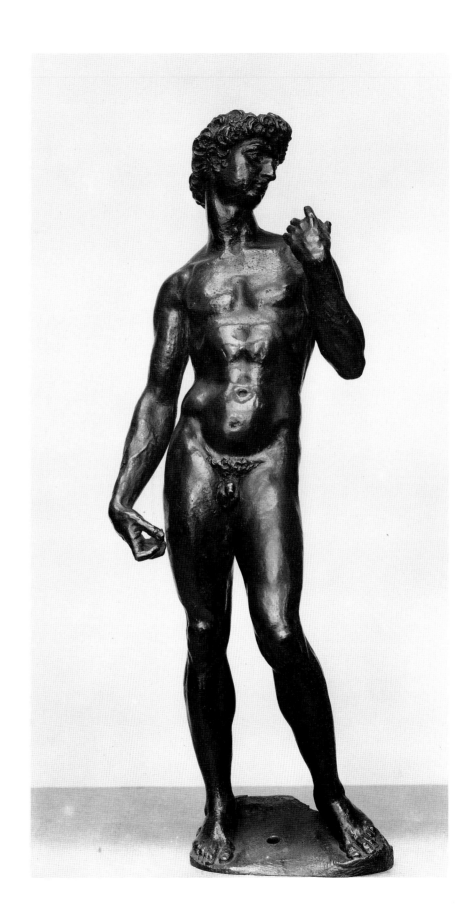

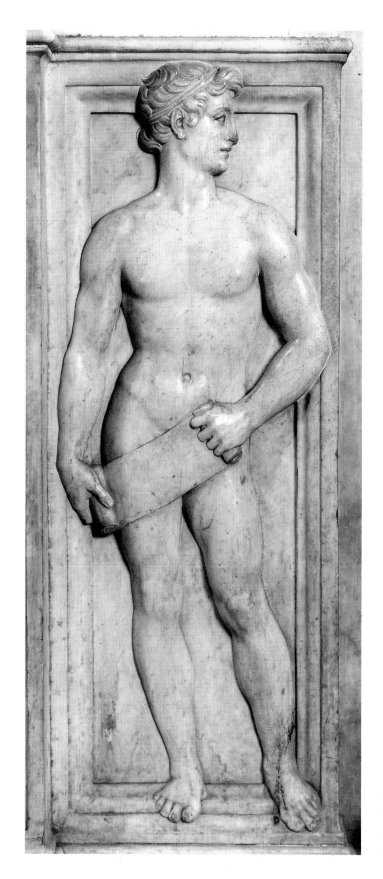

FIGURE 35

Giovanni Bandini dell'Opera,
standing prophet, 1555, marble.
Choir enclosure, Cathedral, Florence.

Anonymous, study after the statue,
early sixteenth century, bronze plaque,
5³/₁₆ x 3⅛ in. Private Collection, U.S.A.

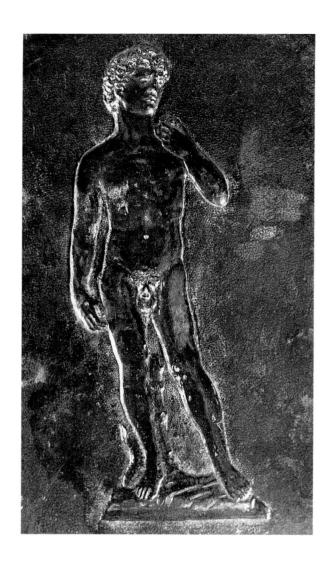

Today every souvenir shop and pushcart in Florence is packed with copies of
the *David* in several sizes, ironically enough often carved out of alabaster by mass-
production methods in the mountaintop city of Volterra, from whose environs the
alabaster for the material used in Michelangelo's model probably came, to sell to
tourists. But in the early sixteenth century a believable copy of this colossal statue,
even with the variations visible in our model but with a comparable degree of
definition, would have been next to impossible to make. One cannot copy what
one cannot see. To do a thorough job a sculptor would have required a scaffolding
before the Palazzo Vecchio so as to carry the wax model and some kind of squaring
or pointing device up and down and compare it at every level, especially with those
portions too high to see from the ground. And the loins of the *David* itself, as I
have pointed out in a recent article (see bibliography), would have been impossible
to see. For at least the first half of the sixteenth century they were totally concealed

from view by a brass garland holding twenty-eight copper leaves, hung around the statue immediately after it was placed on its pedestal in 1504 and before it could be shown to the public. So elaborate an undertaking could not have been performed without leaving a paper trail, and there is none. It would also have cost a great deal of money; who would pay it and why? Both Gonfaloniere Soderini and his Medicean successors in the government of Florence were in touch with the artist himself and could have got the original model free anytime they wanted it.

Fig. 31
Fig. 32

Fig. 33
Fig. 34

Fig. 35

Fig. 36

Surviving memory images of the *David*—and they are no more than that—are understandably few, and never commercialized. Save for Raphael's careful drawings, these copies concentrate on surface at the expense of bodily tension and spiritual energy. They range from the fleshy young man rapidly drawn from memory by Leonardo da Vinci to the rather sloppy wax *bozzetto* in the Casa Buonarroti and the languid and dainty bronze in the Louvre, remarkably unsure anatomically. The only heroic one, in attitude if not in size, is the standing prophet carved by Giovanni Bandini dell'Opera for a panel in the handsome octagonal parapet surrounding the choir space under the dome of the Cathedral of Florence—a sacral purpose. A fascinating and unpublished copy is the delicately modeled bronze plaque in an American private collection. Alone among all Renaissance artists depicting the nude David, the unknown artist represented the youth as circumcised. One is tempted to speculate—could the sculptor have been Jewish? At the very least he shows a greater sensitivity to Hebrew Law than can be observed elsewhere in Renaissance depictions of nude figures from the Old and New Testaments, including Jesus who was duly circumcised on the eighth day. Authenticity, then, cannot be established by inspired guesswork or snap judgment. Only comparison with many examples by the artist, familiarity with his working methods, and detailed information concerning the purpose and history of the work in question can produce a believable verdict.

THREE

THE PURPOSE OF THE MODEL

THERE IS AN IDEA ABROAD that Michelangelo went at the marble directly without any necessity for a preliminary model—such was the intensity of his grasp of form—to liberate the figure dwelling inside. This is about as realistic as the notion that he painted the Sistine Ceiling lying on his back. It derives from a misreading of his poems, and as anyone who has had any practical experience in sculpture will bear witness, it is literally impossible. No sculptor, however great a genius, could keep control of the proportions and relationships of a large-scale work without a preliminary try-out, as complete as possible. Failure in marble can be corrected only by cutting away, and too much removal ends in disaster. All known Renaissance sources explain the use of models, and those writers who knew Michelangelo personally—themselves gifted artists—testify that he used them consistently. Documents record their existence. Both Irving Lavin (see bibliography) and Rudolf Wittkower (see bibliography) have written in detail about Michelangelo's use of models and his procedure in transferring a figure from model to statue.

There are, however, two distinct varieties of models, *modelli* and *bozzetti*. Which is which and how do they differ in their relation to the process of making a large-scale sculpture in marble? The distinction is both real and useful, but sometimes it is blurred by the Italians, who wrote voluminously about art and its myriad technical procedures, even when far from precise in their language. (See appendix B for the texts, in translation.) Giorgio Vasari, who knew the master well and even worked with him briefly in the Medici Chapel, tells us in his life of Michelangelo that for the *David* he made a model in wax. Our model is in gesso, a form of stucco. The discrepancy should not disturb us, first because all the documents given in appendix C list the model as stucco, and second because Vasari, precious though his testimony is, frequently made mistakes. For example, in 1550 he described the

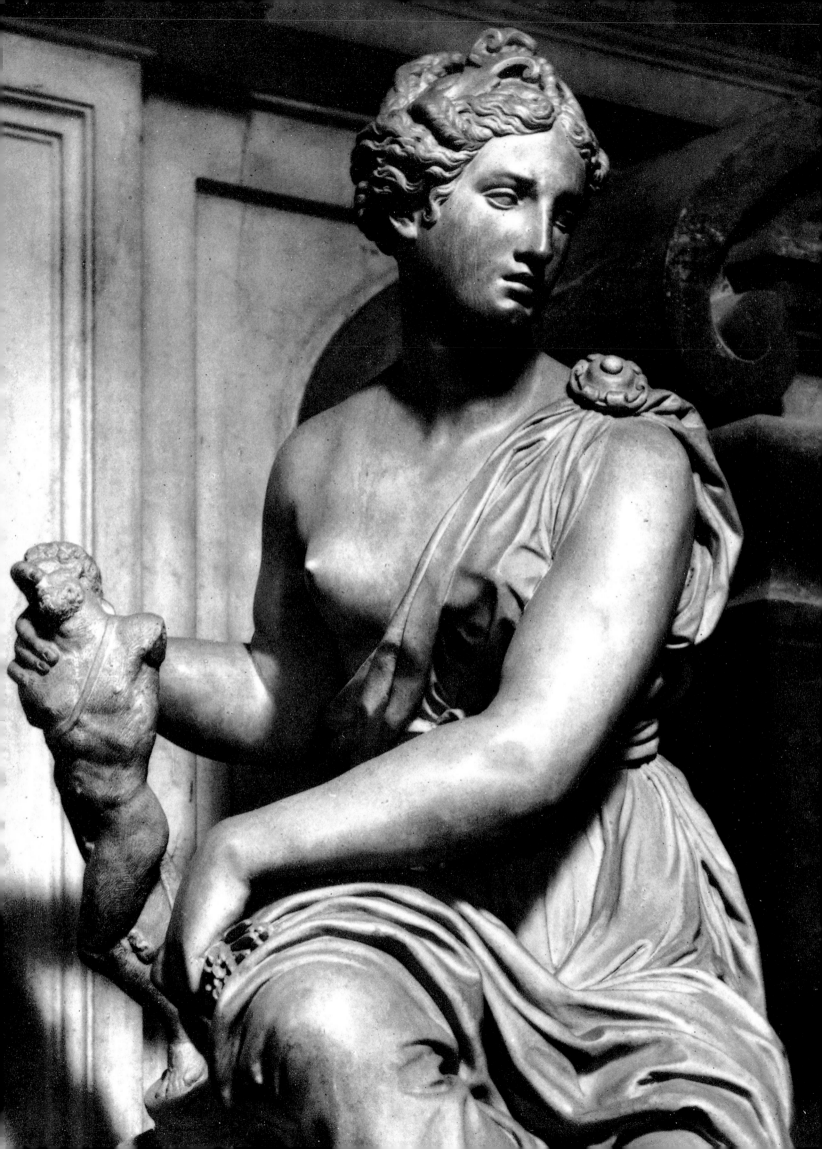

Bruges Madonna, a marble statue in the round, as a relief in bronze. Ascanio Condivi, the official biographer of the great artist, repeated the same error in 1553. Oddly enough, Michelangelo himself never corrected either of them.

In his chapters on sculptural technique, however, Vasari talks about making models in clay, wax, or stucco, and gives detailed directions for each. (The procedures will be taken up in chapter 4.) The purpose of such a model is to "show . . . the pose and the proportion which is to have the figure that they want to make, trying to accommodate themselves to the width and the height of the stone that they have had cut to make it in." He also tells us that "when these little models are finished, of wax or of clay, it is customary to make another model which should be as large as the figure one is seeking to make from marble. . . ."

To complete the confusion, in his chapters on painting Vasari describes how in order to paint foreshortened figures Michelangelo "first from clay or from wax for this purpose made models; and from these, which more than life stay still, drew the outlines, the lights, and the shadows." We might be inclined to dismiss these as *bozzetti* today, if indeed they were not mere mannequins, which we know Raphael to have used extensively. Interestingly enough, the figure of *Allegory of Painting* by *Fig. 37* Battista Lorenzi del Cavaliere on Michelangelo's tomb in Santa Croce in Florence is holding a model, possibly for the lost youthful *Hercules.* Again according to Vasari, Michelangelo's pupil Antonio Mini took to France two big boxes of models of some sort, probably *bozzetti,* along with the painting of *Leda* and many cartoons. All have been lost.

Benvenuto Cellini, who also knew Michelangelo personally, is somewhat more explicit about the distinction between models and *bozzetti,* defining the purpose of the model as to "resolve the pose with beautiful invention, either clothed or nude as it ought to be. Thereafter one should make it large exactly as it must come out of the marble; and as much as one desires to make it better, so one should finish the large model better than the small one; but if one is pressed for time . . . it will be sufficient if the large model is executed from a beautiful sketch [he uses the word *bozza;* the modern word is *bozzetto*], because this requires little time to make such a sketch, and saves a great deal of time in working the marble." In the end, however, sculptors "do not find themselves satisfied with the big piece as much as when they

FIGURE 37

Battista Lorenzi del Cavaliere, *Allegory of Painting,*
detail showing a model by Michelangelo, from the Tomb of
Michelangelo, 1574, marble. Santa Croce, Florence.

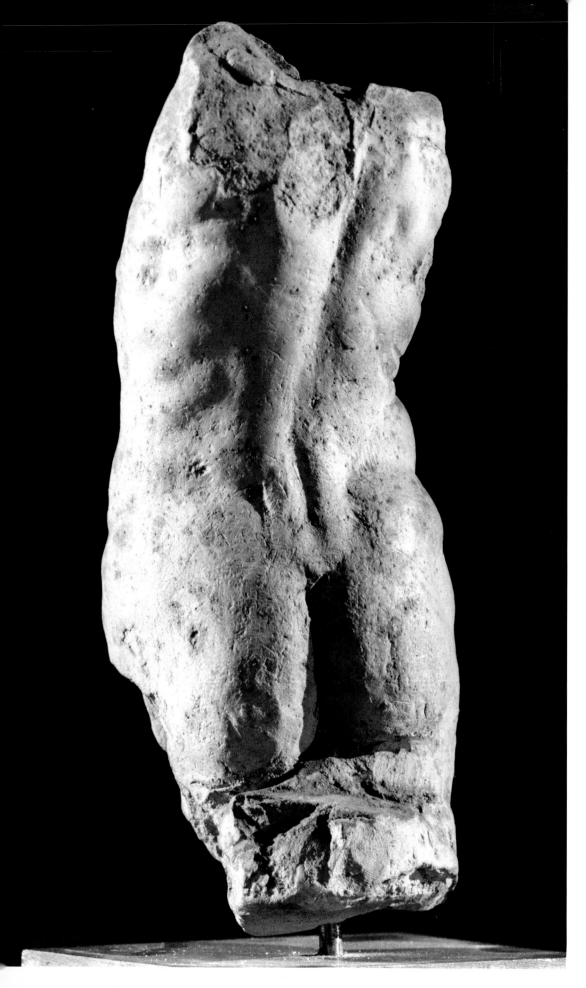

FIGURE 38 *(left)*

Bozzetto for the
"Atlas" *Slave*(?), back,
probably 1527,
terracotta.
Casa Buonarroti,
Florence.

FIGURE 39 *(opposite)*

Bozzetto for the
"Atlas" *Slave*(?), front,
probably 1527,
terracotta.
Casa Buonarroti,
Florence.

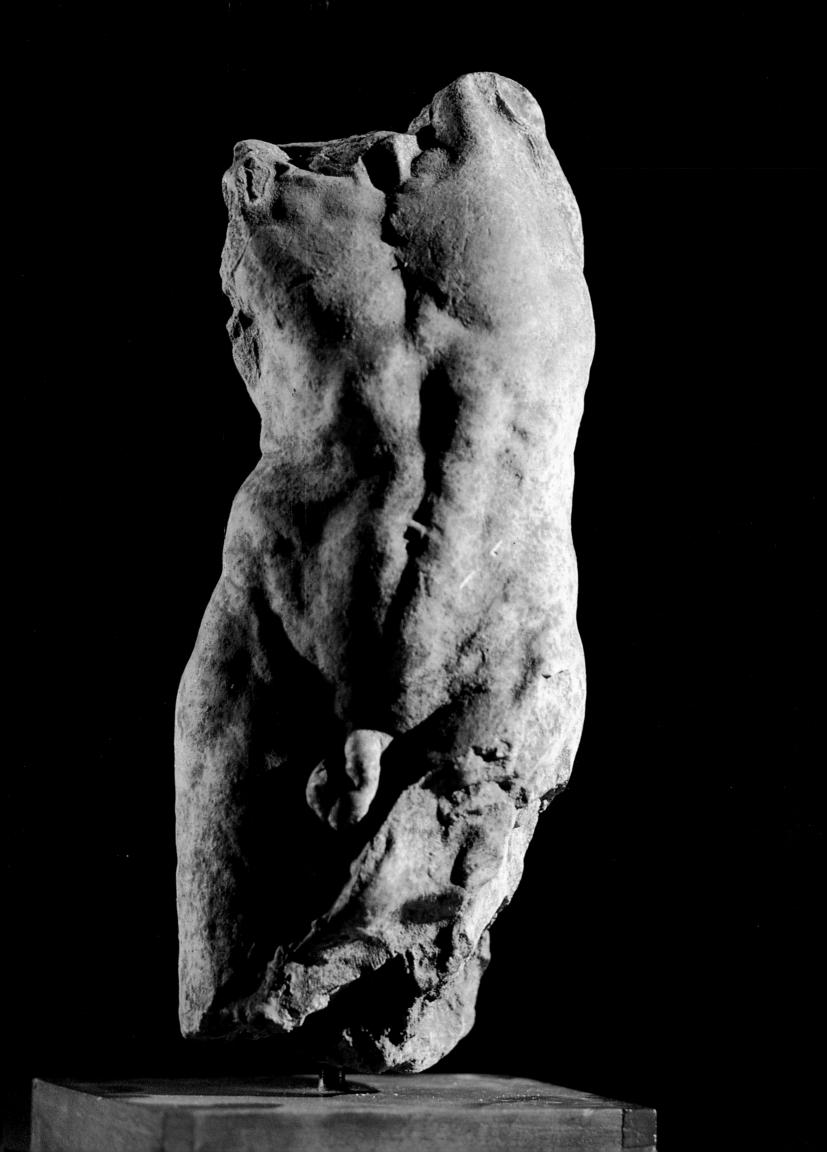

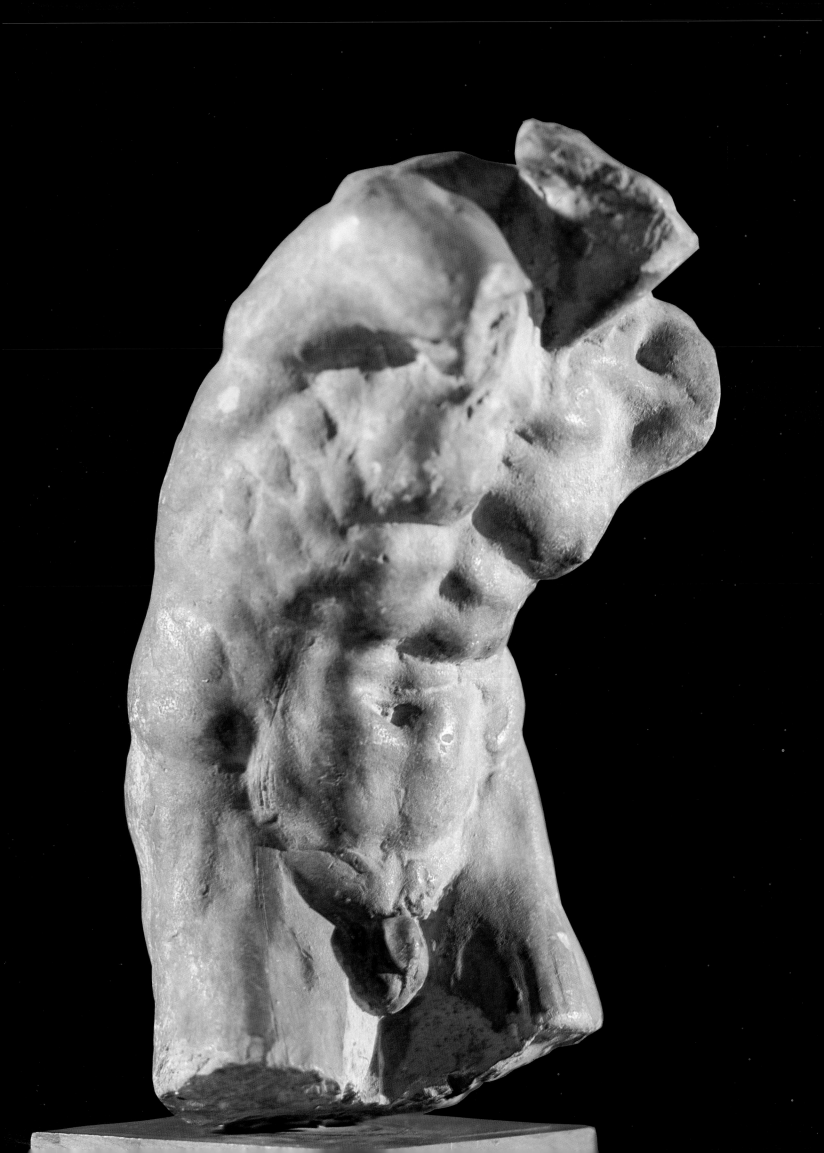

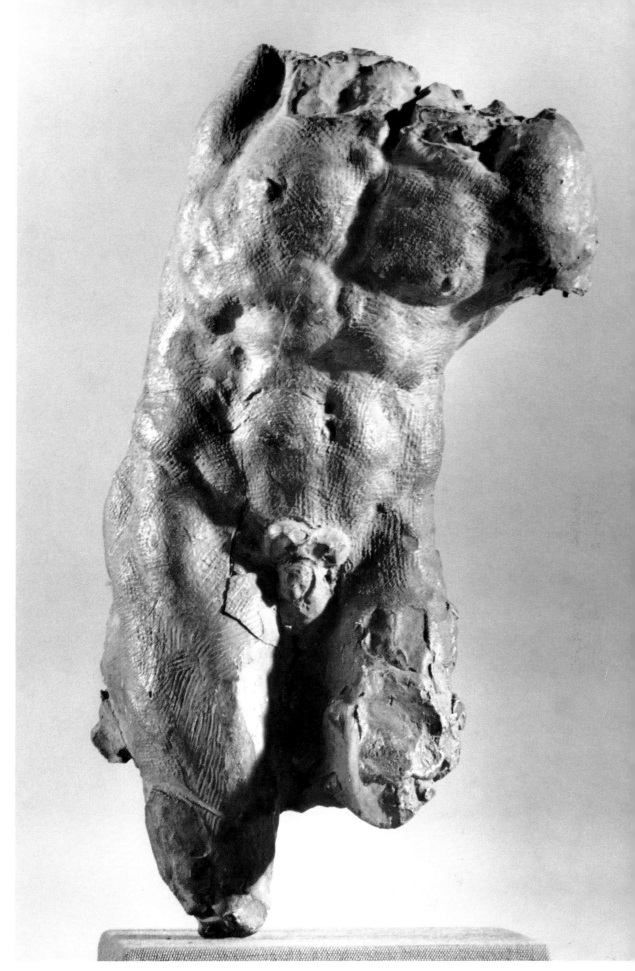

have made a big model. And this has been seen through . . . the marvelous Michelangelo Buonarroti, who has worked in both ways; but having recognized that he could not long satisfy his good talent with little models, ever after he set himself with great obedience to make models exactly as large as they had to come out of the marble for him: and this we have seen with our own eyes in the sacristy of San Lorenzo."

This passage alone is enough to demolish any claims for the authenticity of small models in connection with Michelangelo's mature and late sculptures. Circumstances bear Cellini out. The model held by Lorenzi's statue is indeed small, and armless, like all of Michelangelo's surviving *bozzetti*. A full-scale model is preserved, as we have seen, for one of the four never-executed River Gods for the tombs of the dukes Giuliano and Lorenzo de' Medici. With Cellini's testimony we must conclude that such models existed not only for all the other statues in the Medici Chapel but for many other works as well, probably the four *Slaves* for the Tomb of Julius II now in the Accademia which date from the same general period. The large models could not have been done in clay alone, which would have shrunk and cracked in drying. Clay had to be combined with other materials, such as tow, horsehair, and glue, to prevent shrinkage and resist damage. Unfortunately none but the *River God* have survived. Neither have Michelangelo's cartoons for his frescoes, save for the so-called *Adoration of the Magi* in the British Museum and a fragment of the cartoon for the *Crucifixion of Peter* in Naples, and for the same reason. Such huge objects in temporary materials were difficult to keep, to show, and even to preserve. Many may have been destroyed by the artist himself once they were no longer useful.

Filippo Baldinucci, the seventeenth-century writer who brought Vasari's *Lives* up to date, wrote a dictionary of artistic terms called the *Vocabulario Toscano dell'Arte del Disegno,* which in this instance, as in many others, comes to our aid when we need it the most. He makes a clear-cut distinction between *bozze* (the plural of *bozza*), "small models or pictures which Artists carry out, to make them larger afterward in the work, almost the beginning of the work, whether of painting or of sculpture, or other," and true, detailed, finished models. For him the *modello* is "the thing, which the Sculptor or Architect makes, to example or show of that which should be put into work . . . at a certain time . . . less, at another . . . of the same size . . . of wood, wax, or stucco, or other. The model is the first, and principal labor of the work [of art], since in its destroying and remodeling, the Artist arrives at the most beautiful and most perfect." The model for the *David* obviously belongs to this latter category, for it fulfills Baldinucci's definition to the letter.

The little *bozzetti* are another matter. They are just as fragile as the large models and cartoons, but their small size made them easy to exhibit, and they were highly prized in the sixteenth century, much like drawings which were avidly collected. Two male torsos in the Casa Buonarroti in terracotta for the Accademia *Slaves,* a third in terracotta in the British Museum, a female *Victory* in terracotta (which

Figs.
38–40
41, 44

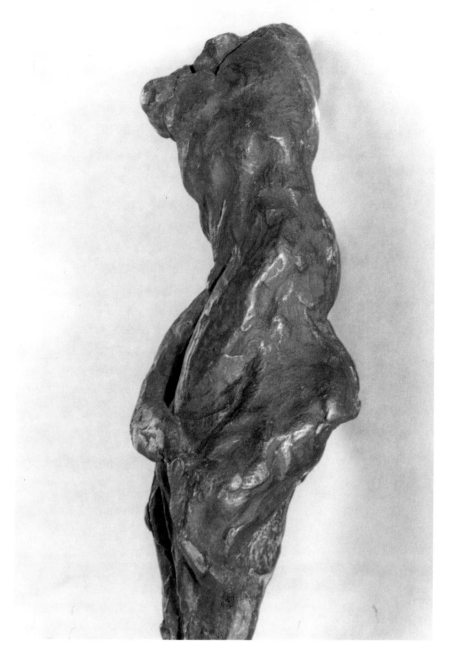

FIGURE 42

Bozzetto for final
version of the
Leg-crossed Slave,
probably 1527, wax.
British Museum, London.

David Finn and I discovered at the same moment bears Michelangelo's own thumb-prints), and a *Hercules and Cacus* or *Samson and a Philistine,* and a glorious wax study for the bearded Accademia *Slave* in the Casa Buonarroti must, therefore, all *Fig. 43* have been intended as preparatory *bozzetti* for full-scale models. The power and intensity of the conception, the expert knowledge of anatomical structure, and the freshness of execution are convincing in this entire group. At times strokes with a toothed clay-modeling tool duplicate the effect of Michelangelo's three-toothed chisel, the *gradina,* appearing also in the hatching of his drawings. Especially strik-ing is the realism of the single-figure sketches, in which we feel the living presence of the human subject, down to details of adipose tissue and loose skin which would never reappear in the large, finished statues. A tiny wax *bozzetto* in the British Mu- *Fig. 42* seum is not as easy to place. Generally exhibited on its side, it is really related to

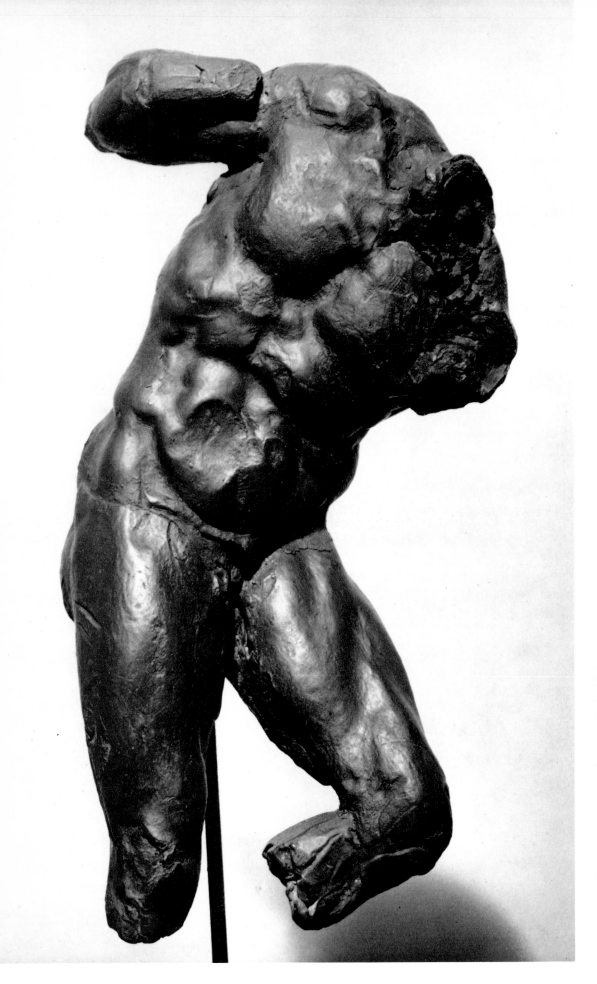

FIGURE 43 *(left)*

Bozzetto for early
idea for the
Leg-crossed Slave,
or for a River God,
probably 1527
(or 1520), wax.
Casa Buonarroti,
Florence.

FIGURE 44 *(opposite)*

Bozzetto for a
female *Victory*,
probably 1527,
terracotta.
Casa Buonarroti,
Florence.

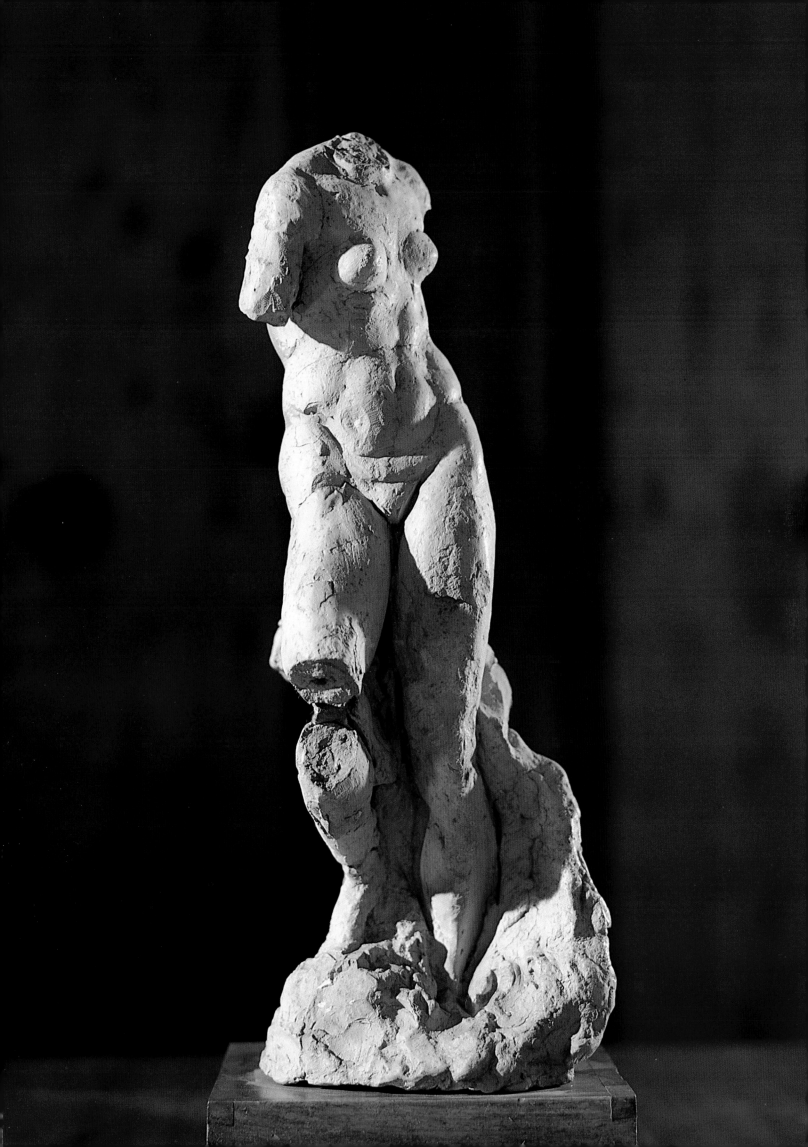

the standing *Leg-crossed Slave*. But it is so much smaller than any of the others and so free and fluid in its modeling that we have nothing to compare it with. Nevertheless the quality is very high and the handling spontaneous; it looks like the work of twenty impassioned minutes on the artist's part and is perfectly consistent with the freedom of his small figure sketches in pen or chalk.

All seven *bozzetti* save the *Hercules and Cacus* share a significant characteristic: they lack heads, legs, and arms. At least three of these sketches clearly never were much more than torsos, as the unfinished portions are distinctly visible. This was in keeping with Michelangelo's overwhelming interest in the vibrant torso as the seat of physical and therefore spiritual drama; in consequence his life drawings, even finished studies, usually omit the heads entirely, often hands and feet as well. Sometimes the breaks look accidental, sometimes cleaned off roughly with a knife. The wax *bozzetto* in the Casa Buonarroti shows that Michelangelo never did complete the limbs, but only added shapeless pellets to suggest where limbs should go.

In accordance with the academic trend of the so-called Maniera, the dominant artistic style in the late sixteenth century, art students and even accomplished artists produced small copies of Michelangelo's statues which look deceptively like models. One set was made by Daniele da Volterra, Michelangelo's friend, pupil, and devoted admirer, from the statues in the Medici Chapel. According to Carlo Ridolfi, Vasari's Venetian opposite number, Daniele's models were acquired by Tintoretto, who studied them again and again from every conceivable angle and in all kinds of light. But many copies were made either for study purposes or for sale to collectors, much as they still are today. Many are complete with attributes and ornament which, as we have seen, Michelangelo never included in his studies, whether drawings or *bozzetti*. Some thirty-three supposed Michelangelo models were sold individually at auction in London in 1938. Eleven have disappeared from knowledge, but the others have been acquired for public and private collections and published (see bibliography). All but the three remaining copies of the *Times of Day* from the Medici Chapel are smoothly modeled studies after legs, arms, hands, and feet from Michelangelo's statues or other sources, done without basic knowledge concerning where muscles, tendons, and bones fit together and how muscular tonus shapes the surfaces and contours of living tissue and responds to tension and motion. These fragments are neatly cut and carefully hollowed out to survive firing. One is a copy of a right leg and hip from an unidentified ancient statue, with the right side of a fig leaf meticulously copied; very interesting considering Michelangelo's notorious views on the subject of any prudish attempts to cover the genitals.

The only stucco model certainly known to have existed is that for the *David*. As the other surviving genuine studies are all *bozzetti*, the subject of this book is unique in two respects: it is the only surviving work by Michelangelo in stucco, and the only true, detailed model by his hand.

F O U R

TECHNIQUE

In our slow procedure through the problems attending the model for Michelangelo's *David,* we come to the method by which this unique—in the absolute sense—work of art was produced. The word *stucco* gives us an immediate impression of those Italianate villas built in so many prosperous suburbs in the early years of the twentieth century. Whatever material American builders may have employed, it is a safe bet that it bore little relation to the various kinds of stucco used in the Italian Renaissance for works of architecture, sculpture, and painting.

In the ducal inventories our model is consistently listed as being made of stucco. But this was a generic term, comprising a considerable number of different ingredients and different combinations. The young Michelangelo must have admired the adaptability of the stucco Donatello had used for all the reliefs which adorn the interior of the Old Sacristy of San Lorenzo in Florence, in those days still relatively fresh and presumably undamaged. Vasari, again, informs us with great completeness how this kind of stucco was composed and put to use. To make "a stucco paste, one has pounded with a machine in a stone mortar chips of marble" mixed with a white lime "made either of marble chips or of travertine; and instead of sand one takes the pounded marble, and one sifts it finely and one makes a paste of it with the lime, putting two-thirds lime and one-third pounded marble; and one makes it coarse or fine, according to whether one wants to work roughly or delicately." So a work of sculpture in stucco, to all intents and purposes, was made of marble and would retain some of the depth and surface glow of this incomparable sculptural material. Vasari goes on to describe how to make a core of "coarse, grainy" stucco around an armature, over which inner mass, while still damp, goes the fine stucco, "wetting continually where one puts the stucco, so that it renders itself easier to work."

Before reading the exhaustive scientific report prepared after studies in thermoluminescence by the University of Bordeaux (appendix D), I proceeded on the basis

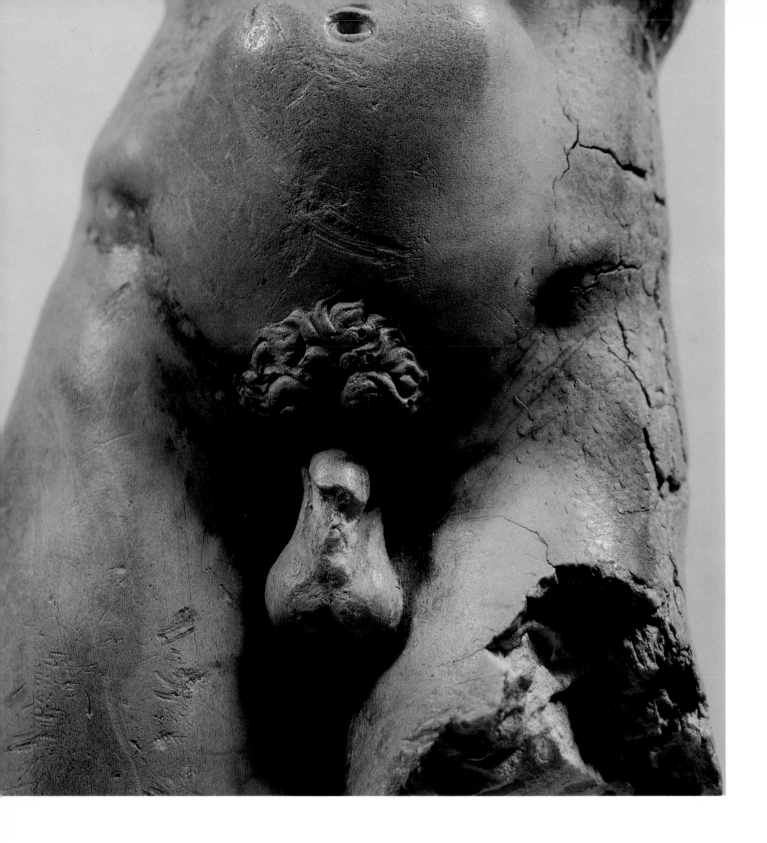

FIGURE 45 *(above)*
Detail of the model, pubic region, showing air bubbles.

FIGURE 46 *(opposite)*
The model from below, showing absence of armature.

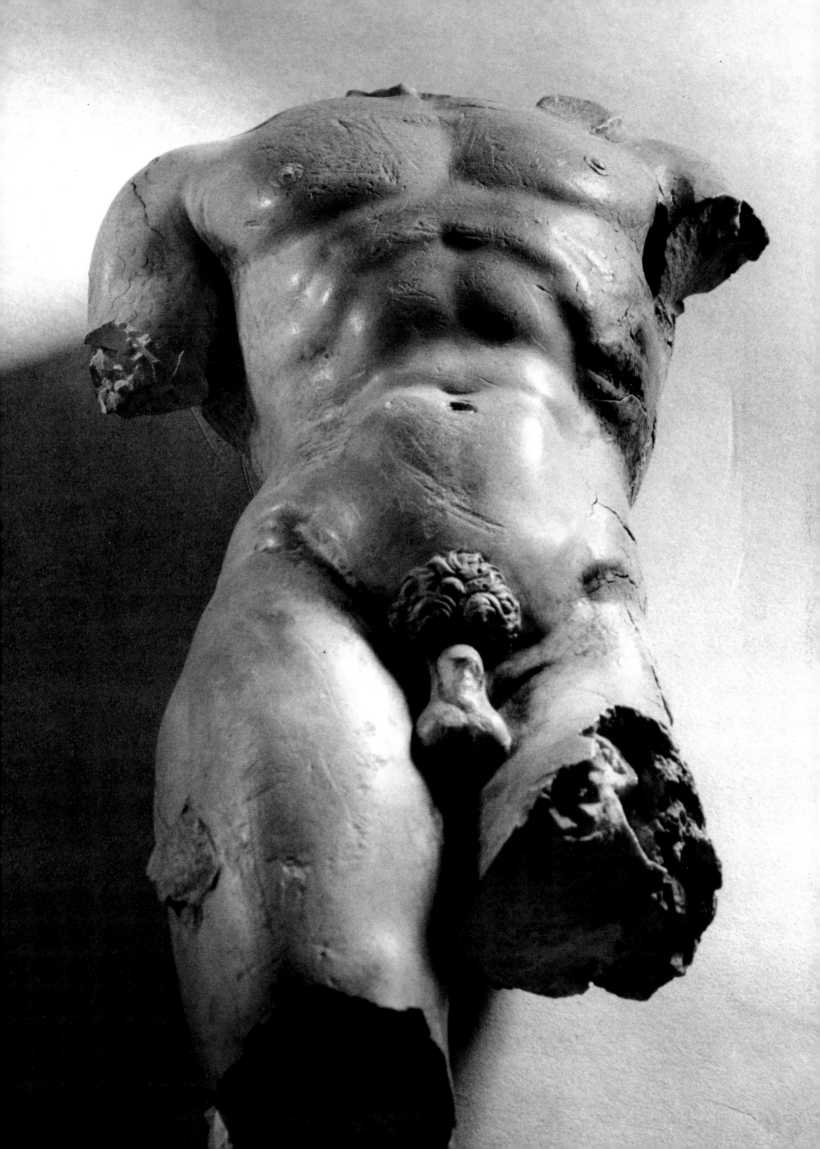

Fig. 46

of Vasari's description of stucco. But I had considerable difficulty in accounting for our model with his technique. An armature would have been essential to make the wet stucco paste stand up by itself, and the broken sections show that the model never had one. Moreover, even if there had been an armature the unusual naturalism of the model indicates that the living subject must have been standing in front of the artist for quite a while, far too long for him to shape in wet stucco, keep it wet overnight, and come back to it day after day.

So how could the dilemma be resolved? Vasari does provide a method for carving a concave mold for cornices or foliage, and putting "stucco which should be not really hard, nor really soft . . . onto the aforesaid carved form, dusted with marble dust; and striking it with a hammer so that the blow should be equal, the stucco remains printed, which one continues to clean and polish afterward, until the work becomes straight and equal." Second, there may after all be something in his statement that the original model was in wax, like that listed in the documents Seymour cites for Agostino di Duccio's original model in 1464 (see bibliography).

I proceeded on this basis. A model in wax would have to be built around an armature of wood or wire, and Vasari gives exact instructions on how to do this (see appendix B). The melted wax is mixed with tallow, turpentine, and black pitch, which gives it the necessary hardness. "When it is cold, one makes lozenges . . . which from the heat of the hand become like dough, and with this one creates a seated figure, or standing . . . which should have under [the wax] an armature, to hold it up by itself . . . and little by little, working with judgment and with the hands, while the material is growing, with sticks of bone, of iron, or of wood, one presses into the wax: and with the fingers one gives to this model the final polish." This is undoubtedly how the beautiful wax *bozzetto* in the Casa Buonarroti was made, except for the armature, which it did not need since the extremities were never modeled. The tiny sketch in the British Museum was rapidly shaped out of one of the little lozenges.

I came to the conclusion that Michelangelo made a wax model for the *David* on an armature, so that he could model head, arms, legs, and base in the greatest detail. Then he made a two-piece plaster mold around it, separating the front half from the back, as is still done today, by means of a continuous strip made of thin pieces of metal inserted into the wax before the plaster for the mold was applied. From there on, Vasari's procedure for molding architectural ornament could be carried out with some changes. Each half of the mold would be coated with a thin layer of fine stucco, fairly soft so that it would fill every tiniest detail, and allowed to harden

Fig. 45

somewhat, but kept moist enough to permit more stucco to adhere. Four little air bubbles visible in the pubic hair of the model indicate that a casting procedure of some sort was followed. A core of stucco could then be built up on one half of the mold thus partially filled, and by a process of constant adding, subtracting, and fitting, brought to the point where the two halves could be put together again, tied securely, and allowed to harden. Once the two pieces of the mold were removed

and the stucco cast found to be satisfactory, both the pieces and the wax original would have been destroyed.

Fig. 45

Such a procedure would inevitably leave joint marks on the sides of the stucco cast, like those on plaster casts made today. Plaster casters go to some pains to remove such traces, but the model for the *David* shows the mold marks quite clearly along the right flank, crossing the external oblique muscle and running down the hip and the thigh, probably circumnavigating the destroyed right hand. These marks could have been removed, as they were on the left side. Throughout his career, even in such apparently finished works as the *Bruges Madonna* and the *Doni Madonna,* Michelangelo left tiny unfinished areas here and there, as if out of the same respect for tools and processes which compelled him to imprint the shadow of his scaffolding in the simulated architecture of the Sistine Ceiling. But even in the completely finished left side of the model one can still sense the shadowy presence of the vertical division between the two halves of the mold.

Fig. 46
Fig. 47

Fig. 48

The Bordeaux report dissolved my cumbersome hypothesis into thin air. I do not miss it. The model is made not of calcium carbonate (marble) but of calcium sulfate (gypsum), the Italian gesso, or plaster. Then how does one explain the soft inner glow so impressive in the model as compared to the notorious deadness of plaster casts, no matter what kind of finish is applied? Mineralogist Richard S. Mitchell, a professor at the University of Virginia, has confirmed the plausibility of my suggestion that the calcium sulfate was derived from alabaster quarried, like gypsum, near Volterra. And Baldinucci's *Vocabulario* lists five different kinds of stucco, one of which—used by woodworkers—was made of gesso. Painters, of course, used gesso in combination with glue to provide a porcelainlike surface for panel painting, and Michelangelo himself used it for the smooth surface of his *Crucifix* in 1494, only seven years before the *David.* The mold marks visible on the model are accounted for quite simply: it was poured into a mold. Although no traces of an armature now remain, some sort of supports must have been inserted to provide reinforcement for the ankles and wrists, which would have been very fragile. The threads of any cloth become extremely resistant, almost metallic, when impregnated with plaster and allowed to harden, and therefore cloth, fine or coarse according to circumstances, is used today in order to reinforce plaster casts and keep them to the thinnest possible shell so as to diminish weight and increase resistance. In the case of so small a model this would have been impossible, and consequently the model is solid throughout. But it is quite believable that cords impregnated with plaster were floated in plaster spooned into the wrists and ankles of one half of the mold and allowed to firm up slightly before it was put together. After assemblage the rest of the plaster could have been poured from the base. Or conversely the cords could have been inserted from the base after pouring. In any case the legs would still have been weak, and it was no wonder they eventually broke.

No *bozzetto* shows the high pitch of finish to which Michelangelo carried the

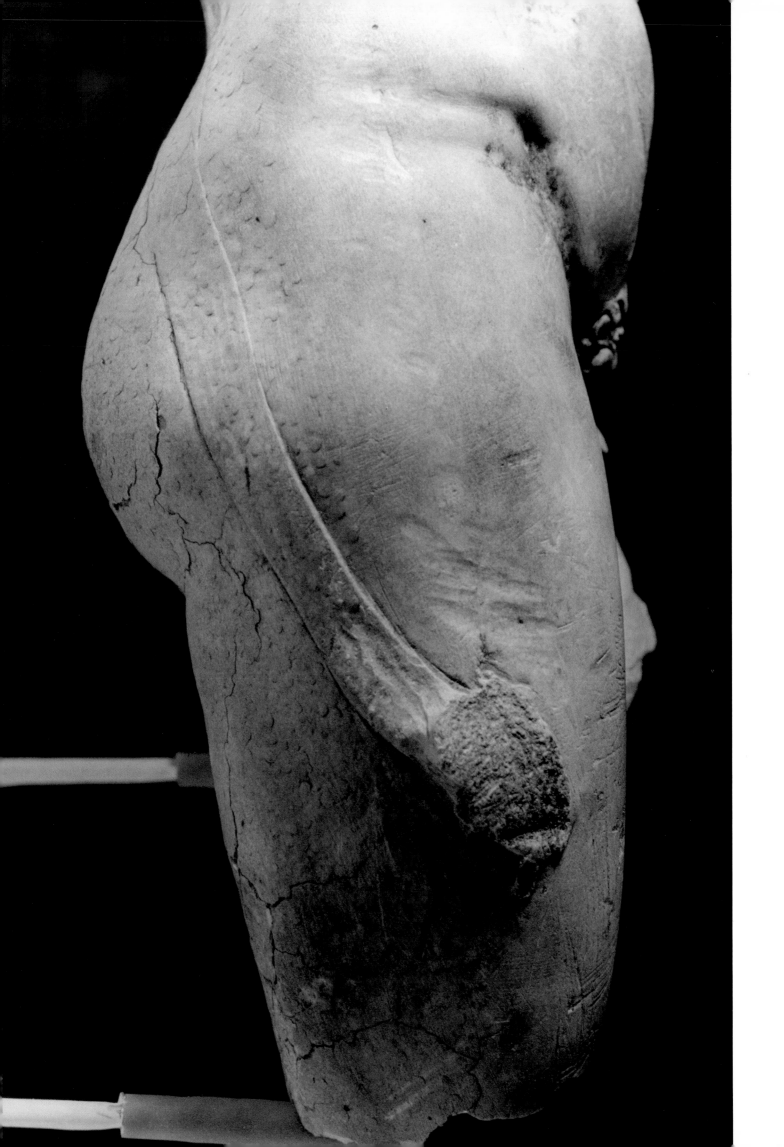

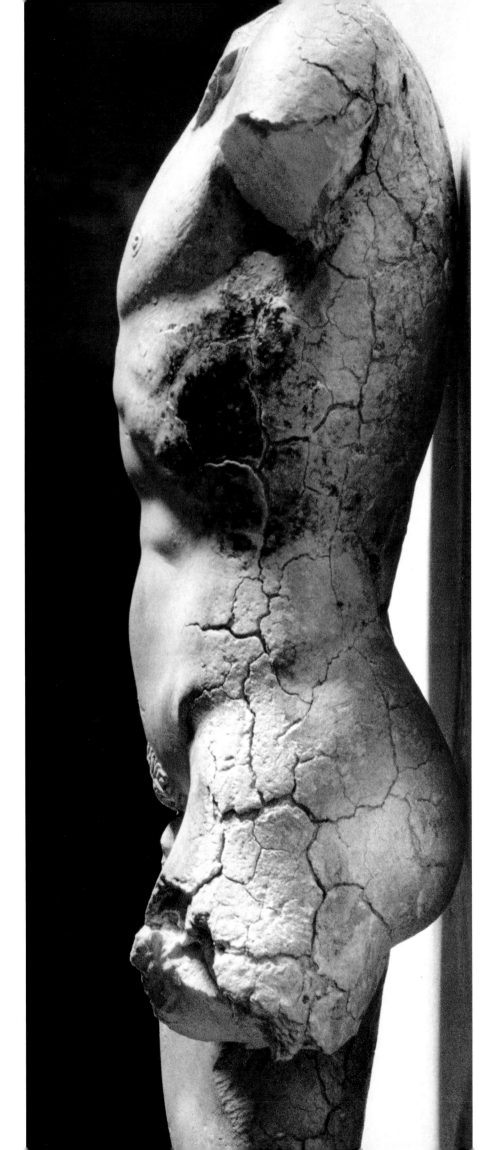

FIGURE 47 *(opposite)*

Detail of the model, right hip and thigh, showing joint marks and position of right hand.

FIGURE 48 *(right)*

The model, left side, showing joint marks and fire damage.

David model, even to the rings around the nipples and the delicate drawing of the ornamentalized locks of pubic hair. Could these details have been done on the gesso surface? I think not, and indeed in Vasari's accounts of how to handle marble stucco he gives no indication that such a procedure was possible. Even less likely with gesso. The character of the tool marks wherever these appear is just what one would expect from the tips or blades of delicate tools made of wood, or perhaps bone, as Vasari says. Lemon and olive wood are generally used today for such fine work. When the model still had its head, limbs, and base all brought to the same degree of finish, the effect must have been dazzling. Either the wax model or the gesso cast, originally radiant as the baked alabaster of which it was probably composed, was used by the twenty-six-year-old artist to convince the officials of the Opera del Duomo that they should give him the colossal block to work on. The gesso model could stand in the workshop, impervious to summer heat, which would have softened a figure in wax to the point where it would no longer be usable. By means of squaring with horizontal and vertical rules crossed at right angles, which Vasari also describes (see appendix B), Michelangelo proceeded to enlarge the small model and project it systematically onto the block of marble.

FIVE

THE MODEL AND THE STATUE

IN THE ABSENCE of the head, the left arm and leg, and most of the right arm and leg, for a moment one does not connect the model with the marble *David* at all—a sufficient refutation, if one were needed, of the notion of a copy. Yet every anatomical element is treated in much the same sharply projected manner in both the model and the statue. What has changed is the conception, the spirit of the work. This transformation manifests itself in all kinds of ways, but most of all in the proportional relationship between the elements. The statue represents a "boy of the people," as I once put it, and the muscles and in consequence the bony structure beneath them, and above all the massive hands, radiate the kind of power which springs only from hard and energetic work. Yet we do not feel that we could ever have seen a body of such magnificence on any beach or in any locker room. Without in any way sacrificing his workmanlike aspect, the marble *David* is a hero, sprung from a superhuman race in which only the youngest and strongest among us can dimly aspire to membership. One thinks of Philippians 3, 21:

> Who will reform the body of our lowness [Vulgate: "humility"], made like unto the body of his glory, according to the operation whereby he is also able to subdue all things to himself.

This miraculous process works within the profoundly Catholic Michelangelo, guilt-ridden by his own unconquerable desires, so as to enable him to transform the body he saw and studied into the body of incomparable glory which transfixes visitors to the Accademia today, reducing the most boisterous student to awestruck silence. Jesus Christ, after all, was "of the house and lineage of David," who is thus as deeply venerated by Christianity as by Judaism. The youthful artist must have been con-

scious of David's dual role of prophet and ancestor, as he was of his traditional significance as protector and defender of the Florentine people. In this marble image artistic creativity and divine creation are fused. And in the beautiful smoothness of body and limbs the tension of the pose and the fire of the expression are transfigured by a new harmony which proclaims the superiority of Michelangelo's vision of the human body—"mortal veil of divine intention"—over both the musclemen and the hermaphrodites of his less inspired contemporaries and followers. Not even in antiquity, as Vasari well knew, had an artist experienced such a revelation of human, and therefore of divine, beauty. Idealization is an anticlimactic word for what has taken place between model and statue, but the language provides no fitting expression.

Fig. 49

Yet even after all that has been said about the statue the model, significantly enough, does not come off second best. The essential difference between them is that, as hardly needs to be demonstrated, Michelangelo really saw and studied with intense penetration a person who looked like the young man in the model. As compared with the finished harmony and perfect poise of the statue, intended for a symbolic purpose and for public view, we feel the rugged youth who posed for the model tremble and sweat as the demanding artist exhorted him to assume and hold a breathless state of abdominal tension, intolerable for more than a few minutes at a time. In its immediacy and dynamism the realistic model is in some ways more intense than the ideal statue. Surprisingly, it is also just as monumental—witness the difficulty of persuading oneself from the photographs how tiny it is. "Implicit monumentality" is an eloquent phrase that has been used to characterize Michelangelo's desire to convey from the very start the sense of the figure's commanding public destiny.

Fig. 50

Fig. 51

Fig. 52

Fig. 53

In spite of the similarity of the anatomical projections in both model and statue, the proportions differ. Conspicuous in the overlay is the wasp waist of the model, which reminds us almost of a supple dancer in some Minoan fresco. Michelangelo decided to thicken the waist in the statue, as if to give it greater solidity in keeping with its enormous scale. In the model the chest swells as the abdominal muscles contract. Indeed, the whole thoracic cage seems spherical from below, as if announcing its ability to rotate easily at the waist on the pivot of the spine. The pectoral muscles contract and arch as we watch, as compared with the relative flatness of the statue, in which at every point we still feel the frontal plane of the marble block.

FIGURE 49
The model, one-quarter left.

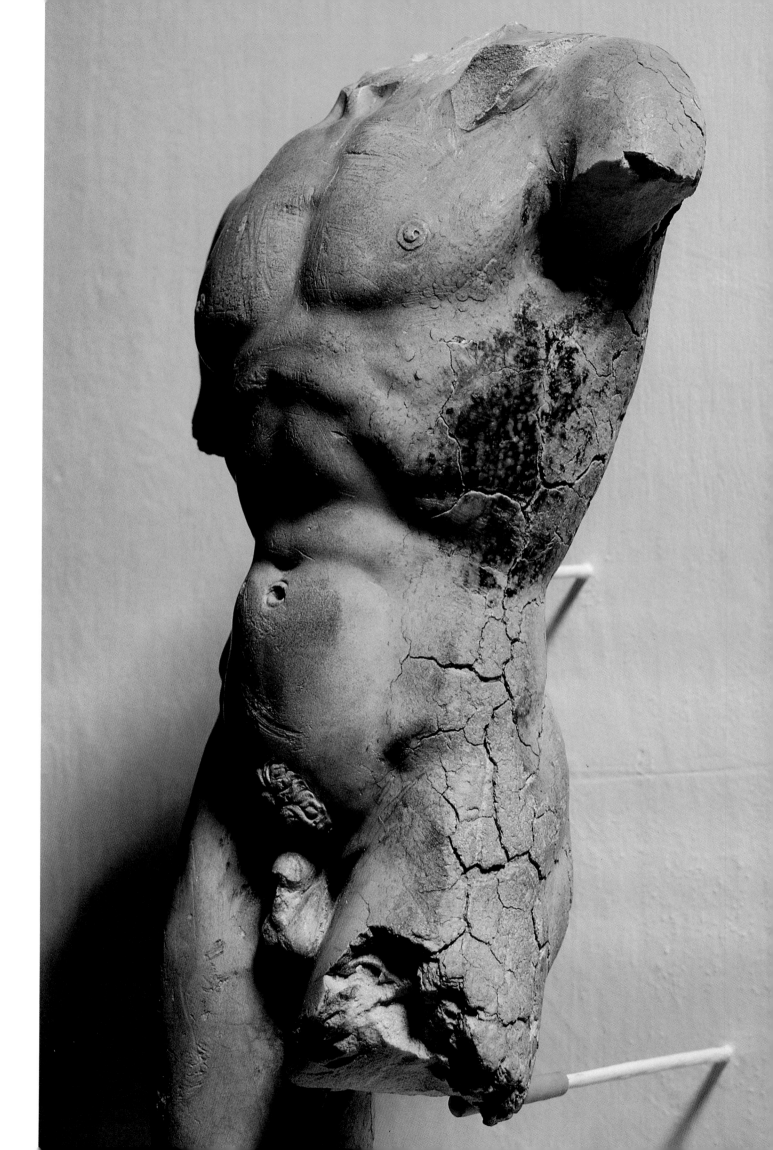

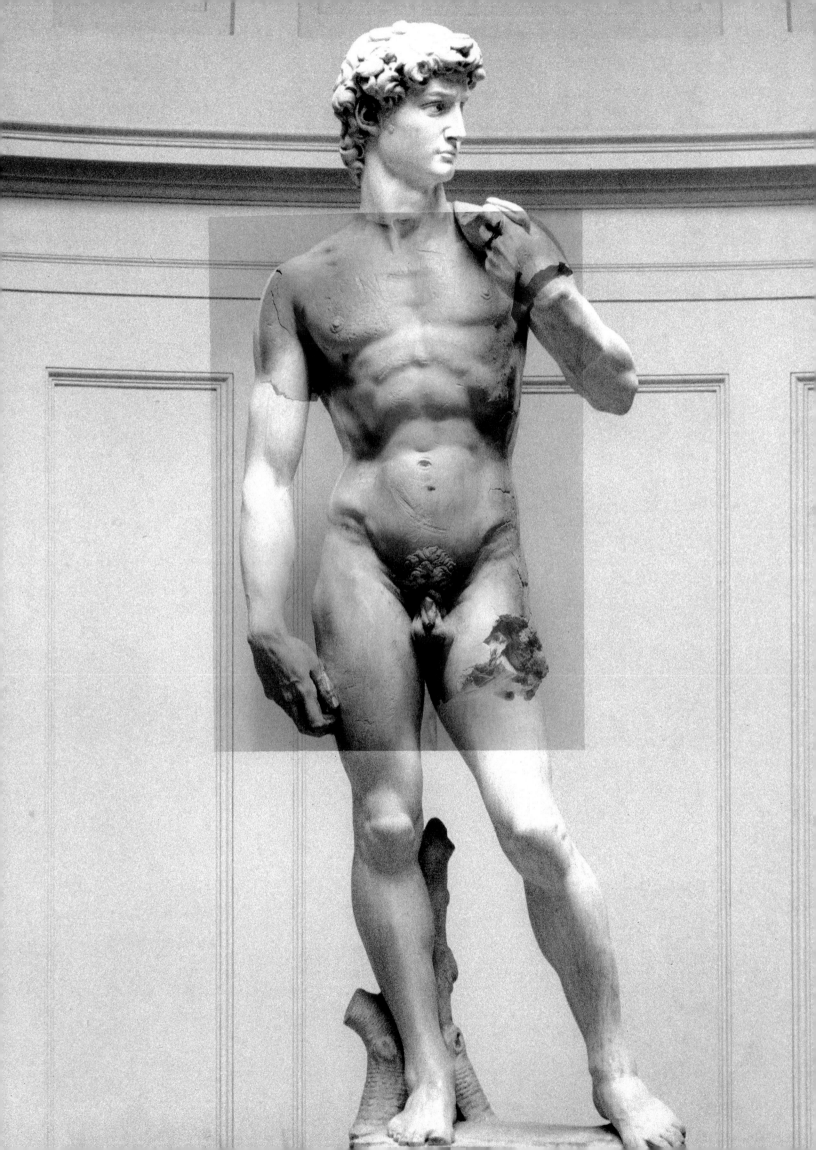

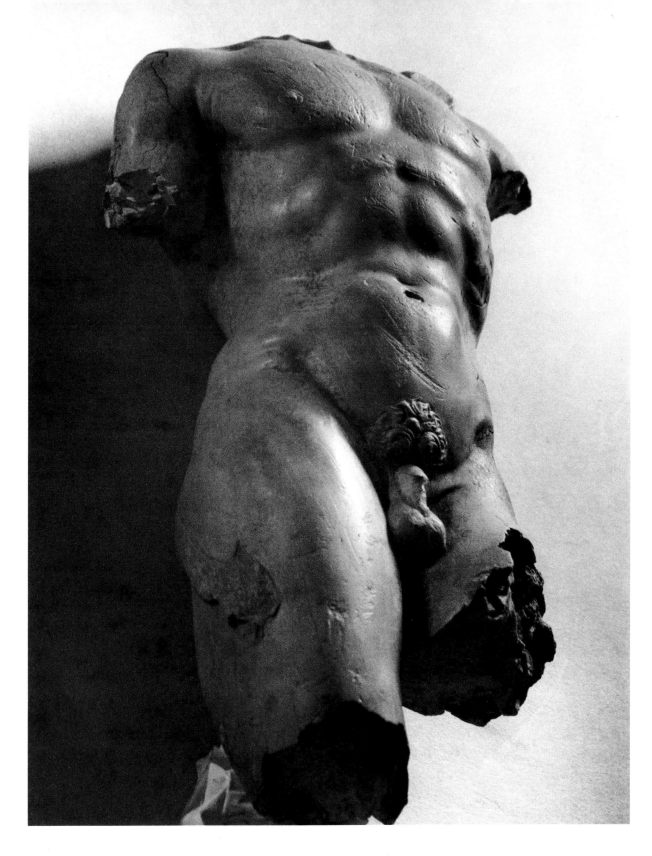

FIGURE 50 *(opposite)*

Composite photograph of the model and the statue, showing differences of proportion and pose.

FIGURE 51 *(above)*

The model from below, one-quarter right, showing swelling thorax and contracted abdominal muscles.

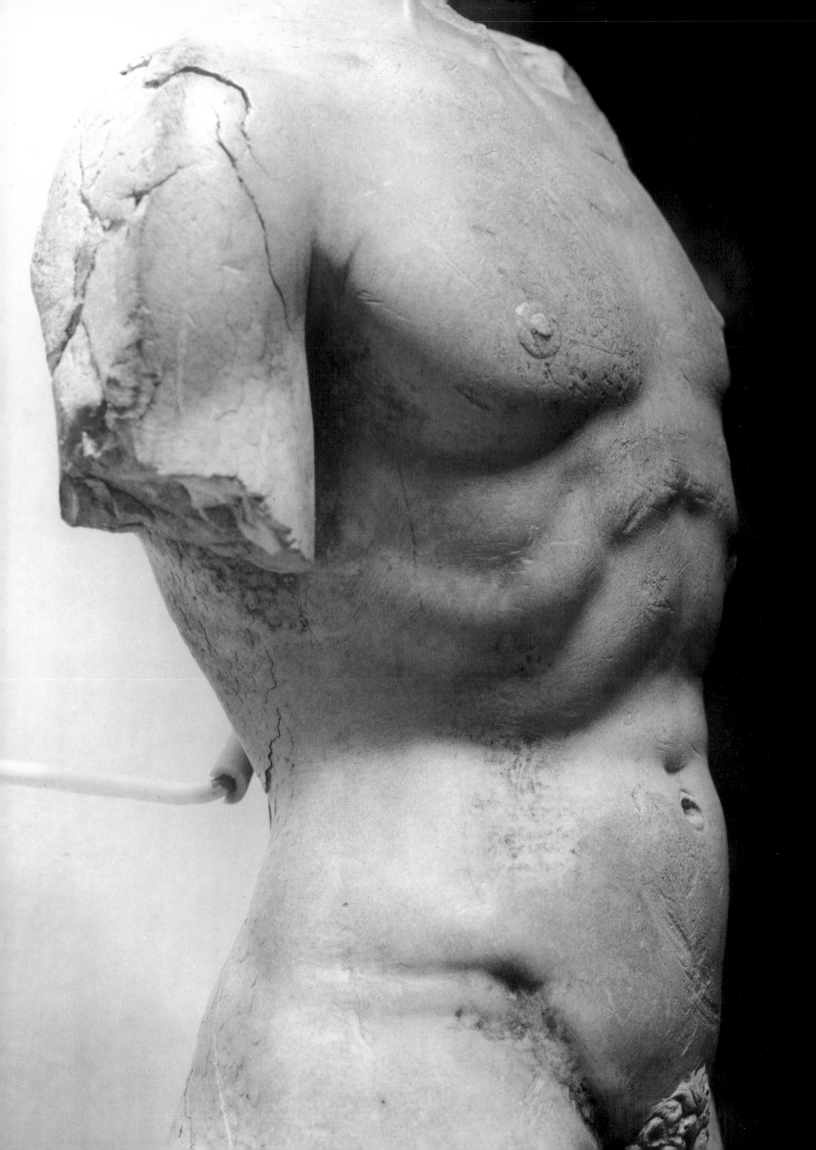

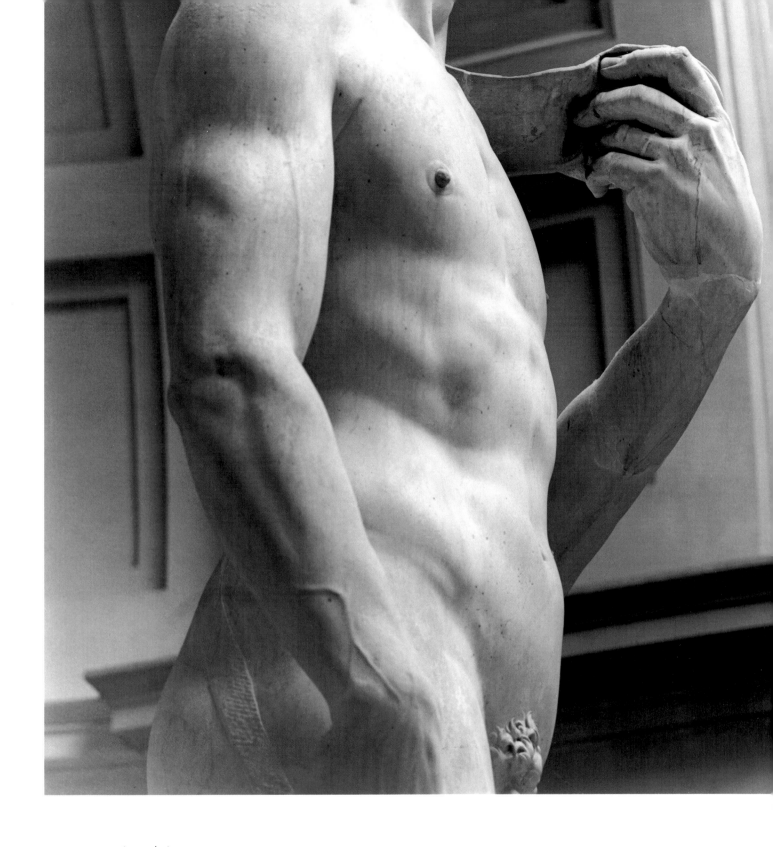

FIGURE 52 *(opposite)*
Detail of the model from one-quarter right, torso.

FIGURE 53 *(above)*
Detail of the statue from one-quarter right, torso.

Fig. 54

At this point Michelangelo may have been influenced by the swelling chests and slender waists of the anatomically schematic crucifixes carved in the 1490s by various members of the Sangallo family, especially that by Antonio da Sangallo the Elder, with the possible collaboration of his brother Giuliano, now in the Santissima Annunziata in Florence. None of these crucifixes shows anything approaching Michelangelo's command of anatomy at any stage of his career, and he may have considered his convincing study of the abdominal muscles from life in the model as an eloquent commentary on the shortcomings of his older contemporaries. In creating his tiny model, Michelangelo almost miraculously went farther than anyone in history had yet done to analyze and state certain anatomical subtleties. According to James Elkins there are two areas—the upper abdomen between sternum and umbilicus, and the right inguinal region—in which the model shows greater anatomical precision than the marble colossus. In fact, there are in the model no less than seven features virtually unknown outside the work of Michelangelo, and never before his time.

While Michelangelo was at work on the marble, he must have concluded that if he had kept the chest as strongly arched as it is in the model, it would have detracted from the face when seen from below, and in consequence he decided to flatten it. All the projections, whether due to muscles or to bones, are more smoothly rounded in the statue, as if veiled by a thin layer of adipose tissue. Not that the statue looks in any way soft or effete—far from it. But the succession of projections and hollows is made to appear more harmonious and less abrupt, in keeping with the scale and public purpose of the finished work. The buttocks of the model display a degree of tonus diminished in the statue. A muscular tension similar to that of the model runs through all of Michelangelo's early pen drawings of the nude male figure, from both classical and living models. One in particular, a vibrant study in the Louvre of a tall, gaunt, yet muscular, youth is so close to our model as to compel us to believe that the same individual posed for both. "*C'est le même personnage!*" exclaimed M—— when I showed him a photograph of the drawing. Accustomed to energetic activity, the young giant was restless under the strain of standing still. Michelangelo studied the muscular and bony structure of his right side—our left—with great care, but by the time he got to the left—our right—the youth had moved so that the two sides are seen at different moments and produce the illusion of a heavier torso. Such discrepancies are common in Michelangelo's drawings, and even in larger questions, such as the proportional system of the Sistine Ceiling, whose earlier sections are crowded with relatively small figures in contrast to the final triumphant section populated by few figures of more than twice their size.

Fig. 55

Fig. 56

I once published this drawing as a study connected with the *Slaves* for the Tomb of Julius II. Tolnay suggested that it was made for the *David,* and in a sense he was right. Although he could not have known this, the drawing really is a study—for the model. The variations between the idiosyncratic proportions of the slender model with its preparatory drawing and the harmonious statue parallel those be-

FIGURE 54

Antonio (and Giuliano?) da Sangallo, detail of *Crucifix*, from Sant'Jacopo tra i Fossi, about 1495, wood. Santissima Annunziata, Florence.

tween the British Museum life study and the *Adam* on the Sistine Ceiling for which *Fig. 58* it was done. On account of the heavy dorsal muscles, powerful legs, and underdeveloped pectorals visible in this drawing, I have suggested that Michelangelo employed a stevedore from the port of the Tiber, used to carrying heavy weights on his back, whom Michelangelo had plenty of opportunity to observe when his marble blocks were being unloaded for transport to St. Peter's Square. The same process at work between model and statue transforms the humble body of the workman into the glorious one of the first man, created in the image of God.

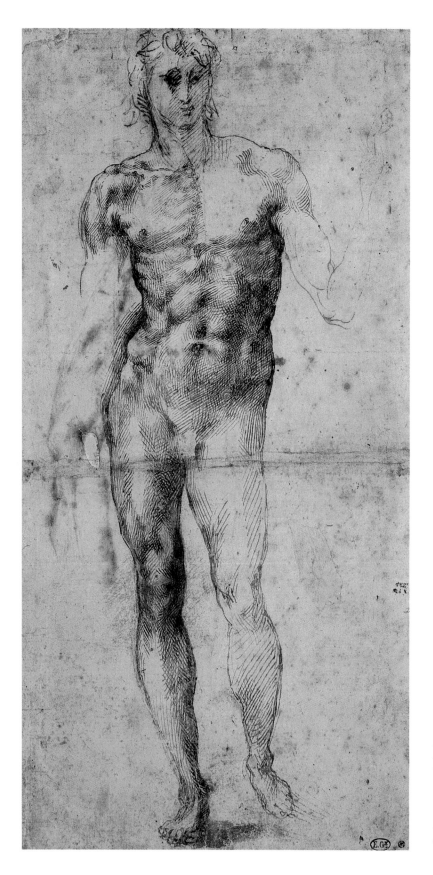

FIGURE 55 *(left)*
Figure study for the model, 1501,
pen and ink. Louvre, Paris.

FIGURE 56 *(opposite)*
The model, front.

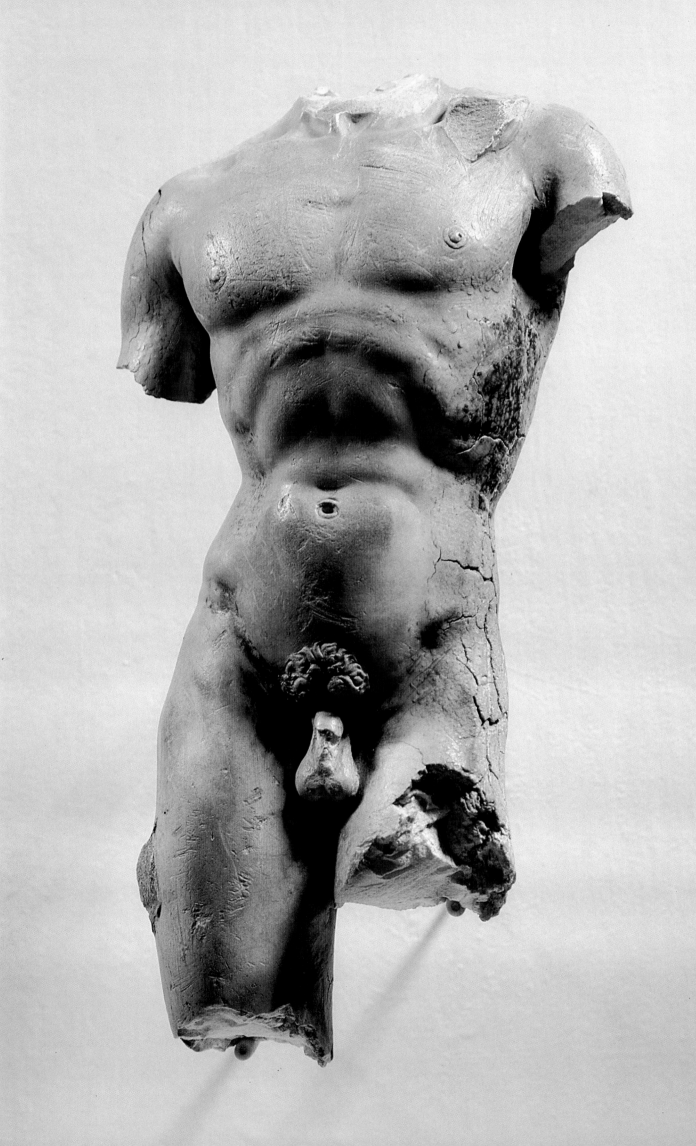

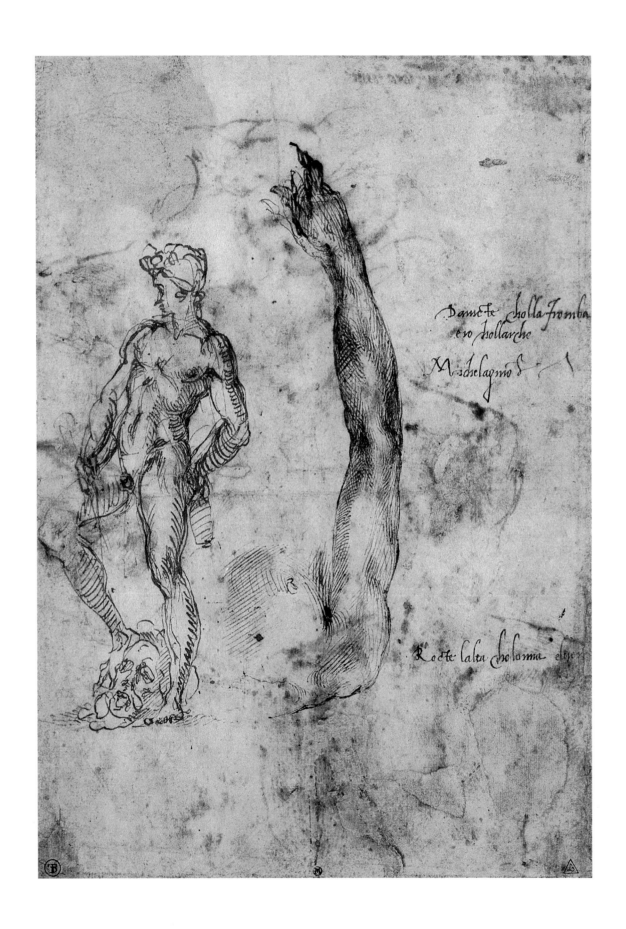

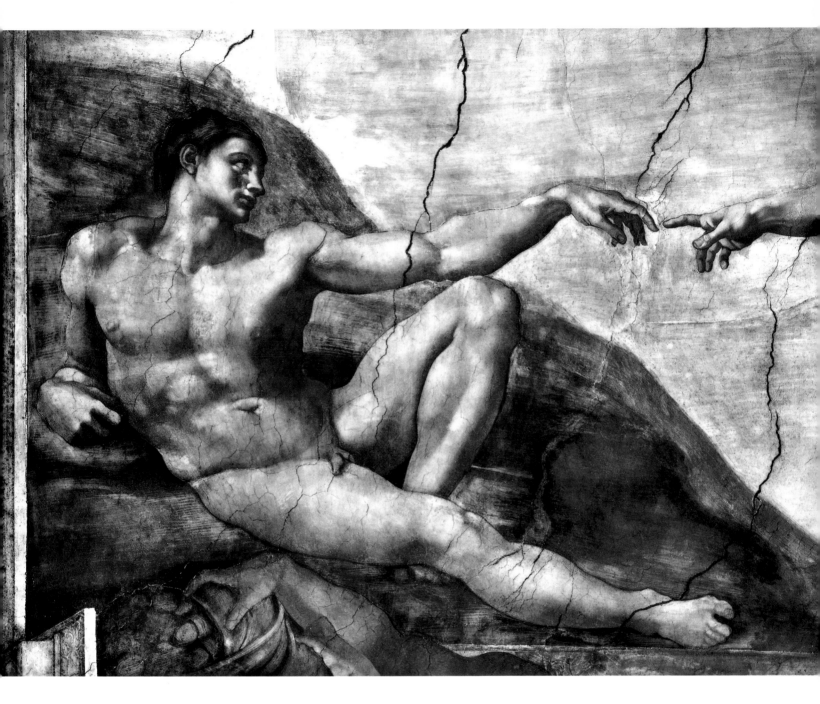

FIGURE 57 *(opposite)*

Study for the right arm of the marble *David* and sketch
for the lost bronze *David*, 1501, pen and ink. Louvre, Paris.

FIGURE 58 *(above)*

Adam, from the *Creation of Adam*, 1511, fresco.
Sistine Chapel, Rome.

In the present instance I think he also chose a workman as a model, possibly one of the mountaineer quarrymen from Carrara. Such a lean build, especially the contrast between broad, muscular shoulders and taut, tiny waist, would be the normal result of habitually rotating the torso while swinging a heavy hammer against the iron point used to split the marble. His own stonecarver's hammer is used by Michelangelo in a poem dating from the 1530s as an early counterpart of the divine hammer in the hand of the Almighty.* Such a metaphor was appropriate enough since a hammer was wielded daily by the young Jesus in Joseph's carpentry shop.

As our eyes move back and forth between drawing and model, we observe an infinity of correspondences. Skeletal structure and muscular revetment are treated in much the same insistent way in both. There is the same concentration on the pectoral muscles, nipples, and wrinkles around the armpits, the same sharp exposure and minute analysis of the thoracic cage, the same interest in the exact formation of tissue around the navel, the same tilt of the pelvic basin, the same degree of thinness and tension in the musculature girdling the powerfully contoured waist.

Many irregularities in the drawing, including even sharp anatomical discrepancies between right and left sides, are ironed out and harmonized in the model. The drawing is a valuable aid to the reconstruction of the model before it was damaged. Michelangelo's tentative pen strokes show that the pose of the hanging right arm, studied in another and more famous drawing also in the Louvre and including a *Fig. 57* study for the lost bronze *David,* had not yet occurred to him. That of the left would surely have been quite different—more open and less strongly bent. One can follow the strokes to the point where, as often in Michelangelo's early studies, they trail off into mere squiggles like the shapeless pellets where limbs should be in the Casa Buonarroti *bozzetto.* Nonetheless the position of the left hand holding the slingshot can be roughly established. It would have projected far beyond the body, holding a lengthy sling. The fact that none is yet suggested should not disturb us. In his numerous life studies for the *Battle of Cascina,* the Sistine Ceiling, and the *Last Judgment,* Michelangelo seldom drew the attributes which the figure was eventually intended to hold, even when he indicated clearly such prosaic details as the headcloth intended to bind up the living model's streaming locks. For example, in none of the drawings for the twenty Sistine nudes is there any indication of the long bands of cloth they are intended to hold. In the Louvre drawing for the *David* the artist had as yet no intention of bringing the hand up to its present position just above the shoulder and close to the face; the head is only slightly turned to the figure's left. The moderate tension of what little remains of the sterno-cleido-mastoid muscle in the model, clearly visible in section, indicates that the head was posed just like this, in contrast to the near-profile of the head in the statue. The fullness and tension of the left deltoid and left pectoral muscles in the model show that beyond question, the left arm was not bent as in the statue but partially ex-

*Michelangelo Buonarroti. *Le Rime.* E. N. Giraldi, ed. Bari: Giuseppe Laterza, 1960.

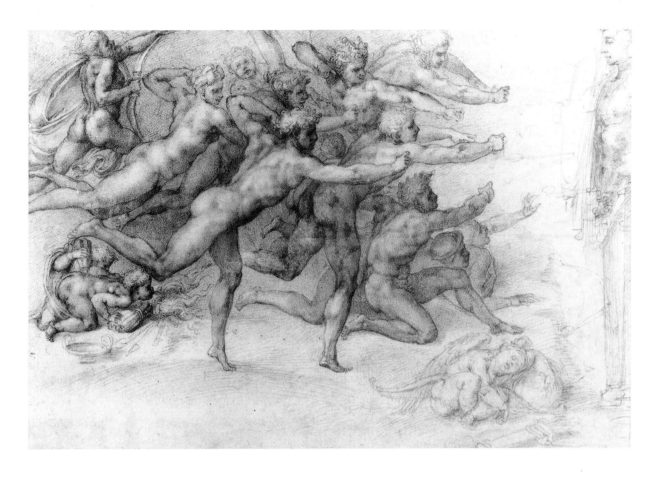

FIGURE 59

Archers Shooting at a Herm, 1533–34?, red chalk. Windsor Castle, Royal Library.

tended as indicated in the drawing, with the forearm and hand lifted and projecting outward and perhaps also leftward from the body. The slingshot, then, was a free-standing ribbon of some length, extremely difficult to carve.

The rendering of pubic hair in a colossal statue precipitated problems of taste which were not easily solved. In small-scale figures, especially those in narrative scenes, pubic hair was customarily depicted, although usually ornamentalized. Michelangelo experienced no difficulties in this regard in his relief of the *Battle of Lapiths and Centaurs* in the Casa Buonarroti. But the only precedents for large-scale nudes were the statues of Adam and Eve he must have seen during his first sojourn in Venice in 1494, and these were supplied by their sculptors with ample and carefully rendered fig leaves. Crucifixes were another story. Few in Florence were totally nude, and they were undoubtedly to be supplied with actual loincloths. Only the crucifix by Michelozzo in San Niccolò Sopr'Arno shows the pubic hair. In his own

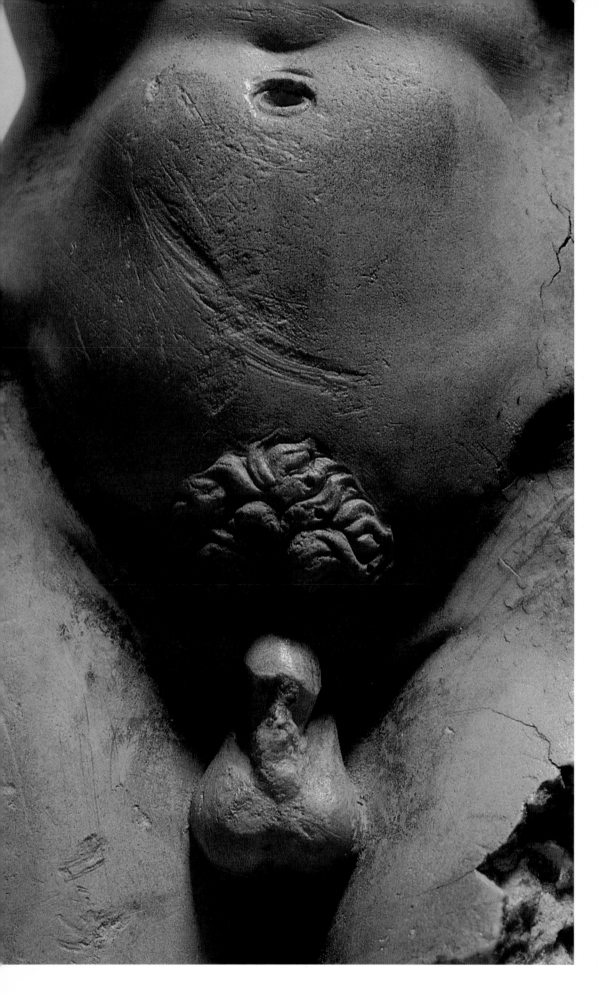

FIGURE 60 *(left)*
Detail of the model,
lower torso.

FIGURE 61 *(opposite)*
Detail of the
statue, genitalia.

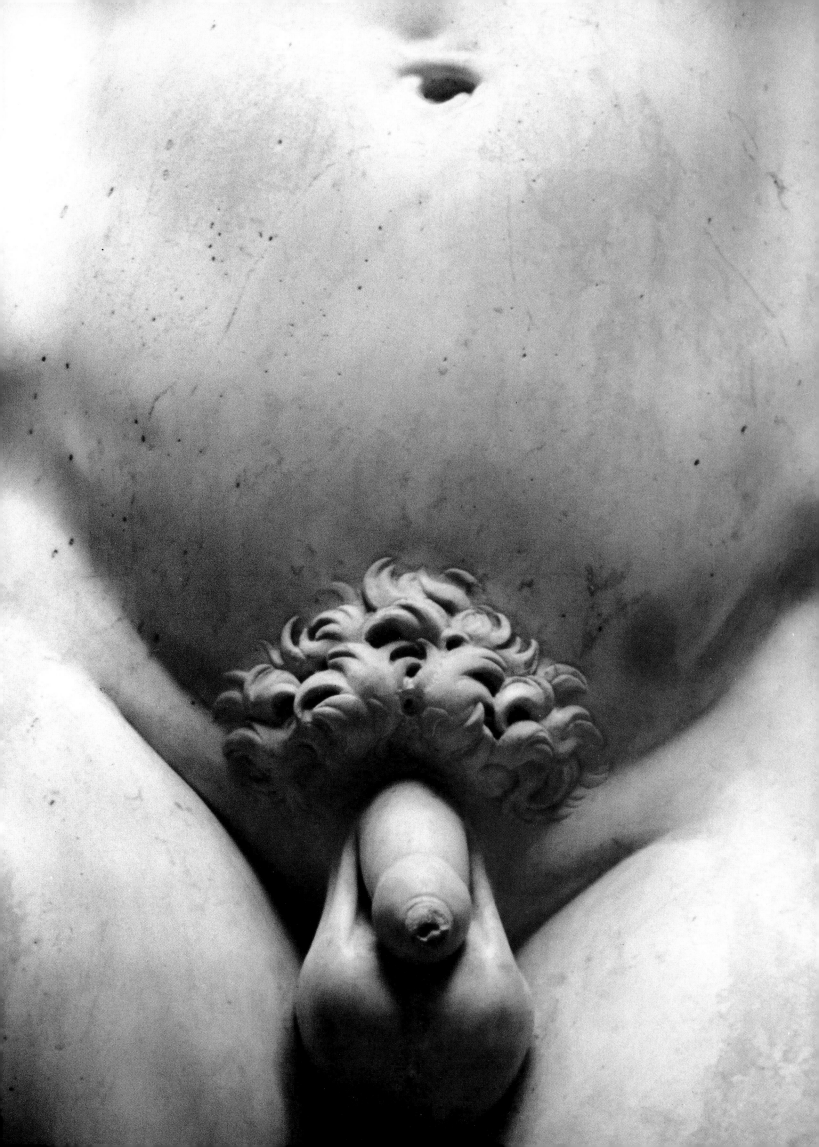

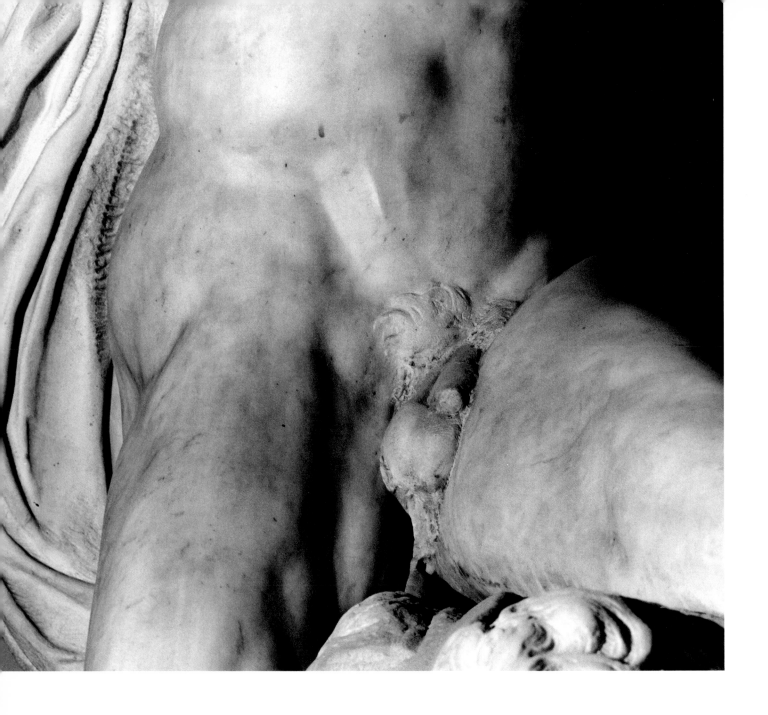

half-lifesize crucifix for Santo Spirito, possibly also to be concealed with a loincloth, Michelangelo indicated the hair by a few touches of the brush. About his lost *Hercules* we have no certain information, but in his lifesize *Bacchus* of 1496–97 he chose to omit the pubic hair entirely, with consequences disagreeable to modern eyes and presumably to his as well. When he faced the creation of the *David* on a gigantic scale, the dilemma became acute. He could continue to omit the pubic hair as with the *Bacchus,* or cover the genitals with the customary fig leaf. Courageously, he chose to depict the pubic hair, ornamentalized with unprecedented intensity and intricacy. This battle, as we have seen, he was to lose for the time being to official prudery. Nonetheless, he later restated and dramatically simplified his ornamental treatment in the boldly asymmetric flaring locks of pubic hair which adorn the unfinished *Victory* for the Tomb of Julius II.

Fig. 62

94

FIGURE 62
Victory, for the Tomb of Julius II, detail, torso, 1527–30,
marble. Palazzo Vecchio, Florence.

No indication of the pubic hair is visible in the drawing, and there is a hole (deliberate? made by whom?) where the genitals once were. But the patterned, flamelike locks with which Michelangelo experimented, producing such beautiful results in the model, are further elaborated in the statue. The central lock is drawn upward above two flaring lateral locks to form a triangle of spirals. As in the magnificent curls of Renaissance sculptured beards, no man's secondary hair will really grow like that. Too bad. A wildly asymmetrical arrangement of these pubic locks is partly completed, partly blocked out, in the *Victory* for the Tomb of Julius II. Just such spiral shapes reappear, with poetic propriety, in the flames of love blown by a kneeling *putto* at the end of a bundle of rods at the lower left of the famous *Archers* drawing in Windsor.

Fig. 60

Fig. 61

Fig. 59

Finally, in the drawing the left leg, only lightly indicated, is bent forward somewhat at the hip, and the left foot is placed well behind the right, the great toe barely touching the ground, giving an entirely different and more classical character to the pose as compared to the defiant outward and slightly forward thrust of the left foot in the statue. The small remaining fragment of the left leg in the model is slightly advanced, and the fragmentary thigh muscles fuller than in the statue, corresponding to the forward movement of the thigh in the drawing, which would have resulted in a flexed knee and backward placing of the foot, as in the drawing. At this point the young Raphael, whom Michelangelo cordially detested as an outsider and an imitator, comes to our rescue with two careful life studies, both in the British Museum. The larger of these has been universally recognized as an attempt to study the pose and disposition of the limbs of the marble *David* in what might be described as a one-quarter view, from the back and partly from the right side, and also—inevitably—from below, while treating such elements as the curls and the tree stump with a certain freedom, and omitting the slingshot entirely. The lighting from the back would suggest that Raphael studied the statue not in its final emplacement before the Palazzo Vecchio, where the back remained either in the shadow of the building or in its own shade save for an hour or so at noon, but in the workshed of the Opera del Duomo, where it was carved and just set up in a vertical position.

The smaller drawing has generally been described as a study from life, in a pose suggested by the marble *David,* but possibly holding a staff. In reality the pose corresponds closely to that of the figure in Michelangelo's Louvre drawing, especially in the position of the right leg and foot, seen not from below but from the right side, at eye level. The object barely indicated in the subject's left hand is the

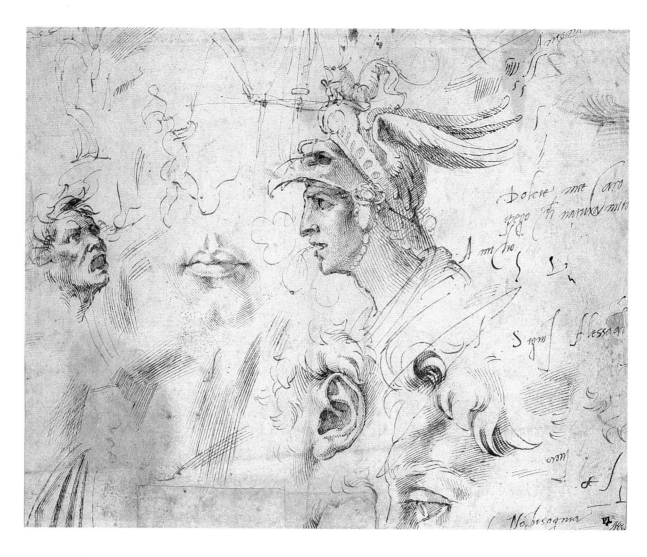

FIGURE 63

Sketches for the mouth, left ear, left eye, and locks of hair of *David*, standing male figure, a *putto*, and a helmeted head in left profile, 1501, pen. Kunsthalle, Hamburg.

beginning of the sling. We can only conclude that Raphael had our model in front of him as he drew. Apparently he changed his position or else moved the model slightly without quite realizing the consequences, because when he sat toward the right of the model he could not possibly have seen both the profile of the left pectoral muscle and that of the left buttock at one and the same time. Parenthetically, the young painter—twenty-one in 1504—did not yet know enough anatomy to understand exactly what was going on in either the model or the statue. More interesting from our point of view, the drawing from the model shows no tree stump. We are thus presented with the not surprising conclusion that Michelangelo

hit on the idea of leaving such a mass only when he realized in the course of carving that the marble, long exposed to the elements, might be too fragile to support the immense body on legs only. It has only recently occurred to me that the stump from whose roots this son of Jesse seems to spring may also have a symbolic meaning:

> And there shall come forth a rod out of the root of Jesse, and a flower shall rise up out of his root. (Isaiah II, 1)

The inspired youth exemplifies the gifts of the spirit in the next verses, including above all fortitude, and it may be no accident that Vasari's account so emphasizes justice, "the girdle of his loins." Indeed he has no other, now that the girdle of leaves has been removed.

We can therefore reconstruct the probable open pose of the model before damage from the drawings by Michelangelo and by Raphael. Obviously such a pose could not be made to fit into the contours of the colossal block for a *David* to go on one of the north buttresses of the cathedral. This block had been lying *male abbozatum* (badly roughed out, to quote the barbarous mixture of Italian and Latin in the document of deliberation given in appendix C), ever since the minor sculptor Agostino di Duccio, who had quarried it in one piece, abandoned it in 1464, for reasons still not known for sure. On July 2, 1501, the *operai,* members of the Opera del Duomo, decided to lift the recumbent block to its feet and call in artists to see if it could be turned into an acceptable statue. Not until August 21 did the consuls of the Arte della Lana (the Wool Guild), who bore financial responsibility for the cathedral, sign a contract with Michelangelo, then twenty-six years of age. During the intervening fifty days the sculptor studied with his square, according to Vasari (see appendix B), the block which had probably been lifted to an erect position in accordance with the deliberations of the consuls. He then made his life drawing, and presumably others as well, including the sensitive pen studies (inscribed with loving messages in Michelangelo's hand) for the mouth, left eye, and left ear of the statue, on a sheet also containing a shouting youthful head and a profile view of a warrior wearing a winged helmet. During these six weeks he must also have worked up the wax model mentioned by Vasari. Surely he presented the model to the consuls for their consideration, according to standard Renaissance practice. Admittedly the model is not mentioned in the commission, but Michelangelo had up to that time carved only one major work in Florence, the now lost *Hercules,* and the consuls would have required some evidence as to what he planned to do.

Between August 21, when the contract was awarded, and September 13, when he actually set to work, a fiercely hot moment in the Florentine summer, he must have made his gesso cast (if he had not already made it) and any other calculations. At that time he certainly tilted the block to an inclined position, as made clear in Florentine reliefs showing sculptors at work, such as that by Nanni di Banco on one of the niches of Orsanmichele. There was good and sufficient reason for carving a statue leaning back; if it stood up straight, every time the sculptor started to work

Fig. 64

Fig. 63

Fig. 65

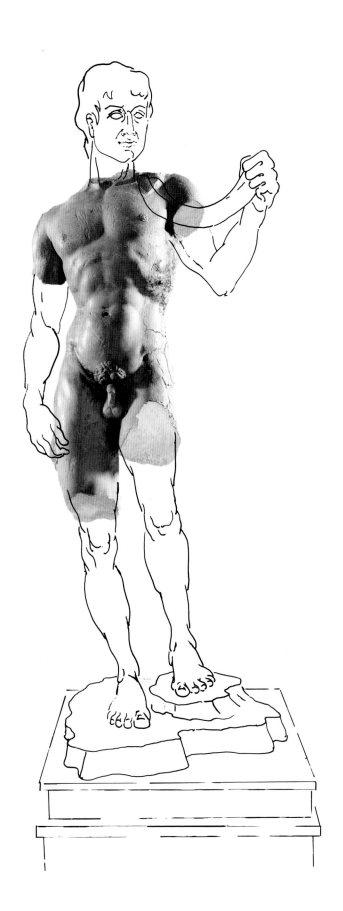

FIGURE 64 *(left)*

Reconstruction of the
original appearance
of the model.

FIGURE 65 *(opposite)*

Nanni di Banco, *Sculptors at Work*,
about 1413, marble.
Orsanmichele, Florence.

on the underside of anything—chin, arms, hands—he would get a shower of chips in his face. Vasari tells us that Michelangelo worked on the basis of the model, and judging by the remaining torso it must have been exact in every detail. But he must have made alterations immediately in the pose of the head, the left leg, and the left arm so that the figure would fit into the block. For if the left arm, especially, were in the position drawn by Raphael it would have had to be pieced. Michelangelo may have intended to do just that, as he later attempted in the *Pietà* in the Opera del Duomo in Florence. His later emphasis to both Vasari and Condivi on his achievement in carving the statue without any piecing whatever suggests, in fact, that he was originally going to add a piece and then contrived the brilliant pose of

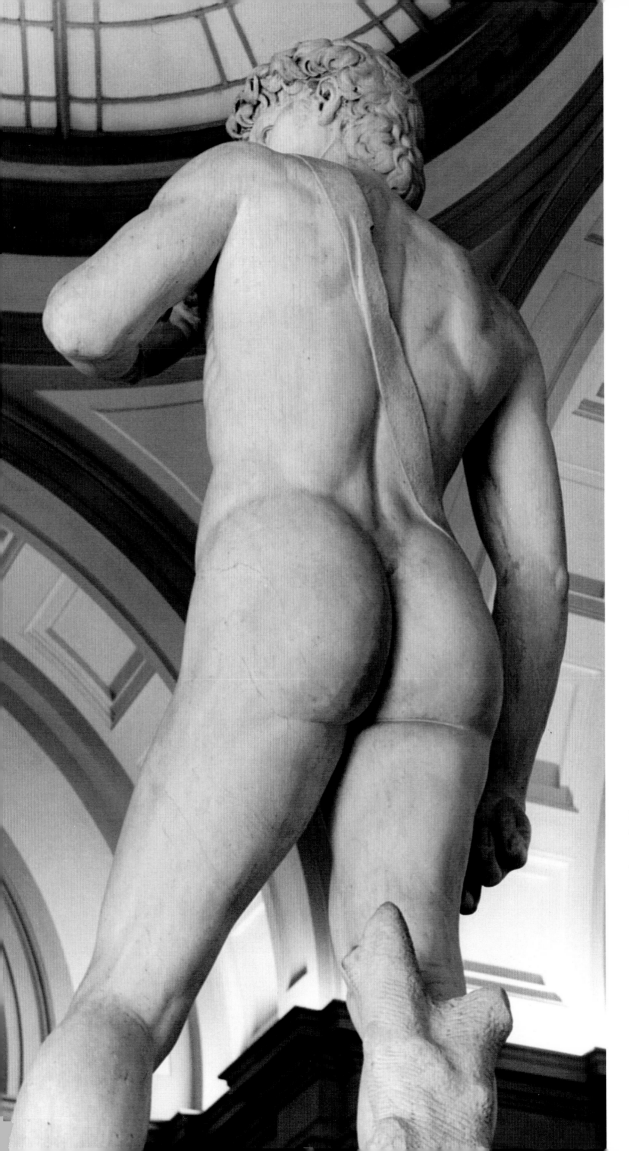

FIGURE 66 *(left)*

The statue from
one-quarter left,
below, back,
detail.

FIGURE 67 *(opposite)*

The model, back.

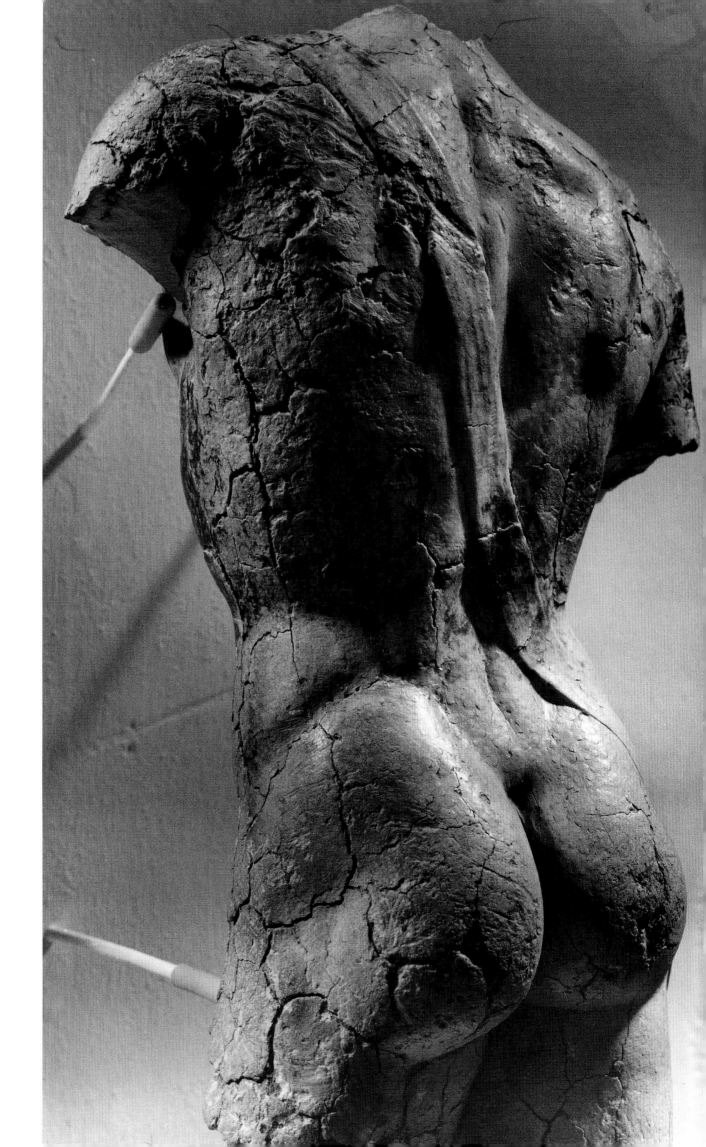

the bent left arm to avoid having to do so. At any rate, the retraction of projecting elements into the block results in a compact figure whose surging drama of formal contrasts is condensed into the torso. In the statue the forms, planes, and curves surge and billow as compared with the choppy seas of the model.

After the work was brought to a semifinal stage, the statue must have been turned over so that the artist could work on the back, always somewhat residual in Michelangelo's sculpture on account of his working method, which always began *Fig. 66* with the front and sides. Residual or not, the back of the colossal *David* is a marvel of perfection. But setting it alongside that of the model, I am willing to contend that the latter is artistically more exciting. The muscles are tenser and more strongly demarcated, and the buttocks somewhat larger and fuller. Proverbially, this particular region of the human anatomy comes in for a lot of abuse in most languages—indeed it is used as a metaphor for anything from stupidity to meanness—yet despite all that it is generally conceded to possess a powerful erotic content. Regarded from the standpoint of abstract form, to which the twentieth century has trained our eyes, the globular shapes, with their gently modulated swelling from almost flat at the top to full at the bottom, can be very beautiful in young and active members of either sex. In this respect the model seems to have attracted Michelangelo's interest more strongly than the statue, since in the model the buttocks are noticeably *Fig. 67* fuller and more powerful. Even in the strap of the slingshot there is a difference between the two. In the statue a diagonal groove is visible on the thong; in the model there is no such groove, but the strap is considerably wider at the top than lower down, possibly for comfort over the shoulders, and projects more sharply as it crosses the lower back, perhaps to suggest that there it hung more loosely.

With this model, head only slightly turned, left arm lower and projecting forward, left thigh forward, foot back and delicately poised, we may suppose that Michelangelo won his first colossal commission from the good consuls of the Wool Guild. They surely respected David's religious and political significance. But did David's job as a shepherd, therefore a protector of their raw material, also enter their commercial minds? I wonder.

S I X

MORE HISTORY

THE STORY OF THE DECISION by a special commission on January 25, 1504, to place the marble *David* in front of the Palazzo Vecchio, and of its slow journey from the workshed of the Opera del Duomo through the center of the city to the *ringhiera* (terrace) in front of the Palazzo Vecchio, has been often told, but never better than by Charles Seymour, Jr. (see bibliography). My own conviction has always been that Michelangelo never intended that his statue should be lost some forty feet above eye level on a cathedral buttress, and facing north where it would never have received proper light. But what of the model meanwhile?

No record of the model has come to light before the inventory of the Guardaroba Secreta (private storerooms) of the Palazzo Vecchio dated November 3, 1553, which has already been cited by Ugo Procacci (see bibliography). In 1540 the massive structure, built as the home of the Priori (the governing body of the Florentine republic), became the fortified residence of Cosimo I de' Medici, elected second duke of Florence in 1537 at the age of seventeen. He at once commenced a vigorous campaign to bring together as much as could be traced of the precious contents of the Medici Palace in Via Larga, which had been sacked in 1494 at the time of the second expulsion of the family from Florence, reassembled at the time of their return in 1512, and sacked again after their third expulsion in 1527. The first inventory of the Guardaroba, including the possessions of the murdered Duke Alessandro, was made in 1538. Careful investigation in the state archives of Florence by Dr. Carol Bradley has unearthed no reference to the model either in this inventory or in any other documents earlier than the second inventory of 1553. By that time Cosimo and his family had moved to the Palazzo Pitti, and the Guardaroba had been installed in the Palazzo Vecchio as remodeled by Vasari and enlarged by Giovanni Battista del Tasso beginning in 1549 but completed only in 1555. Then how did it get there?

My first hypothesis was that it might have been given by the artist himself to the republic after the completion of the statue in 1504. A second and more attractive possibility occurred to me later, namely that Michelangelo retained the model, left

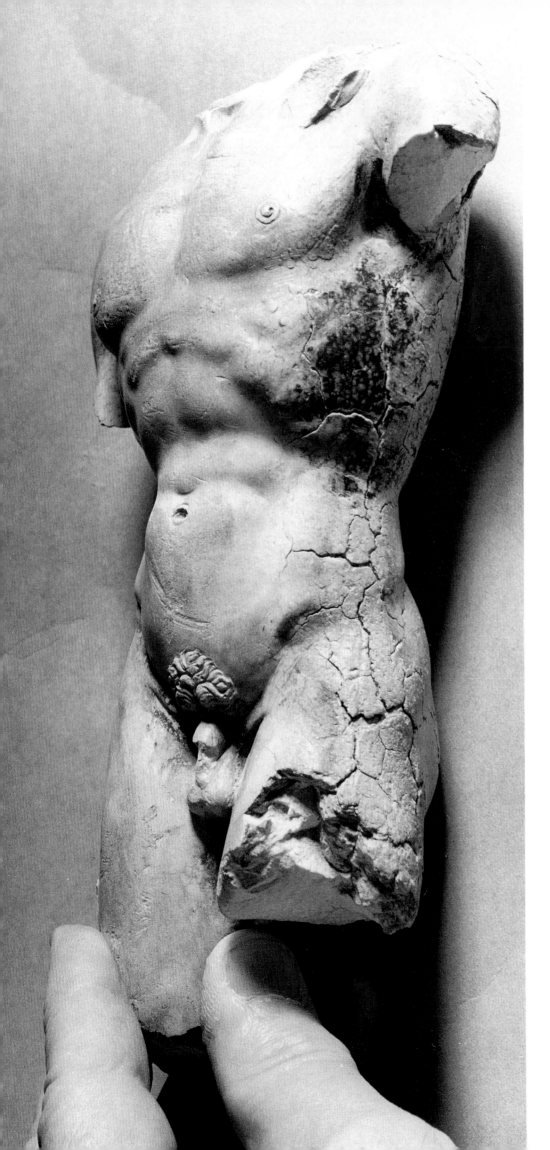

FIGURE 68 *(left)*
The model, held
by David Finn.

FIGURE 69 *(opposite)*
The model from the left.

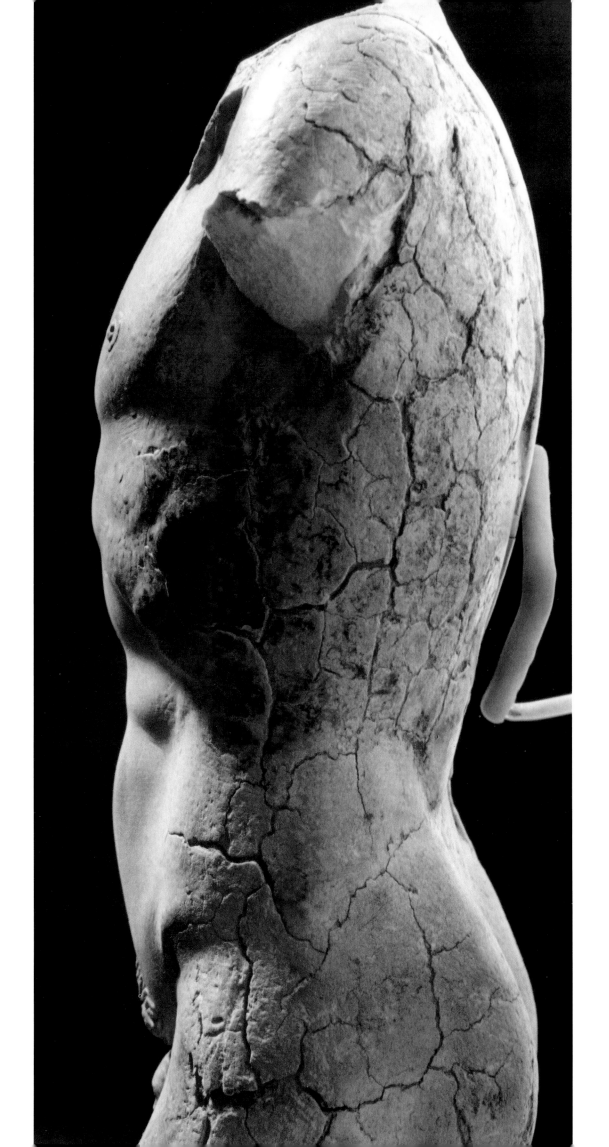

it in his house in Florence at the time of his definitive departure for Rome in 1534, and gave it to Cosimo at the beginning of their protracted and fruitless negotiations for the return of the master to Florence. Although Vasari's eloquent letter attempting to persuade Michelangelo to return, telling him how warmly the duke would welcome him, was written in August 1554, it refers to earlier letters on the subject. The correspondence, including what the artist terms "very great offers," continued for three years, culminating in a personal letter from Cosimo protesting that he had "always much desired" the artist's return. Cosimo was a difficult, cagey, and resentful man. He must initially have had trouble coping with his memories of Michelangelo's part in leading the Florentines in their armed opposition to the return of the Medici in 1530. The artist himself may have found it hard to forget that after the victory of the Medici their commander had secretly ordered his assassination. So before matters reached the happy state recorded in the preserved correspondence, both genius and despot had certainly reached at least the point of mutual trust and regard. In September 1555 Michelangelo wrote to his nephew Lionardo in Florence that he ought to have given the duke, without bothering to write for permission, not only the two models for the facade of San Lorenzo that Cosimo had asked for but anything else in the house he might like. So cordial relations between Michelangelo and the duke are established prior to 1554, as well as the duke's great interest in models (witness, as we will see, the Tribolo, and perhaps the Bandinelli, for the group which still stands outside the portal of the Palazzo Vecchio, flanking the *David*). The probability thus becomes very great that the model for the *David* was a personal gift from the artist to the duke at the outset of their new literary friendship, for the two men never actually met.

The Guardaroba Secreta was housed in a series of rooms along the north side of the top floor of Cosimo's addition to the Palazzo Vecchio, still partly unfinished (it also contained Cellini's workshops), and the inventory was made at the time of installation. The model is listed as "*modello di stucco del gigante di michelagnolo,*" thus keeping the nickname the statue bore during much of the Cinquecento, and by which it was known in the diaries of Luca Landucci (see bibliography). It appears in the first room of the Guardaroba, along with many other works of art, some preserved today and others lost. These include a portrait of Pietro Aretino by Titian (Uffizi), another by Cardinal Ippolito de' Medici also by Titian (probably the one in the Pitti), a "*furia infernale*" by Leonardo da Vinci (lost), a portrait of Carlo de' Medici by Mantegna (Uffizi), a stucco model of an apostle by Tribolo, another of the *Hercules and Cacus* without an artist's name, portraits of members of the Medici family and a *St. John the Baptist* by Bronzino, a *Madonna and Child* by Desiderio da Settignano, and many others. There were also unattributed portraits of other members of the Medici family, various fragments of ancient sculpture, and an elephant's jaw with seven teeth.

In the inventory of 1554–55 the model reappears as "*Un' modello di stucco di gighante di man' di Michelagnolo*" but in 1570 and 1574 its title is "*davit.*"

The contents of the Guardaroba Secreta have been characterized by James H. Beck as "an excellent opportunity to evaluate the tenor of life of the ruling family of Florence and . . . an important source for determining the whereabouts of certain art works during the sixteenth century" (see bibliography). The inventory of 1553 was published by C. Conti nearly a century ago (see bibliography). Its references to the Michelangelo model were considered definitive by Ugo Procacci in his catalog of the Casa Buonarroti (see bibliography) and by Ettore Allegri and Alessandro Cecchi in their massive work on the Palazzo Vecchio under the Medici (see bibliography), and have never been contested. As might be expected of inventories compiled for the Duke of Florence, these entries mean what they say. *Modello* means "model," not "copy." When an artist's name is unknown no attempt is made to supply it. In the case of an unfinished painting, possibly identifiable with that in the Casa Buonarroti after Michelangelo's drawing of a *Pietà* for Vittoria Colonna (now in the Gardner Museum in Boston), the formula used in the inventory is, appropriately, "*di dissegno* [sic] *di Michelagnolo.*" When the *Hercules and Cacus* model, possibly by Bandinelli, appears in the inventory of 1574, more exalted hopes for its authorship had apparently arisen, but the compilers state merely "*disse di Michelagnolo*" ("said to be by Michelangelo"). The first room was used as a *foresteria* (guest chamber), and the importance of the contents of the room is in harmony with this purpose.

Although the model reappears in 1609 and 1640 the artist's name does not. The latter inventory was only begun in 1640, which date is inscribed on the cover; the date 1646 appears before the first item on page 173, and that of 1666 before the second, thus clearly including the model. The height of the model is given in these last two inventories as seven-eighths of a *braccio* (cubit), the Florentine unit of measure, corresponding to approximately 58.9 centimeters. The model when complete must therefore have measured 51.5 centimeters, and our present torso only 20. The remaining 31.5 centimeters would have been taken up by the head and neck, the legs and feet, and the base, which account for about three-fifths of the height of the marble statue, and thus presumably of the model as well. Many of these entries are known to scholars, and it has never been doubted that they indicate a model by Michelangelo himself.

Twenty-four years after the last entry, at nine in the evening of December 17, 1690, during what Sir Harold Acton has rightly termed the "disastrous" reign of Grand Duke Cosimo III, "fire"—probably a pot of live coals covered with fly-ash known even today as a *scaldino* and hung on a wooden frame nicknamed the "priest in the bed," placed between her sheets as a bedwarmer by a careless serving woman and left unattended—caught the bedclothes, and soon the entire top floor was in flames. The blaze devastated twenty-seven rooms, including the Guardaroba Secreta. The Grand Prince Ferdinando, known as a far-sighted and munificent patron of the arts, hurried to the scene, according to the eighteenth-century account given by Giuseppe Richa (see bibliography), "with the aid of cavaliers and armed guards,

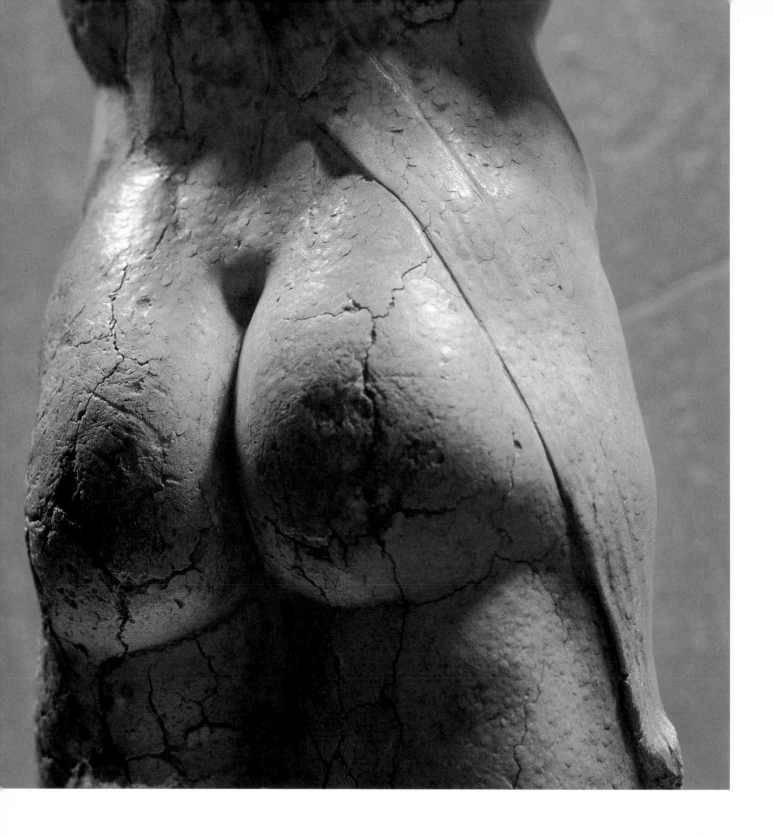

FIGURE 70 (*above*)
The model, one-quarter right, detail, lower back.

FIGURE 71 (*opposite*)
The model, back.

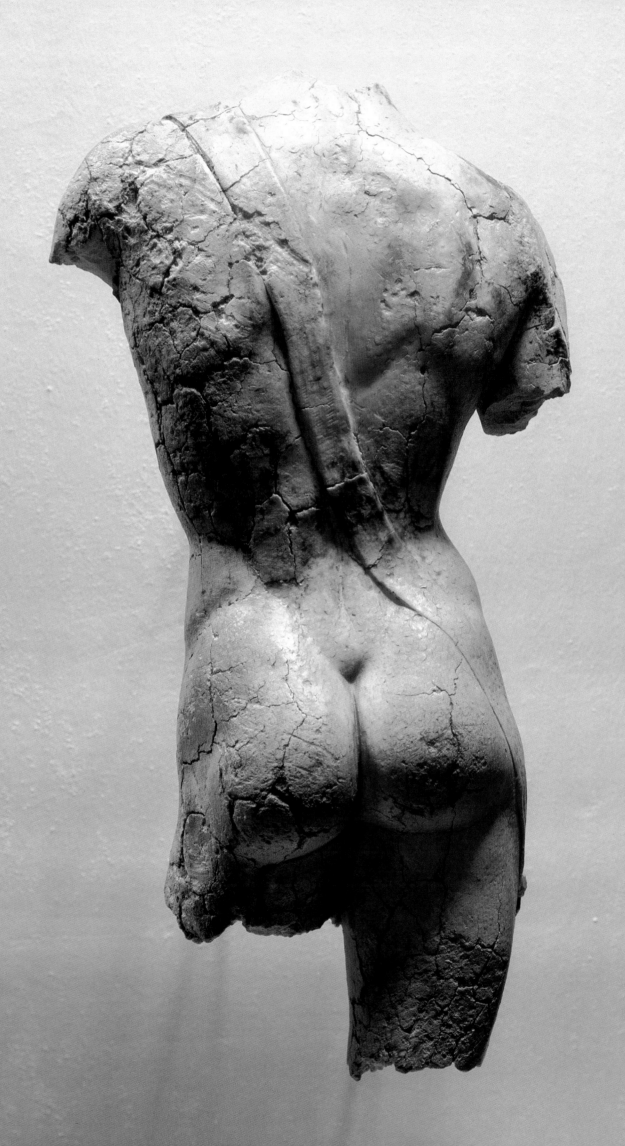

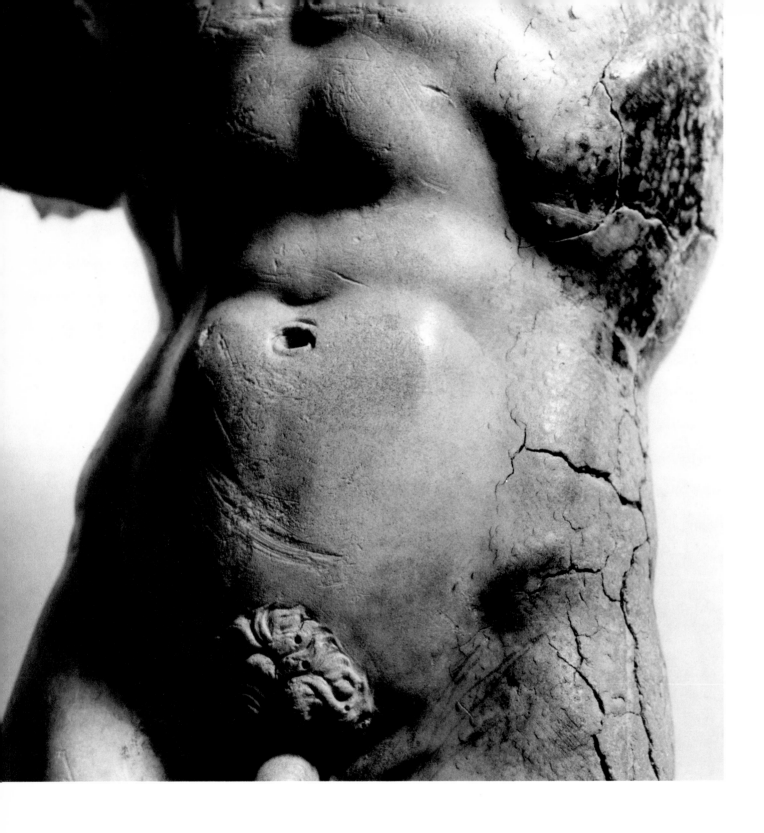

FIGURE 72 *(above)*
The model, detail, abdomen.

FIGURE 73 *(opposite)*
The model, detail, right shoulder and thorax.

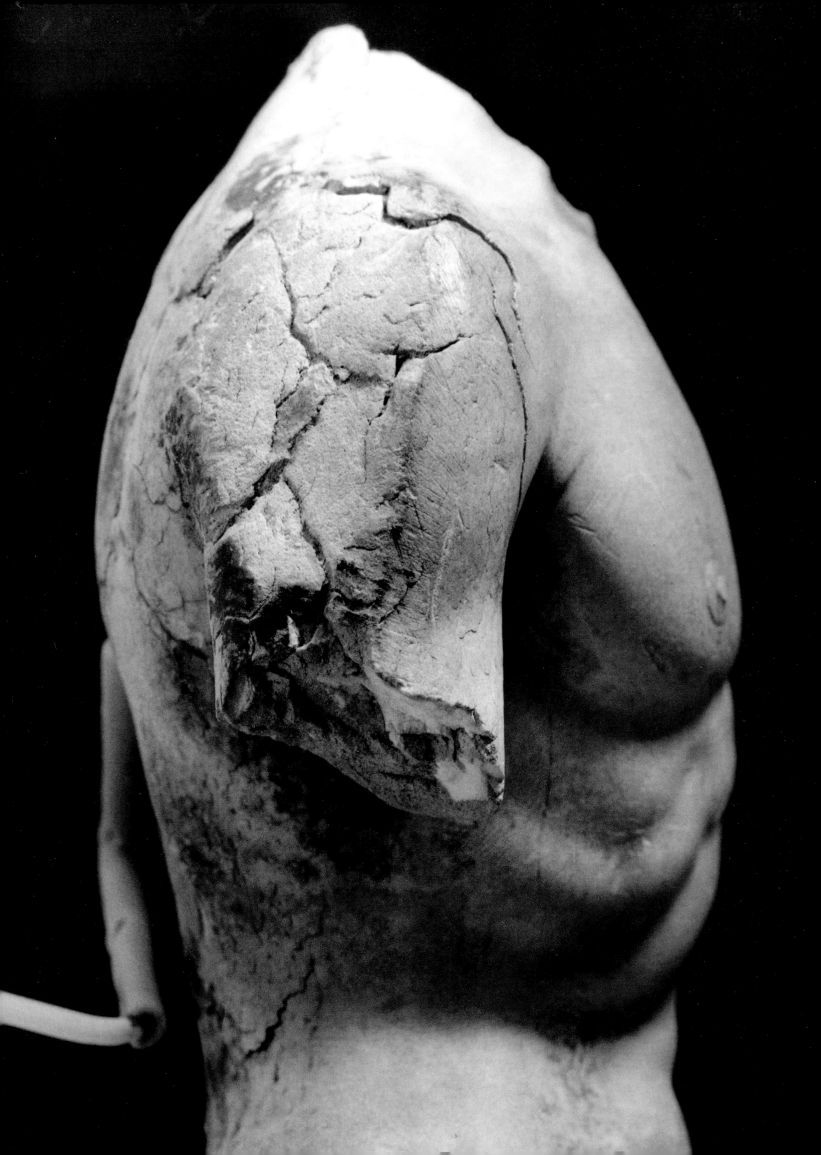

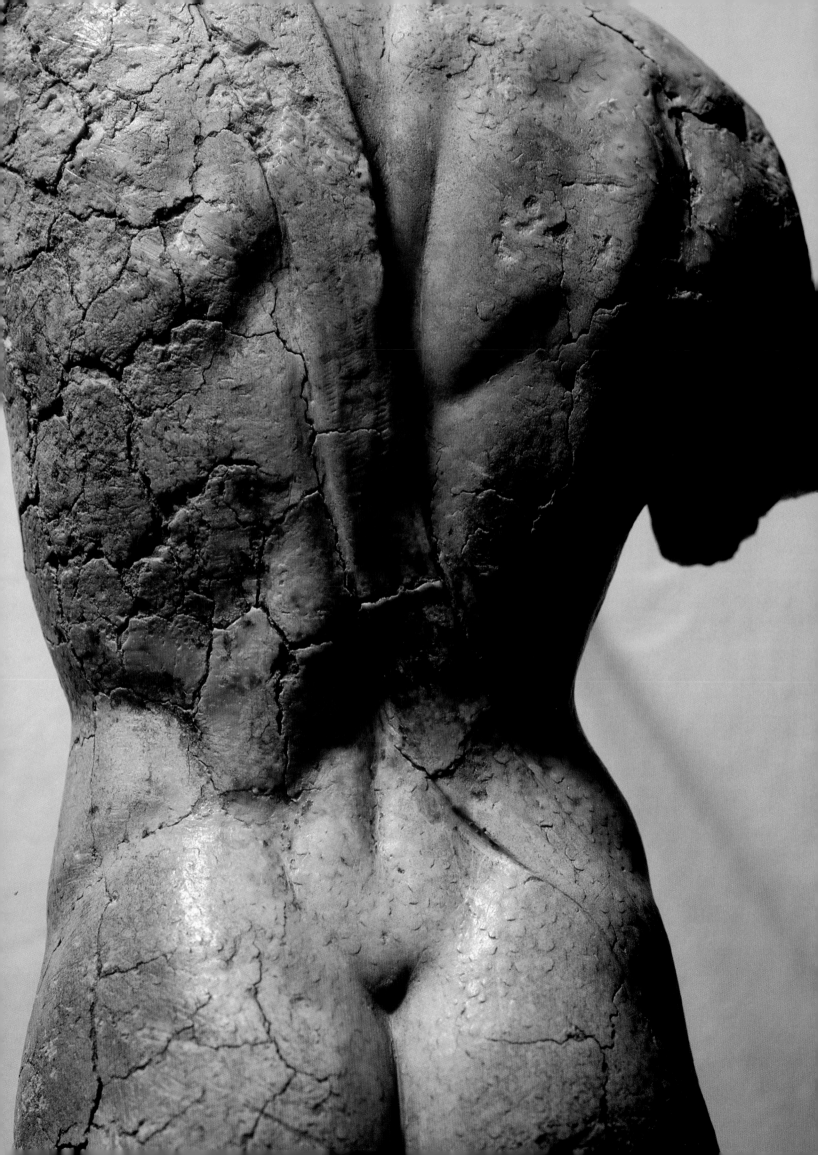

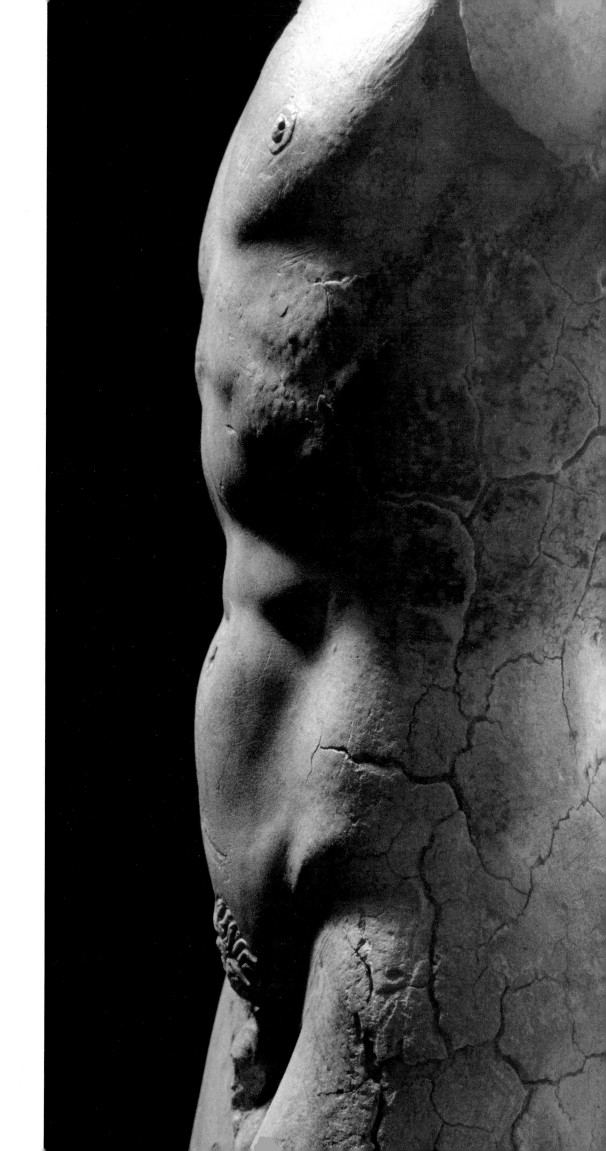

FIGURE 74 *(opposite)*

The model, detail, torso from back.

FIGURE 75 *(right)*

The model, detail, torso from left.

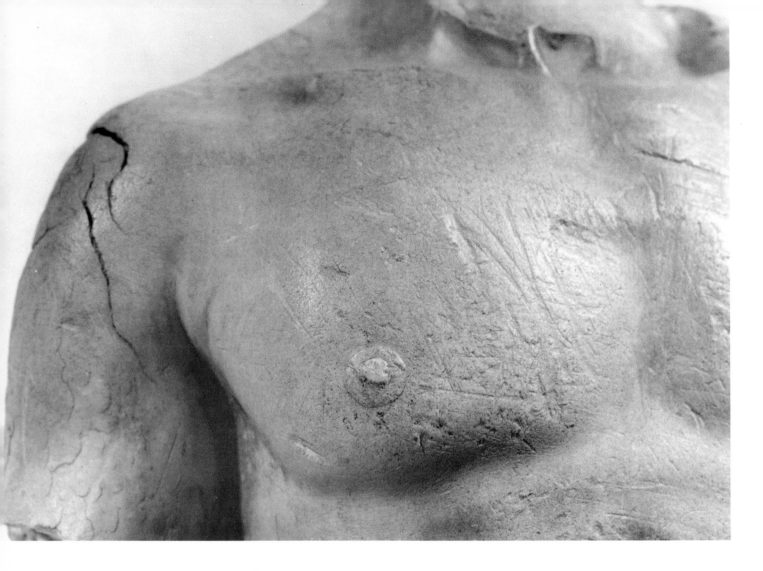

FIGURE 76
The model, detail, right pectoral and shoulder from front.

and with all the common people of the city, by whom were evacuated the most precious objects of the guardaroba." It was feared that the whole ancient structure would be gutted, and indeed not until the seventh hour of the night (midnight, counting on sundown at about five) was the fire brought under control. Among conditions of such terror and confusion anything could have happened. With the soldiers and the crowds, in darkness lighted by flames, there could have been no thought of checking inventories. The big pieces were indeed saved and many are exhibited today. Many, however, were dispersed and others lost. Raphael's portrait of Duke Lorenzo de' Medici, from another room in the Guardaroba, long thought lost, has reappeared only recently, considerably damaged. What about the smaller objects? The little model seems to have been forgotten in the general debacle. It fell forward into rubble and was buried by smoldering embers, for many abrasions are visible, as well as signs of direct fire and intense heat, all listed in appendix A. Did some soldier or townsperson simply pick it out of the ruins and make off with it?

Or did the grand-ducal authorities no longer care, in view of the damage? We will doubtless never know. At any rate, the model must have been more nearly intact than now, because the broken limbs show no sign of damage by fire. At some later time it was buried, as earth stains are evident. The Bordeaux report has confirmed both the fire and the burial, in clayey soil. Oddly enough, only the broken neck shows the earth stains, but not the stumps of the limbs, which therefore must have been broken still later.

About the later history of the model two slightly different stories are current, neither of which can be absolutely verified. According to one account the composer Arthur Honegger, then living in Béziers in southern France, acquired the model from an unknown source and kept it in front of him as he was writing his *King David* oratorio. The other account, current in the Honegger family, no living member of which was born at the time, identifies the work as a gift to the composer from an unknown admirer of the oratorio after its first performance. In neither case was any particular attention paid to the model, which was considered a good copy but of slight importance. The present owners acquired the work from Honegger's heirs in 1985.

Very little in regard to older works of art can be proved beyond a shadow of a doubt, in the absence of a genuine signature or a document of commission, and a record of continuous possession. But to disprove the authenticity of the present model one would have to demonstrate:

1. That it was carefully fabricated first from wax, then cast in gesso with great skill.

2. That an imitator was familiar with Michelangelo's creative processes and his anatomical research and knew the Louvre drawing.

3. That he was willing and able to alter radically the pose of the head, the left arm, and the left leg, for some unknown reason.

4. That he realized from long archivistic experience that the model had been kept in the Guardaroba Secreta and subsequently disappeared.

5. That he knew his way around the inventories of the Guardaroba and could cope with sixteenth-century script.

6. That having made this beautiful thing he was able and willing to damage the object by fire without destroying it, sacrificing the head in the process.

7. That he buried it in the earth long enough for the outer layers to become completely impregnated by clay.

8. That he then dug it up and broke off the limbs.

9. That after all this study and labor he would be willing to part with his product in 1921 without any claim to its authorship.

10. That he was as good as Michelangelo.

SEVEN

THE HEROIC NUDE

FOR THE YOUNG MICHELANGELO the experience of the *David* was a watershed. This was the first colossal nude statue of the Renaissance, and thus the first complete visual affirmation of the power and dignity of the natural human being. It was also the first attempt to identify such power and dignity with both the religious and the political essence of Italian society. Michelangelo's earlier nude statues—the *Crucifix,* the *Bacchus,* and the *Pietà*—were anything but heroic in nature and appearance. Although the last two were slightly larger than life (for the Renaissance, when human stature was much less than today), they were light-years away from being colossal, either in stature or in appearance. The vanished *Hercules* was about seven feet in height, including the base, and according to engravings, his back was hidden by his lion's skin.

But was the *David* a true colossus; that is, was it intended to *look* colossal? I used to think it was not, since on its lofty buttress it would have been dwarfed by the semidome behind it, and even more by the mountainous bulk of the central dome of the cathedral towering above. But the longer I have studied the situation the less I am persuaded. Michelangelo came up from Rome especially to get hold of this block. And in the contract of August 16, 1501, although the consuls of the Arte della Lana did indeed appoint Michelangelo as sculptor for the Opera del Duomo, the document contains not a word about the eventual destination of the finished statue. Even the record of the testimony delivered by the leading Florentine artists before a commission of both the Opera and the Arte della Lana on January 25, 1504, while Michelangelo was still at work, makes no mention of the original purpose of the *David* as part of a series of prophetic figures intended to girdle the exterior of the cathedral. It seems highly probable that the young sculptor intended from the very

start to cut loose from the Opera del Duomo and have his statue set at close to ground level, so as to be experienced as a colossus.

The *David* is inherently an action figure, perhaps more strikingly so in the model than when restricted by the limitations of the shallow block of marble. It is undoubtedly foreshadowed in his imagination by the magnificent pen drawing he made on the basis of the *Apollo Belvedere*. Through the conception and execution of the *David* in the drawings, the model, and the finished statue, Michelangelo had learned to think on a new and loftier level, inhabited by his special race of heroes. Only occasionally, in moments of tender emotion, uproarious fun, or sarcastic fury, did he ever descend from this ideal plane. In itself this exalted manner of thinking

Fig. 80

Fig. 81

FIGURE 77

Study for the lower story of the Tomb of Julius II, 1505, pen and wash. Uffizi, Florence.

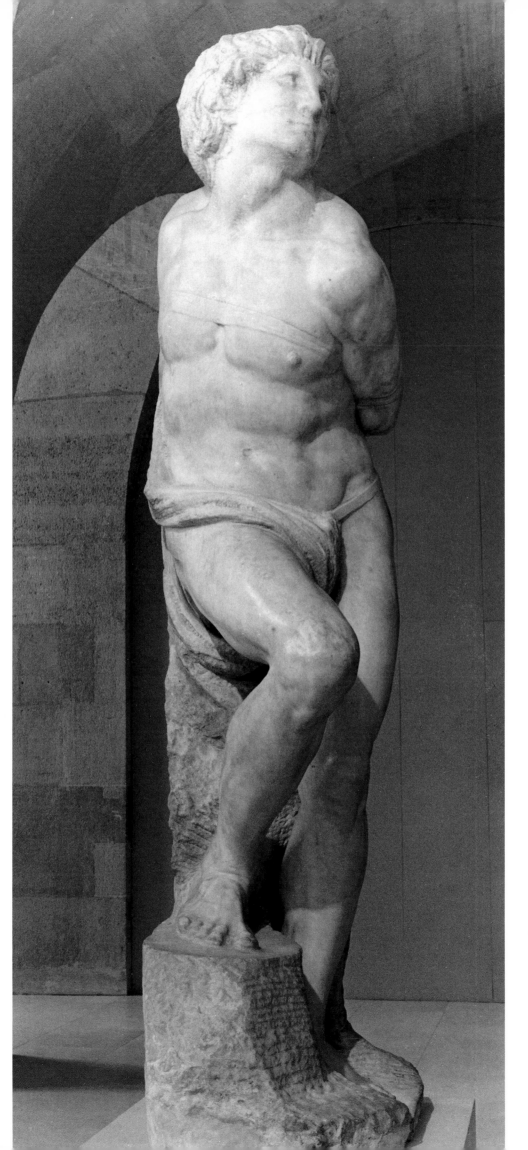

FIGURE 78 *(left)*
Rebellious Slave,
1513–16, marble.
Louvre, Paris.

FIGURE 79 *(opposite)*
Dying Slave,
1513–16, marble.
Louvre, Paris.

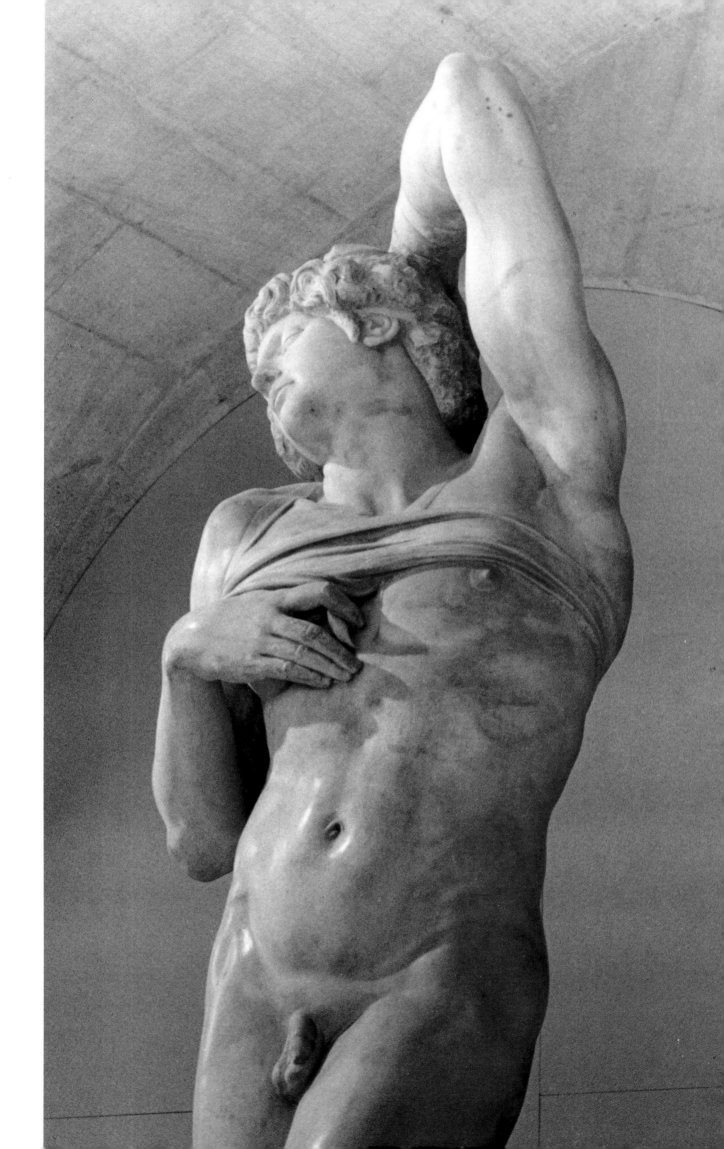

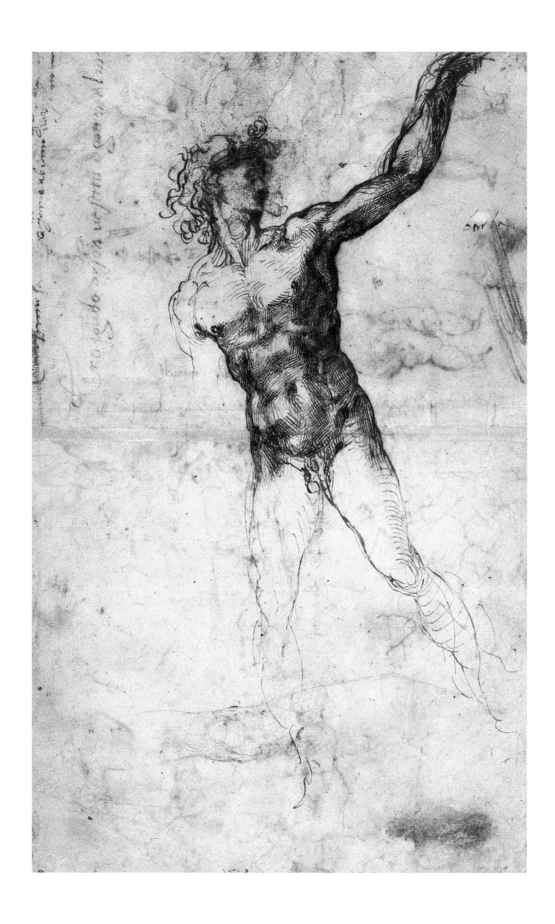

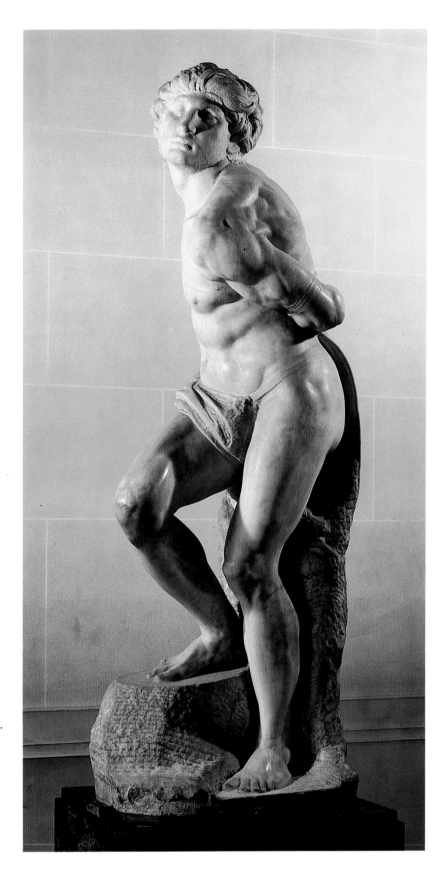

FIGURE 80 *(opposite)*

Nude running male figure,
based on the *Apollo Belvedere*,
1496–1500, pen and brown ink.
British Museum, London.

FIGURE 81 *(right)*

Rebellious Slave, 1513–16,
marble. Louvre, Paris.

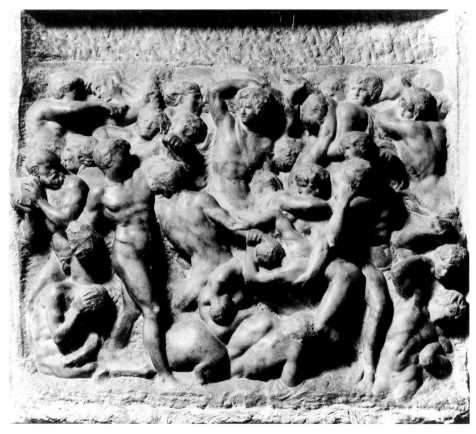

FIGURE 82 *(opposite, above)*

Aristotile da Sangallo, copy of central portion of the *Battle of Cascina*, 1542, grisaille. Collection of the Earl of Leicester, Holkham Hall, England.

FIGURE 83 *(opposite, below)*

Battle of Lapiths and Centaurs, about 1492, marble. Casa Buonarroti, Florence.

FIGURE 84 *(below)*

The Resurrection, about 1520, black chalk. Windsor Castle, Royal Library.

FIGURE 85 *(left)*

Studies for the torso
and legs of Haman in
the *Punishment of Haman*,
1512, red chalk.
British Museum, London.

FIGURE 86 *(opposite)*

Life study for a *Slave*,
1513–16, black chalk over
stylus preparations.
British Museum, London.

and imagining must have been a liberation to a man deeply sensitive to the irritating restrictions of daily life, among unattractive and unsympathetic family members—to whom he was nonetheless deeply loyal—and a social turmoil which threatened the very basis of the republic he loved. Particularly revealing is the story of how, when superintending the quarrying of marble in Carrara for the Tomb of Julius II, he dreamed of carving an entire marble mountain into a colossus looking out to sea.

Shortly after the *David* was set in place before the Palazzo Vecchio, the triumphant sculptor received his first commission for a major painting, for the interior of the selfsame palace, center of the government of the republic. The Priori desired him to design and paint the *Battle of Cascina,* a huge fresco in which the Florentine soldiers were to be depicted roused from their bath in the Arno by a trumpet warn-

ing that the Pisan army was about to attack. Only the cartoon, with magnificent over-lifesize action figures, almost all nude, was ever executed. Despite the universal admiration of the Florentine artists, who considered it a *cosa sacra*, the cartoon was cut into pieces, perhaps as early as 1515. All were eventually lost—some by deliberate destruction. The central composition, preserved in a fine grisaille copy on a panel at Holkham Hall in England, is clearly related to the figural entanglement in the unfinished marble relief of the *Battle of Lapiths and Centaurs* which Michelangelo had carved in the Medici gardens at the age of seventeen. But the boy artist's astonishing intuition into the structure, nature, and capabilities of the human figure was not yet supported by the detailed anatomical knowledge he was to gain three years later by actual dissection in the Hospital of Santo Spirito. His work on the *David* enabled him to endow this newly acquired knowledge, supplemented, according to James Elkins, by acute observation of the living body, with scale and action. The compositional principles of the relief, the new anatomical knowledge, and the heroic action of the marble colossus are all fused in the battle cartoon. Here Michelangelo established a kind of pictorial composition in terms of heroic action figures, whose probable power and grandeur we can appreciate in such drawings as those in Haarlem. He was later to recapitulate the action composition in always grander form in the *Deluge* and the *Brazen Serpent* on the Sistine Ceiling, and many other compositions realized only in drawings, such as that for a *Resurrection* in the British Museum, and eventually in the *Last Judgment*. Many studies for later works show a more direct connection with the model for the *David*. The preliminary drawing, possibly not done from life, for the torso of one of the *Slaves* for the Tomb of Julius II betrays in its construction the memory of the experience. And in such individual life studies as that for the *Haman* of the Sistine spandrel, with its swelling thoracic cage, contracted abdominal muscles, sharply contoured hips, and tense thighs, the knowledge gained through both our model and its preparatory drawing is strongly felt, even though the artist had another male figure before him as he drew.

But what about the importance of the *David*—drawing, model, and statue—to Michelangelo's later sculpture? The fact that it would have been possible to think that the Louvre drawing for our model was a figure study for one of the *Slaves* for the Tomb of Julius II shows the close relation between the two superficially different projects in the mind of the artist. In all the various stages which this project underwent before the final reduced version set up in San Pietro in Vincoli in 1545, the lower story was composed of niches containing victories, alternating with bound nude male captives, as seen in the Uffizi drawing, probably by Michelangelo himself. Characteristically, these heroic figures, struggling to escape from their bonds, substitute for the columns that might have been expected from a more conventional Renaissance artist. In each of the six statues eventually carved, in varying stages of incompletion, the abdominal structure is developed, in one way or another, from that of our model. Even David's leather thong reappears, not as an

Fig. 82

Fig. 83

Fig. 84

Fig. 86

Fig. 85

Fig. 77

Figs. 78,
79

126

instrument of liberation but of captivity, cutting into live flesh—the bonds of the captive Peter for whom the church, that of Julius II when cardinal, was named (*San Pietro in Vincoli* means "St. Peter in Bonds").

Once established, the heroic, struggling figure remains constant in Michelangelo's imagination. Probably he identified himself with this recurrent type. Indeed, throughout his poems the soul, struggling to liberate itself from its earthly bonds, is his own. In his old age, tormented by the consciousness of guilt, he longs to merge his being in

> . . . that love divine
> which opened to receive us his arms upon the Cross.

In the last harrowing *Crucifixion* drawings the Saviour, himself a workman, object of the aged artist's most intense longings, repeats in the moment of his release from mortal incarnation the heroic struggle of the rugged stonecutter who posed for his ancestor David.

APPENDIX A

DIMENSIONS AND CONDITION

DIMENSIONS

(IN MILLIMETERS)

Extreme vertical, from highest point of fractured neck to lowest point of fractured thigh	.210
Extreme depth of thoracic cage	.056
Extremes of broken shoulders	.106
Extremes of hips at joint	.072
Between centers of nipples	.049
Depth from highest point of shoulderblade to nipple	.054
Waist at narrowest point	.053
Depth of waist	.043
Depth at crest of buttocks	.051
Width of strap at shoulder	.015
Width of strap at right hand	.006

CONDITION

Breaks

Head and neck broken at angle of approximately 45°, from about sixth cervical vertebra down to just above insertion of sterno-cleido-mastoid muscles.

Right arm at angle of approximately 25° in front, from just below insertion of deltoid muscle in irregular curve to approximately one-third down biceps.

Left arm in irregular concave curve, from above insertion of biceps to approximately center of deltoid.

Sling broken off diagonally downward just above clavicle, leaving slight concavity.

Right hand and sling broken off cleanly, leaving minute stump of vertical edge.

Right thigh broken irregularly upward at about 40° angle from inside of thigh to approximately 2 milli-meters below groin, then downward, leaving sharp, jagged edge.

Right shoulder broken vertically in approximately 80° angle, shearing off outer surface of deltoid muscle; break even and flat with worn edges.

Abrasions

Several more or less vertical scratches on right pectoral and a few roughly horizontal scratches on left pectoral; sharp and shallow as if produced by pieces of grit.

Thoracic cage heavily abraded at right.

Sharp abdominal scratches in curve to the right from navel to slightly above pubic hair.

Scattered short abrasions on right thigh.

Burns

Traces of soot in groin.

Left intercostal muscles and left armpit deeply blackened, but much of left side seamed with large cracks from heat.

Right thigh heavily cracked.

HYPOTHESIS

Model fell forward into debris, so front is scratched but not burned. Small burning brand landed on back, diagonally up from just below center of back across right scapula; great heat partly melted stucco, so that it gave way under weight of fallen objects above and swelled slightly, deforming stucco in a ridge over the scapula, giving false impression of distortion on the part of the artist. Burning coals or cinders fell at small of back, under armpit, over right shoulder, alongside rib cage; heat may have caused split on right shoulder, which crackled as heat continued, and edges melted. Right thigh distorted from heat, producing unnatural ridge. All over back hundreds of tiny blisters popped up at fairly regular intervals, indicating escaping gas. Deep tan coloring like weathered marble due to earth stains. Breaks of limbs lighter in color than break at neck.

Model must have been removed from ashes and rubble with head, and with limbs more nearly intact than now, since these breaks show no evidence of fire damage. Was buried without head, so broken neck absorbed earth stains, but limbs, or portions thereof, were broken after exhumation.

APPENDIX B
SOURCES

Note: Translations are the author's and are kept as close to the Italian wording as English will allow, preferring clumsy accuracy to readable paraphrase. An agreeable by-product of this policy may be the maintenance of a certain antique flavor in the texts. Full references are given in the bibliography.

THE *DAVID*

Giorgio Vasari. *Le Vite de'Più Eccellenti Pittori Scultori ed Architettori,* vol. VIII. G. Milanesi, ed. Florence: Sansoni, 1876, pp. 152–56.

It was written him from Florence by some of his friends that he should come because it was not out of the question to have that marble which was in the Opera [del Duomo] spoiled; the which Piero Soderini, made *gonfaloniere* [standard bearer–leader] for life of that city, had discussion many times to have executed by Leonardo da Vinci, and then was in the process of giving it to Master Andrea Contucci da Monte San Savino, excellent sculptor, who sought to have it; and Michelagnolo (however much it would be difficult to carve [Italian *cavare,* "extract"] from it an entire figure without pieces, to do which the others lacked the courage to finish it without any pieces, but not he, and he had the desire many years before), when he arrived in Florence, tried to get it. This marble was nine *braccia* high, in which by bad fortune one Simone da Fiesole had commenced a giant, and so badly prepared was that work that he had split it between the legs and all badly executed and maimed; in such a way that the *operai* of Santa Maria del Fiore, who were in charge of such things, without caring about finishing it, had left it in abandonment, and already many years it was thus and was still to remain. Michelagnolo squared it [see below, "Squaring"] anew, and examining if it was possible to carve a reasonable figure from that stone, and adjusting himself to the pose of the stone, which had remained maimed by Master Simone, resolved to ask for it from the Opera and from Soderini, by whom it was conceded as a useless thing, thinking that whatever he did with it would be better than the state in which it was found, because, neither cut in pieces nor fixed in that way, was it of any use to the fabric [of the Duomo]. Therefore

Michelagnolo, having made a model of wax, represented in that, as a sign for the palace, a young David with a slingshot in his hand; so that, as he had defended his people, and governed them with justice, so he who governed the city should courageously defend it and justly govern it; and he began in the Opera of Santa Maria del Fiore, in which he made an enclosure between wall and planks, and surrounded the marble, and continually working it, without anyone seeing him, brought it to ultimate perfection.

Ascanio Condivi. *Vita di Michelagnolo Buonarroti.* Milan: Rizzoli, 1964, pp. 36–38.

After these things were done, for his domestic affairs he was forced to return to Florence; where, having stayed a while, he made that statue, which is placed to this day in front of the door of the Palazzo della Signoria, called by everyone the Giant: and the thing passed in this way. The *operai* of Santa Maria del Fiore had a piece of marble nine *braccia* high, which had been brought from Carrara a hundred years before by an artist, from what one could see, no more skilled than necessary. Because of this, to bring it more conveniently and with less work, he had roughed it out in the quarry itself, but in such a way that neither he nor anyone else had the courage to put a hand to it to carve from it a statue, not even of that size but also of much less stature. Since from that piece of marble they could not carve anything which would be good, it appeared to Andrea dal Monte a San Savino, to obtain it from them, and he sought to have them make a present of it, promising that, adding some pieces, he would carve from it a figure: but they, before they were disposed to give it to him, sent for Michelagnolo, and telling him of the desire and opinion of Andrea, and having heard the opinion he had to be able to extract a good thing from it, they offered it to him. Michelagnolo accepted it, and without other pieces he carved the aforesaid statue, so exactly that, as one can see at the summit of the head and in the pose, the old skin of the marble still appears.

MODELS

Vasari. *Le Vite,* vol. I, Della Scultura, capitolo II, pp. 152, 153.

Sculptors are accustomed, when they want to work on a figure in marble, to make for it a model, which is thus called; that is an example, which is a figure of the size of half a *braccio,* or more or less, according to what seems convenient to them, either

of clay or of wax or of stucco, because they can show in that [the model] the pose and the proportion which is to have the figure that they want to make, trying to accommodate themselves to the width and the height of the stone that they have had cut to make it in. But to show you how wax is worked, we will speak of working wax and not clay. This, to render it softer, one puts in it a little tallow and turpentine and black pitch; of which tallow renders it more manageable; and turpentine, holding itself together, and pitch gives it a black color, and gives it a certain hardness after which it is worked into finished state, so that it becomes hard.

But, to return to the way of working in wax; when this mixture is prepared and melted together, when it is cold, one makes lozenges out of it; which in handling them, from the heat of the hand become like dough, and with this one creates a seated figure, or standing, as one wishes, which should have underneath [i.e., inside] an armature, to hold it up by itself, either with wood, or with wire, according to the wish of the artist; and again one can make it with this [the armature] or without, as it seems good to him: and little by little, working with judgment and with the hands, while the material is growing, with sticks of bone, of iron, or of wood, one presses into the wax: and with the fingers one gives to this model the final polish.

Benvenuto Cellini. *La Vita di Benvenuto Cellini, i Trattati della Oreficeria e della Scultura.* Arturo Jahn Rusconi and A. Valeri, eds. Rome: Società Editrice Nazionale, 1901, pp. 778–79.

Wishing to carry out well a figure in marble, art sets forth that a good master should make a little model of at least two *palmi* [a Roman measure using the palm of the hand], and in that he should resolve the pose with beautiful invention, either clothed or nude as it ought to be. Thereafter one should make it large exactly as it must come out of the marble; and as much as one desires to make it better, so one should finish the large model better than the small one; but if one is pressed by time or by the wish of the patron, who might want to have such a work fast, it will be sufficient if the large model is executed from a beautiful sketch, because this requires little time to make such a sketch, and saves a great time in working the marble: so that although many resolute good men rush to the marble with vigor of tools, relying on the little model with good design, at the end they do not find themselves satisfied with the big piece, as much as when they have made a big model.

And this has been seen through our Donatello, who was very great, and then through the marvelous Michelagnolo Buonarroti, who has worked in both ways; but having recognized that he could not long satisfy his good talent with little models, ever after he set himself with great obedience to make models exactly as large as they had to come out of the marble for him: and this we have seen with our own eyes in the sacristy of San Lorenzo.

Filippo Baldinucci. *Vocabulario Toscano dell'Arte del Disegno.* Florence, 1681; reprint with notes by Severina Parodi, Florence, n.d., pp. 23, 99.

Bozza, f. One says for certain small models, or pictures, which Artists carry out, to make them larger afterward in the work, almost the beginning of the work, whether of painting, or of sculpture, or other.

Modello, m. That thing, which the Sculptor, or Architect makes, to exemplify or show that which he should put into work, of various proportions to the work to be made, since the model at a certain time is less, at another is of the same size. Models are made of various materials, to the taste of the Professors [experts], and according to need; that is, of wood, of wax, or stucco, or other. The model is the first, and principal labor of the work [of art], since in it destroying and remodeling, the Artist arrives at the most beautiful and the most perfect.

STUCCO

Vasari. *Le Vite,* vol. I, Dell'Architettura, capitolo IV, p. 140; Della Scultura, capitolo IV, pp. 165–66.

Now, wishing to show how one makes a stucco paste, one has pounded with a machine in a stone mortar chips of marble; nor does one take with that anything other than a lime which should be white, made either of marble chips or of travertine; and instead of sand one takes the pounded marble, and one sifts it finely and one makes a paste of it with the lime, putting two thirds lime and one third pounded marble; and one makes it coarse or fine, according to whether one wants to work roughly or delicately.

Then, with stucco, which in the fourth Chapter we said was made into a paste with pounded marble and with lime of travertine, one should make on the aforesaid bone [armature] the first sketch of rough stucco, that is coarse and grainy, so that one can put over it the finer [stucco], when that underneath has taken hold, and it should be firm, but not entirely dry; because, working the mass of material over that

which is damp, it takes hold better, wetting continually where one puts the stucco, so that it renders itself easier to work. And wishing to make cornices or foliage carved in reverse of those same carvings which you wish to make. And one takes stucco which should not be really hard, nor really soft, but in a tenacious manner; and one sets it to work in the quantity of the carving one wants to make, and one puts it onto the aforesaid carved form, dusted with marble dust; and striking on it with a hammer so that the blow should be equal, the stucco remains printed, which one continues to clean and polish afterward, until the work becomes straight and even.

Baldinucci. *Vocabulario Toscano*, p. 159.

Stucco, m. Composition of various tenacious materials for use properly of fastening together, or of repairing cracks. It is also used for works in mosaic, to make statues, and moldings, for chiselling, and other things, according to the materials of which it is composed.

Stucco to make figures, and other. A mixture of marble chips well ground, and lime of marble or travertine chips; serves to make columns, cornices, and other ornaments of Architecture, and figures; and is most durable; because in process of time it becomes almost as hard as marble itself.

Stucco of Woodworkers. It is made of gesso distempered with glue; and one gives it various colors (according to what sort of wood is used) to fill cracks.

GESSO
Baldinucci. *Vocabulario Toscano*, p. 65.

Gesso, m. Material similar to lime, made for the most part from baked stone. Our artists use it not only to make forms or molds; but to pour into the same molds works in the round or in low relief: this is made into a paste with clear water, well mixed so that it is completely incorporated, observing that in using it it should not be so liquid that it will not hold together nor so stiff that it will not make an impression; but in a manageable state like a delicate paste. After it has made an impression, having already hardened, one can remove it from the mold or from the shaped things [works of sculpture?] respectively.

Gesso to make an impression, otherwise called masons' gesso. Used by sculptors and metal casters, to shape the models of the works they are going to cast, and to form things artificial and natural in relief, in the way we have said above. This gesso is made of a certain white stone, which is quarried at Volterra and is called *spugnoni* ["big sponges"], which reduced in little pieces are baked in a very hot oven.

SQUARING
Vasari. *Le Vite*, vol. I, p. 154.

Wishing to enlarge it [the model] in proportion in the marble, it is necessary that in the same stone where one has to carve the figure, be made a square, of which one straight [portion] goes level at the foot of the figure, and the other goes up and holds the level always firm and thus the upright above; and similarly, another square either of wood or of other material to the model, by means of which one takes the measurements of the other one from the model, how much the legs project outward and the same for the arms: and one goes pushing the figure inward with these measurements, carrying them onto the marble from the model; so that measuring the marble and the model in proportion, one begins to lift from the stone with chisels, and little by little the measured figure begins to come out of that stone, in the manner that one would draw out of a basin even and straight, a figure of wax; that first would come out the body and the head and the knees, and then little by little uncovering itself and lifting it upward, one would see the roundness of that [figure] to past the middle, and then at last the roundness of the other parts.

Baldinucci. *Vocabulario Toscano*, p. 156.

Square. The instrument with which one squares, which are two rulers connected at right angles.

To square. To render square, or at right angles as might be.

APPENDIX C
DOCUMENTS

The most nearly complete series of documents concerning the *David* and its prehistory is given by Charles Seymour, Jr. (see bibliography). One change needs to be made, however, as recently pointed out by Saul Levine (see bibliography). The accepted version of the deliberation of the *operai* of Santa Maria del Fiore of July 2, 1501, does not declare that the block for the *David* was *male abbozatum et sculptum* (badly roughed out and carved), but *male abbozatum*

resupinum (badly roughed out lying on its back), which makes a lot of difference. This reading was kindly confirmed by Dr. Enzo Settesoldi, director of the Opera del Duomo in Florence, although not clear in one detail of spelling. My translation of the corrected document (no. 448 in the Opera archives) follows, with all its lapses of syntax duly included. I have also noted, in brackets, certain legible and illegible words absent from previous readings of the text.

> 1501, July 2. [With everyone present] the *operai* deliberated that a certain man of marble called David, badly roughed out lying on its back existing in the courtyard of the said Opera and desiring that the said consuls as well as the *operai* to erect such a giant and to elevate it on high by masters of the said Opera [three illegible words crossed out] and to stand on its feet now so that it may be seen by masters expert in this to be completed and finished [two illegible words].

All further excerpts below are entries in the inventories of the Guardaroba Secreta, or private ducal storeroom, in the Palazzo Vecchio in Florence, and are today housed in the Archivio di Stato in Florence. The model of Michelangelo's *David* appears in the first room of the Guardaroba. In the inventories of 1553, 1554–55, and 1560 it is listed as *"il gigante di Michelagnolo"*; in 1570 it becomes *"il Davit [sic] di Michelagnolo,"* and in 1608–11 and 1640 merely *"un Davit."* Each excerpt is taken from a long list of works of art, and the model appears in a different position in each list. All excerpts are given in the original Italian including variant spellings.

Guardaroba 28, carta 29 verso
> M D L III
> A di 3 di novembre
> Nella Prima stanza della Guardaroba secreta
> . . .

Ibid. carta 30 verso
> 1 modello di stucco del Gigante di mano di michelag†o

Guardaroba 31, 1554–55, carta 36 recto
> Entrata
> Figure et Ritratti di Gesso
> un modello di stucco del Gigante di marmo di

Guardaroba 45, 1560, carta 72 verso
> 173 [this number appears at the left of all entries on this page] Un' modello di stucco di gighante di man' di michelagnolo

Guardaroba 73, 1570, carta 46 verso
> 68 Uno modello di stucco del davit di Michelagnolo --- n°. I

Guardaroba 87, 1574, carta 38 recto
> Modello n uno di stucco dl david di michelagnolo

Guardaroba 289, 1608–11, carta 80 verso
> Addi 5 giugno 1609
> in 153 n l figura di stucco o cera di un davitt alto 7/8 ----- n I [figura]

Guardaroba 585, 1641–1666
> 17 settembre 1640
> MDCxL
> Carta 172 verso
> Dare
> . . .
> una figura di Stucco, o Cera d'un Davit', alta braccia
> 7/8, da ------ 63 B I [figura]
> carta 173 recto
> . . . Havere
> una figura di stucco d'uno David inv-------88 I [figura] [To the left of the first item entered on carta 173 is "1646"; the second item is dated "1666" in the margin at left. The date is not repeated, but it must apply to all subsequent entries, including Michelangelo.]

APPENDIX D

THERMOLUMINES-CENSE OF THE *MODELLO* OF THE *DAVID*

PROFESSOR MAX SCHVOERER

LABORATORY OF PHYSICS
APPLIED TO ARCHAEOLOGY
UNIVERSITY OF BORDEAUX

RÉSUMÉ: A test of age by thermoluminescence was performed on the statuette described as the model in stucco of Michelangelo's *David*. One was able to

think that it had been composed of calcium carbonate recrystalized at the moment of fabrication, and that in addition, it must have undergone in part the effects of intense heat. The results obtained have shown that the crystalline structure of the samples examined evolved in the course of elevations of temperature, destroying the homothesia of the curves of thermoluminescence, indispensable in dating. The physical characterization of the samples permitted us to understand this phenomenon: in fact it was a question of a plastic mixture of a stucco based not on lime and marble powder but on plaster—that is, on hydrated calcium sulfate—whose fragility in regard to heat is well known.

I. Object of the Study in Physics Applied to Archaeology

The male statuette brought to light in 1921 and interpreted as the model for Michelangelo's *David* presents an epidermis partially altered by deep crackling, as well as by a very marked brown pigmentation suggesting the localized action of an intense source of heat.

This observation did not escape the art historian, who thought that the method of dating by thermoluminescence could be carried out in order to determine the date of burning. It was for the purpose of verifying this hypothesis that he consulted us in early summer 1986.

Experiments were undertaken at the University of Bordeaux, intended to discover—starting from very small fragments of the constitutive material—a signal of natural thermoluminescence taking account of the dose of radiation received since the burning, a dose itself proportionate to the local radioactivity of the place of burial and to the elapsed time. The nature of the results obtained in thermoluminescence led us to complete this study by a characterization of the samples through scanning by electronic microscopy, fluorescence X in the dispersion of energy, and diffraction X. Let us finally state that the micro-removals carried out under binocular magnification in the inner points of the breaks, at the level of the thighs and the shoulders of the subject, represent in total less than a cubic millimeter of material.

II. Natural and Induced Thermoluminescence of the *Modello*

Before recounting the results obtained and their interpretation, it seemed useful to us to recall briefly for the reader possibly unfamiliar with the concepts which we will utilize some fundamental elements regarding the method put into practice and our way of reasoning.

A. The thermoluminescence of a crystal (1, 2*)

Under the effect of natural radiation due to radioelements present in the state of traces in the soil of burial and, to a very faint degree, to cosmic radiation, the atoms of a crystal submitted to this continuous and constant bombardment are ionized and the electrons torn out are transferred toward defects of structure such as atomic gaps or foreign atoms (cationic impurities) which capture them. If these traps exert on the electrons forces of intense retention, the latter can remain for a very long time: many tens or hundreds of thousands of years.

Heating to a temperature above 450° C empties these traps. This is the case of the grain of sand in a fired clay, or the stone of a hearth. But after this heating, and particularly after burial in the earth, of the object which contains it, the process of transfer of electrons toward the traps resumes, in a continuous and constant manner: the number of electrons trapped is directly proportional to the local radioactivity and to the elapsed time. If one knows how to determine the total number of electrons trapped as well as the number of electrons trapped each year, one can deduce the time elapsed by dividing one by the other. This is the simple principle of dating by thermoluminescence. To put it into practice is sharply more complex!

The name of the method corresponds to the phenomenon put into practice to number the electrons. In fact, when the latter, under the effect of an elevation of temperature, leave the traps and recombine with certain atoms of the crystal, they emit light. The intensity of the signal at high temperature is proportional to the number of electrons trapped, that is to say to the total dose of radiation received, itself produced by the annual dose of radiation multiplied by the duration of radiation (the age).

To measure the total dose, one compares the intensity of natural thermoluminescence to that of the thermoluminescence induced in the laboratory, on the same sample radiated with an artificial radioactive source delivering known doses.

Such a procedure presupposes that one can heat a sample many times between 20° and 500° C without altering its crystalline structure. This is generally the case with quartzes, feldspars, and zircons, often present in the mineral impoverishment of ceramics. This is not the case with calcium carbonates (lime-

* See bibliography at end of report.

stones, marble), which can change structure under the effect of heat (transformation of aragonite calcite or calcite lime) or present anisotropies of dilation (calcite). This is not the case with hydrated calcium sulfate or gypsum ($CaSO_4$, H_2O), which lose their molecules of water under the effect of heat to become plaster. In general one should eliminate from a sample to be dated all traces of carbonates or sulfates in order to obtain an exploitable thermoluminescence. Nonetheless, in certain cases we arrive at calcium carbonates deriving from fossil corals (3, 4) with satisfactory results.

B. Dating or estimation of age?

The annual dose of radiation includes two ingredients: on the one hand an internal dose due to radioelements in the state of traces in the sample itself, on the other an external dose which is the sum of radiation issuing from the surrounding soil and of cosmic radiation (only 2 percent of the annual dose). Neither of these ingredients being accessible, since it would be necessary to sacrifice a little more material to determine the internal constitution and to have available samples of the burial soil to determine the external contribution, there could be no question of dating here but at best of estimation of age. In this case we possess data on the medium radiochemical composition of calcium carbonates and on that of a medium sedimentary soil, permitting, if the experiments in thermoluminescence are satisfactory, to propose a trial value of the annual dose which leads to an estimation of age whose uncertainty is on the order of 20 to 30 percent. Even though incompatible with a properly named dating, whose precision is on the order of 6 to 8 percent, this procedure is quite sufficient when it is a matter of bringing an objective element at the time of a study on expertise and authenticity. This is the case here.

C. A dilemma: The conflict between characterization and dating

Ordinarily, before any study on thermoluminescence, we proceed to a preliminary characterization of the crystalline constituents of the object to be dated. To do this we take a fragment which is analyzed by different methods: we put into practice for each sample diffraction X, fluorescence X under electronic scanning microscope, microscopy in polarization, and cathodoluminescence. In any case the fragment examined, having been radiated by X-rays or electrons, or transformed mechanically and heated, has become inaccurate for a measure of its natural thermoluminescence. From this fact it is lost: one is obliged to take a new sample. Faced with the obligation to respect to the maximum the integrity of the work, we decided to reverse the usual order of procedure, to study first the thermoluminescence of the available samples and to characterize them later. This choice presented problems because the *modello* was presented to us as a stucco fabricated on the basis of a "powder of compacted marble" (5). If it had been thus we would have exposed ourselves to the above-mentioned difficulties. There remained happily the hope of detecting an exploitable thermoluminescence, in the measure that we have developed at Bordeaux a technique for the study of carbonates of calcium (4).

D. The choice of an instant zero: heating or recrystalization?

Ordinarily in dating by thermoluminescence it is the heating of the object examined which determines the instant zero one is looking for. In studying the parts supposedly "burned" of the *modello,* it is then the date of a fire which could be accessible. But one can consider that in certain cases the moment of crystalization also determines an instant zero, under the same heading as heating. But the *modello* is composed of a very dense material, wherefore we think that it was not obtained by compacting but rather by passage through a certain degree of dissolution in a watery medium. From this fact, in studying the "internal" parts of the *modello,* protected in principle from fire, it is the date of fashioning of the statuette that could be accessible.

E. Thermoluminescence of the *modello.* Experimental results and interpretation

1. *Samples*

A series of experiments was undertaken on five fragments taken from different points of the statuette. Figure I (a, b, c) localizes these samples.

2. *Curves of thermoluminescence*

Figure II shows for sample C the curves of natural luminescence (TL nat.) and of induced thermoluminescence (TL ind.) obtained by increasing beta doses. The experimental conditions of the study are defined in the legend for figure II.

In order not to overload the figure uselessly, we have limited ourselves to report:

—the curve (TL nat.) which comprises a combination of two masses showing peaks badly resolved at 200°, 250°, and 425° C.

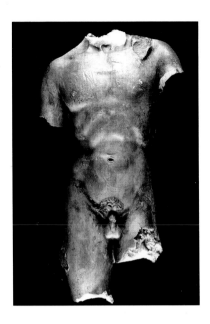
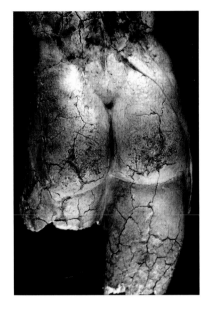
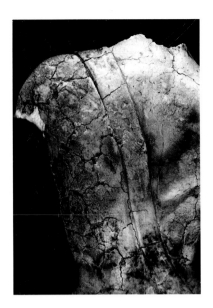

FIGURE I (a, b, c):
Localization of the 5 micro-samples taken of the statuette for a study in thermoluminescence.

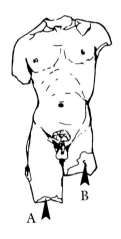
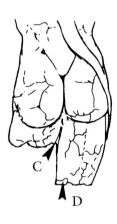

(a): samples A and B (b): samples C and D (c): sample E

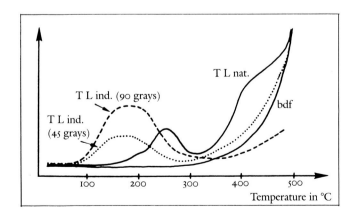

FIGURE II:
Curves of natural TL (TL nat.) and induced TL (TL ind.) of sample C, taken from the statuette. Heating speed 5°/s, nitrogen atmosphere, appropriate optical detection (white filter and tube PM56 TUVP RTC). The induced TL is obtained by radiation with a source 8 (Sr).

—the curve *bruit de fond* (bdf) obtained by a new heating without radiation.

—two curves (TL ind.) due to doses of 45 and 90 grays respectively. These two curves, also badly resolved, show a mass distinct from the preceding, whose maximum is situated around 175° C. All the same the two cross at high temperature and the curve induced by the stronger dose passes even below the curve *bruit de fond*.

3. *Interpretation of the results*

For the five samples the results are identical. In the first place one can note the non-homothesia especially at high temperature (beyond 300° C) of the TL nat. and TL ind. curves. This excludes all comparative study of these curves and by the same token all possibility of going any further in the project of chronological research. In addition the non-homothesia at high temperatures which one observes also on the TL ind. curves tends to prove that the crystals studied evolved in the course of thermic cycles, and that the material examined, structurally unstable, is not datable by thermoluminescence.

The TL nat. which exists, and is intense, is probably due to the cooperative effect of an emission of classic thermoluminescence and of a luminescence provoked by ruptures of the interatomic connections at the time of the structural change. These two emissions are for the moment indiscernible experimentally.

The form of the TL curves which present notable differences with the TL curves of the carbonates which we know (3, 4) has induced us, in spite of the negative result of the thermoluminescence study, to undertake the characterization of the crystals examined.

III. Characterization of the Constituents of the *Modello*

Aside from the witness fragments not heated, remaining from the study of thermoluminescence, a characterization of the constituents of the *modello* was undertaken using two methods, fluorescence X under scanning electronic microscopy and diffraction X.

The results obtained in fluorescence X on whitish samples coming from inner portions (samples A, B, and E, figure 1) reveal, taking account of the classic limitations of this method, the exclusive presence of calcium and sulfur.

On the grayish-brown samples, issuing from outer portions (samples C and D, figure 1), one detects calcium and sulfur as before, and as well iron, potassium, barium, silicium, and aluminum.

The simultaneous presence of calcium and sulfur is characteristic of crystals of calcium sulfate, and in consequence of a plaster ($CaSO_4$, H_2O). In any case the impossibility of detecting carbon, an atom too light for this method, does not permit us to exclude the presence of a calcium carbonate. In order to remove this ambiguity, we carried out a series of spectra of X-diffraction. These permitted us to conclude without ambiguity that this stucco is in any case a calcium sulfate. We thus discard the hypothesis of a calcium carbonate; that is, the proposal of a stucco on the basis of marble powder.

Iron, potassium, silicium, and aluminum, which one observes only on the surface of the statuette, are characteristic of the presence of clay and confirm the fact of a sojourn of the *modello* in the earth; they would in any case be foreign to the material of origin.

As for barium, which we found at several points of analysis, it could come from a barium sulfate (baritine) whose presence with calcium sulfate is not surprising.

Finally, figure III shows an aspect of the texture of the material. The legend indicates the provenance and the nature of the major elements identified by fluorescence X.

s/ MS.
Max Schvoerer
January 1987

FIGURE III:

Modello of the *David:* sample B in the inner region of the thigh (see figure 1). Image in secondary electrons of a region showing a well-crystalized texture.

Analysis by fluorescence X reveals for each monocrystal the presence of calcium and of sulfur. The segment represents ten microns (electronic scanning microscope Cambridge Stereoscam 200).

ACKNOWLEDGMENTS

We are grateful for their participation to the Electronic Microscopy Center of the University of Bordeaux I (Monique Le Blanc), to the La Teste Center for Research in Electronic Microscopy (Michel Lacaille), and to the Institute of the Geology of the Aquitaine Basin (Yvon Lapaquellerie and Noëlle Maillet), as well as to the members of our laboratory who, in various ways, have contributed to this study: Dr. Bertrand DuBosq, Rémy Chapoulie, Jean Paul Gess, and Claude Ney.

BIBLIOGRAPHY

1. Hackens, T., and M. Schvoerer. "Datation-caractérisation des céramiques anciennes," Cours Post-Gradué Ecole Européenne de Bordeaux, PACTS 10 Ed. du Conseil de l'Europe et du CNRS, Strasbourg, 1984.

2. Schvoerer, M. "Datation par thermoluminescence et gamma-thermoluminescence," in *L'Archéologie et ses Méthodes,* ed. Horvath, 1985, 267–79.

3. Gallois, B., P. H. Nguyen, F. Bechtel, M. Schvoerer. "Datation par thermoluminescence de coraux fossiles des Caraibes," PACT 3, 1979, Actes du Séminaire d'Oxford, July 1978, TLS66, 493–505.

4. Nguen, Phu Hao. "Thermoluminescence du Corail," Doctorat de 3ème cycle, Université de Bordeaux I, n. 1408, June 1978, 137 pages.

5. Private communication, June 1986.

A NOTE ON THE PHOTOGRAPHY

Photographing a Michelangelo sculpture is a unique experience. Whether it is a highly finished work like the Rome *Pietà,* or a work-in-progress like an Accademia *Slave,* there is an unmistakable tension in the way the forms flow and ripple across and around and within the figure. With lights which bring out the vibrancy of the surfaces and the strength of the curves and planes existing wherever Michelangelo's hand touched the material, there is no limit to the number of beautiful photographs one can take of a single work. This is as true of his smallest *bozzetto* as it is of a monumental sculpture such as the *David.*

When I first heard about the discovery of the model, I believed that my camera might help to determine the work's authenticity. Before I began, Frederick Hartt, who had studied the work with great care, gave me a diagrammatic picture of the sculpture indicating sections he thought I should photograph. They covered every inch of the surface as seen from every conceivable angle. He did so with some hesitation, since we had collaborated on books before, including *Michelangelo's Three Pietàs,* and he knew that I didn't like to be told how to photograph a work of art. The adventure of making one's own discoveries is what makes the art of photography a creative and rewarding act. But Frederick Hartt was so fascinated by the piece, he wanted to be sure I included everything I could possibly find.

Since the work was no more than the size of a hand span, the suggestion that I make so many close-ups made me apprehensive. I was afraid that I would end up with a series of descriptive archaeological details rather than revealing photographs. But when I was able to focus my lenses on the model and begin to take Polaroid test shots, I could hardly contain myself. The forms were magnificent, equal in monumentality and sheer beauty to the finest sculpture I had ever photographed, and, at least to my eyes, on the same level as Michelangelo's universally accepted works.

Without the versatility and superb quality of my 500c Hasselblad together with a sturdy tripod, I would never have been able to take the photographs of the work and show all of its remarkable details. Although I always use my 80mm lens for overall shots, the most revealing photographs were taken with a 250mm lens and extension tubes. I also used Proxar lenses for additional close-up focusing. The color film I used was EPY-120 (ASA 50), and the black and white was TRI-X 120 (ASA 400). I had two 600-watt lights with shutters which enabled me to control the lights on the sculpture. With four magazines for my camera (usually two filled with color film and two with black and white), I was able to work intensely for minutes on end, stopping only periodically to reload the magazines. Exposures were usually two, four, and eight seconds for bracketing of color shots, with openings of f16 or f22, and proportionally shorter exposures and smaller apertures for black and white. The Sekonic Digi-spot meter (L-488) was my indispensable guide, and my Hasselblad Polaroid back the key to testing the lighting and

exposure as well as the positioning of details in each frame. I had specified in advance that I wanted to be able to photograph the sculpture freely from all sides, and an ingenious contraption had been designed for me with metal rods extending out from a vertical wooden mount. Rubber sleeves were fitted over the rods to avoid any possible damage to the sculpture, and the rods were placed to fit the configuration of the sculpture so that it floated freely and safely in space. I was able to work in a completely darkened room with only my controlled lights shining on the sculpture, and I spent many hours photographing in what proved to be ideal conditions.

I have been photographing Michelangelo's sculpture for more than twenty years, and I am aware that the way light falls on his magnificent forms can influence one's response to them. In a series of photographs that I took earlier, the highlights on the knees of Christ (*see figure 18*) in the *Rondanini Pietà*, sometimes juxtaposed with the highlight on the arm which would eventually have been removed, created an effect like flames rising in the air. Almost always I find breathtaking nuances in views of the torsos of Michelangelo's figures with their wonderful bulges and hollows. For me, the side view of the newly discovered model, with the light skimming around its taut stomach and chest muscles, was a revelation (*see figure 75*). It was not a signature, nor a fingerprint (like the one that Frederick Hartt and I discovered in one of Michelangelo's *bozzetti* at the Casa Buonarroti), but it was as close as I came as a photographer to recognizing the hand of the master. This was a quality, I thought, that could not be copied or imitated.

Unfortunately I could not light the *David* with the same freedom as the model and so was unable to compare exactly all the different forms. But that, after all, was not my goal. My objective was to portray in two dimensions the most compelling views I could discover with my camera of this extraordinary three-dimensional work. If what I was photographing struck me as a masterpiece, my challenge was to produce pictures which revealed the qualities of that masterpiece. I hope that some of the photographs in this book come close to achieving that goal.

As anticipated, I followed the spirit of Frederick Hartt's diagrammatic suggestions when I photographed the model, and snapped my shutter wherever I found some marvelous combination of forms. I took more rolls of film than I think I have ever done before with a work of art this size.

It is always a shock when people look at the photographs of the model and then discover how small it actually is. It has a monumentality which belies its size, and part of the excitement of photographing it was to use close-up lenses and see the figure on a grand scale as the sculptor himself must have imagined it. It is not uncommon today for sculptors to make small models of major works and have them enlarged photographically to the right size to see how they will look. Michelangelo didn't have the benefit of a camera to help him, but I think the enlarged photographs of this model are echoes of what was in his mind. I believe the monumentality of the *David* becomes more accessible because we can see these details of what, in my judgment, is the original version of one of Michelangelo's greatest works.

David Finn

SELECTED BIBLIOGRAPHY

In general, selections are limited to the most important recent works, where possible in English. Items marked with an asterisk (*) are available in paperback editions.

BIBLIOGRAPHIES

Dussler, Luitpold. *Michelangelo—Bibliographie, 1927–1970*. Wiesbaden: Harrassowitz, 1974.

Steinmann, Ernst, and Rudolf Wittkower. *Michelangelo—Bibliographie, 1510–1926*. Leipzig: Klinkhardt & Biermann, 1927; reprint, Hildesheim, West Germany: Olms, 1967.

SOURCES AND DOCUMENTS

Allegri, Ettore, and Alessandro Cecchi. *Palazzo Vecchio e i Medici*. Florence: Studio per Edizioni Scelte, 1980.

Beck, James. "The Medici Invetory [sic] of 1560," *Antichità Viva* 3 and 5, 1974.

*Cellini, Benvenuto. *Autobiography*. J. Pope-Hennessy, ed. London: Phaidon, 1960.

**Complete Poems and Selected Letters of Michelangelo*. 2nd ed. R. N. Linscott, ed. C. Gilbert, trans. New York: Random House, 1965.

*Condivi, Ascanio. *The Life of Michelangelo.* Hellmut Wohl, ed. Alice Sedgwick Wohl, trans. Baton Rouge: Louisiana State University Press, 1976.

Conti, C. *La prima Reggia di Cosimo I de' Medici.* Florence: Pellas, 1893.

Hollanda, Francisco de. *Four Dialogues on Painting.* Aubrey F. G. Bell, trans. Westport, Conn.: Hyperion Press, 1979.

*Klein, Robert, and Henri Zerner. *Italian Art: 1500– 1600,* Sources and Documents in the History of Art. Englewood Cliffs, N.J.: Prentice-Hall, 1966.

Landucci, Luca. *A Florentine Diary from 1450 to 1516.* Alice de Rosen Jarvis, trans. Notes by Jodoco del Badia. London: J. M. Dent, 1927; reprint, New York: Arno Press, 1969.

The Letters of Michelangelo. E. K. Ramsden, ed. and trans. Palo Alto, Calif.: Stanford University Press, 1963.

Poggi, Giovanni. *Il carteggio di Michelangelo,* vols. 1– 5. Paola Barocchi and R. Ristori, eds. Florence: Sansoni Editore, 1965–83.

Richa, Giuseppe. *Notizie Istoriche delle Chiese Fiorentine divise ne' suoi Quantieri.* 10 vols. Florence, 1754– 1762.

*Vasari, Giorgio. *Lives of the Most Eminent Painters, Sculptors and Architects.* 10 vols. G. du C. De Vere, trans. London: Medici Society, 1912–15.

———. *La Vita di Michelangelo nelle redozioni del 1550 e del 1568.* 5 vols. Paola Barocchi, ed. Milan and Naples: R. Ricciardi, 1962.

GENERAL WORKS

Bode, Wilhelm von. *Florentine Sculpture of the Renaissance.* London: Methuen, 1908(?).

De Tolnay, Charles, ed. *The Art and Thought of Michelangelo.* N. Buranelli, trans. New York: Pantheon, 1964.

———. *The Complete Works of Michelangelo.* New York: Reynal, 1965.

———. *The Youth of Michelangelo.* 2nd ed. Princeton, N.J.: Princeton University Press, 1947.

Elkins, James. "Michelangelo and the Human Form: His Knowledge and Use of Anatomy," *Art History* 7 (June 1984): 176–86.

Goldscheider, Ludwig. *Michelangelo: Paintings, Sculpture, and Architecture.* 5th ed. New York: Phaidon, 1962.

Guazzoni, Valerio. "Gli anni del David," *Michelangelo, Scultore.* Milan: Jaca Book, 1984.

Hartt, Frederick. "Art and Freedom in Quattrocento Florence," *Marsyas: Studies in the History of Art.* Supp. I, *Essays in Memory of Karl Lehmann.* New York: Institute of Fine Arts, New York University Press, 1964.

———. *Michelangelo Drawings.* New York: Harry N. Abrams, 1970; second printing, with Handlist of Newly Accepted Drawings, 1976.

———. *Michelangelo: The Complete Sculpture.* New York: Harry N. Abrams, 1969.

*Hibbard, Howard. *Michelangelo.* 2nd ed. New York: Harper & Row, 1985.

"Michelangelo Buonarroti," *Encyclopedia of World Art,* vol. IX. New York: McGraw-Hill, 1959.

Murray, Linda. *Michelangelo.* New York: Oxford University Press, 1980.

Parronchi, Alessandro. *Opere giovanili di Michelangelo.* 3 vols. Florence: L. S. Olschki, 1968–75. (An object lesson in how attributions to Michelangelo should *not* be made.)

*Pope-Hennessy, John. *Italian High Renaissance and Baroque Sculpture.* 2nd ed. New York: Phaidon, 1970.

Procacci, Ugo. *La Casa Buonarroti a Firenze.* Florence: Cassa di Risparmio di Firenze, 1965.

*Summers, David. *Michelangelo and the Language of Art.* Princeton, N.J.: Princeton University Press, 1981.

Symonds, John A. *The Life of Michelangelo Buonarroti,* 3rd ed., 2 vols. New York: Scribner's, 1899.

Weinberger, Martin. *Michelangelo the Sculptor.* 2 vols. New York: Columbia University Press, 1967.

Wittkower, Rudolf. *Sculpture, Processes and Principles.* New York: Harper and Row, 1977.

INDIVIDUAL STUDIES

Bargellini, Piero. *Michelangelo's "David," Symbol of Liberty.* Florence, 1971.

Bush, Virginia L. "Bandinelli's *Hercules and Cacus* and Florentine Traditions," in *Memoirs of the Ameri-*

can Academy in Rome 35. Henry A. Millon, ed. Cambridge, Mass.: MIT Press, and Rome: American Academy in Rome, 1980.

Cianchi, Marco. *David: storia e mito di una statua; History and Myth of a Statue.* Florence: Becocci, 198?. Text in Italian, English, French, and German.

Fader, Martha Alice Agnew. "Sculpture in the Piazza della Signoria as Emblem of the Florentine Republic." Ph.D. dissertation, University of Michigan, 1977.

Hartt, Frederick. "Leonardo and the Second Florentine Republic," *Journal of the Walters Art Gallery* 44 (1986): 95–116.

Herzner, V. "David Florentinus," *Jahrbuch der Berliner Museen* 24 (1982): 129–34.

Keller, Harald. "Michelangelo als Bauplastiker," in *Festschrift Wolfgang Braunfels.* F. Piel and J. Traeger, eds. Tübingen: E. Wasmuth, 1977,

Lavin, Irving. "Modelli and Bozzetti," in *Acten des Internazionalen Kongresses für Kunstgeschichte* III. Bonn, 1967, p. 98.

Levine, Saul. "The Location of Michelangelo's *David:* The Meeting of January 25, 1504," *Art Bulletin* 56 (1974): 31–49.

———. "Michelangelo's *David* and the Lost Bronze *David:* The Drawings," *Artibus et Historiae* 9 (1984): 91–101.

———. "Michelangelo's *David:* The Continuing Mythology," *Source* 4 (Summer 1985): 15–20.

———. "'Tal cosa' Michelangelo's *David.* Its Form, Site and Political Symbolism." Ph.D. dissertation, Columbia University, 1972.

Lord, Catherine. "A Kripkean Approach to the Identity of a Work of Art," *Journal of Aesthetics and Art Criticism* 36 (1977–78): 147–53.

Park, N. Randolph. "Placement of Michelangelo's *David:* A Review of the Documents," *Art Bulletin* 57 (1975): 560–70.

Procacci, Ugo. *La Casa Buonarroti a Firenze.* Florence: Cassa di Risparmio di Firenze, 1965.

Seymour, Charles. *Michelangelo's "David": A Search for Identity.* Pittsburgh: University of Pittsburgh Press, 1967; reprint, New York: Norton, 1974. For a review of this book, see Herbert von Einem, *Zeitschrift für Kunstgeschichte* 35 (1972): 313–16.

Summers, David. "David's Scowl," in *Collaboration in Italian Renaissance Art.* W. S. Sheard and J. T. Paoletti, eds. New Haven, Conn.: Yale University Press, 1978.

Verspohl, Franz-Joachim. "Michelangelo und Machiavelli. Der *David* auf der Piazzi della Signoria in Florenz," *Städel Jahrbuch,* vol. VIII (1981): 204–46.

INDEX

Page numbers in italics refer to illustrations. Works not otherwise identified are by Michelangelo.

PHOTO CREDITS

The photographers and the sources of photographic material
other than those indicated in the captions are as follows:
Alinari/Art Resource, New York: *plates 22, 27, 30, 35, 37, 62, 65, 83;*
Bildarchiv Foto Marburg/Art Resource, New York: *plate 19;*
Courtauld Institute of Art, London: *plate 82;* Musées Nationaux,
R.M.N., Paris: *plates 57, 58, 78, 79, 81;* By Courtesy R. F. S. P.,
Rome: *plate 18*